Monumental Dreams

UNIVERSITY PRESS OF FLORIDA

Florida A&M University, Tallahassee
Florida Atlantic University, Boca Raton
Florida Gulf Coast University, Ft. Myers
Florida International University, Miami
Florida State University, Tallahassee
New College of Florida, Sarasota
University of Central Florida, Orlando
University of Florida, Gainesville
University of North Florida, Jacksonville
University of South Florida, Tampa
University of West Florida, Pensacola

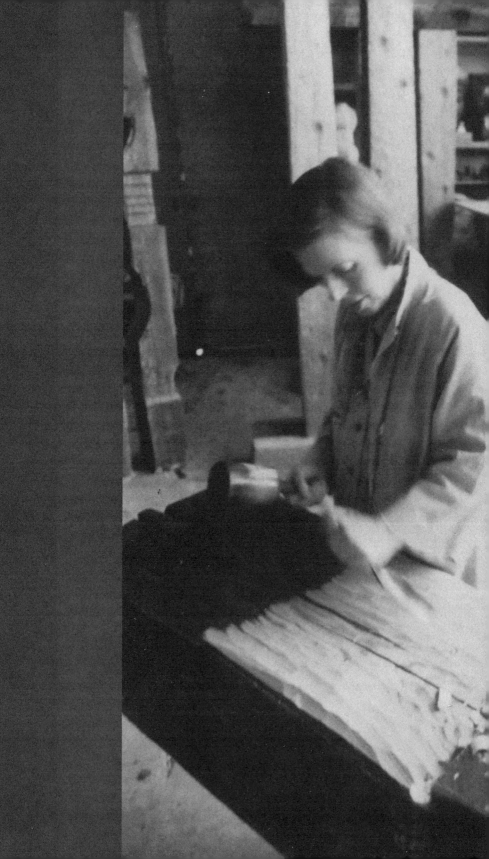

Monumental Dreams

THE LIFE AND SCULPTURE OF ANN NORTON

Caroline Seebohm

UNIVERSITY PRESS OF FLORIDA

Gainesville · Tallahassee · Tampa · Boca Raton · Pensacola
Orlando · Miami · Jacksonville · Ft. Myers · Sarasota

19 18 17 16 15 14 6 5 4 3 2 1

Frontispiece: Ann at work carving with a chisel
in her studio. Photo courtesy of ANSG.

*Library of Congress Cataloging-in-Publication
Data*
Seebohm, Caroline.
Monumental dreams : the life and sculpture of
Ann Norton / Caroline Seebohm.
pages cm
ISBN 978-0-8130-4977-9
1. Norton, Ann Weaver, 1905–1982—Biography.
2. Women sculptors—United States—Biography.
3. Sculpture, American. I. Title.
NB237.N67S44 2014
730.92—dc23
[B]
2013047858

The University Press of Florida is the scholarly
publishing agency for the State University
System of Florida, comprising Florida A&M
University, Florida Atlantic University, Florida
Gulf Coast University, Florida International
University, Florida State University, New
College of Florida, University of Central
Florida, University of Florida, University of
North Florida, University of South Florida, and
University of West Florida.

University Press of Florida
15 Northwest 15th Street
Gainesville, FL 32611-2079
http://www.upf.com

Contents

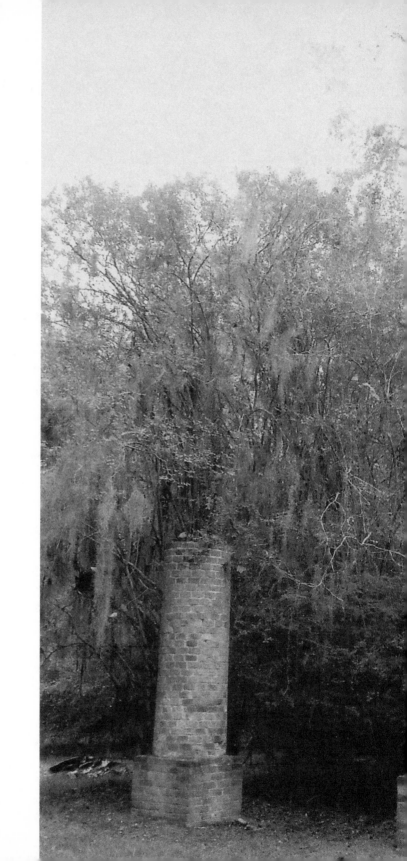

Prologue

About a twenty-five-minute drive from Selma, Alabama, at the spot where the Alabama and Cahaba Rivers meet, lies a ghost town. Once this place was the first state capital of Alabama, but nothing is left now except some traces of streets, ruined buildings, the odd foundation stone, a crumbling cemetery.

In 1819 Cahawba (or Cahaba), a piece of beautiful, undeveloped land in the valley between the two rivers, was made a gift to the state of Alabama by President James Monroe. A year later, the city was the humming center of the state. But catastrophic flooding from the rivers, plus the city's low-lying situation, which encouraged yellow fever, forced state officials to move the capital to Tuscaloosa (and later to Montgomery). Thus, the first city of Cahawba vanished. It had lasted only six years.

But like a phoenix, Cahawba rose again in the 1850s. The city was at the center of the fertile Black Belt of the state, and as the cotton business exploded, the Alabama River became

1

the vital link for ferrying cotton from the vast plantations of the region to the port of Mobile. Cahawba once again flourished, at its height boasting over 3,000 residents. State offices and public buildings displayed the elegant antebellum architecture of the time along streets with names like Vine, Chestnut, and Walnut laid out in a grid, copying the venerable northern city of Philadelphia. With the arrival of the railroad in 1859, the city achieved the South's "best and highest cultivation."

But two years after this accolade, war, rather than natural disasters, brought Cahawba's glittering epoch to an end. Soon after the Civil War began, the Confederate government seized the railroad and tore it up in order to lengthen the main line, and in 1863 an infamous makeshift prison for Union soldiers was set up in the center of town. In 1865, while the Battle of Selma raged a few miles away, the river waters once again inundated the battered city.

There were to be no more miracles for Cahawba. Within ten years, the townhouses had been dismantled or removed. A new rural community of freed slave families took up residence on the foundations of their former owners' mansions, and the Philadelphia-style streets were turned into small farm allotments. But even that transformation did not last. The conditions of the site remained unforgiving, and soon everyone was gone.

There's not much to see now. Straight, sandy roads lead to nowhere. An artesian well, an outhouse for slaves, and the remains of a church gradually arouse the imagination. Yes, this was indeed once quite a place.

The most powerful remnant of Cahawba's glory, however, is discovered almost by accident. Walk through a leafy, dark, tunnel-like pathway, overgrown with shrubs and weeds, and you stumble into a glade punctuated by three enormous, circular brick columns. Higher than telegraph poles and crumbling at the top, they stand alone in the clearing, monumental relics to a glamorous past.

These columns were part of a house built in 1843 by Richard Crocheron for his northern bride. The Crocherons, a shipping family, had opened a store in Cahawba, and Richard came down from Staten Island in 1837 to help run it. His house reflected the prosperity of the time. Beautifully sited at the confluence of the two rivers, it was made of brick, with porches and big windows. The columns were part of a side portico.

But when his wife died in 1850 (of yellow fever? childbirth?), Richard was so devastated that he abandoned Cahawba and returned for good to

New York with his children. After that the house, like the rest of Cahawba, disappeared.

But not these three brick columns. They still stand, obstinate obelisks recalling a southern ghost story. An artist—a sculptor—on seeing them, would not be likely to forget them.

Part I

Southern Roots

Selma, Alabama, 1905–1930

1

The Origins of a Great Alabama Family

ANN VAUGHAN WEAVER was born in Selma, Dallas County, Alabama, on May 2, 1905. Her parents belonged to the three dominant families in Selma at the time—the Weavers, the Minters, and the Vaughans, all of whom who lived in the center of the South's black belt, so-called for its rich, fertile, cotton-loving soil.

Ann's great-grandfather, Philip J. Weaver, whose German antecedents came from Maryland, was perhaps the most famous Selma native in its history. Born in 1797, he was famous for several things: for being the first permanent white settler in Selma and also the richest man in the region, thanks to an entrepreneurial talent for running cotton plantations (at one time he had over seven hundred slaves working for him); for looking outside his home territory and buying real estate that extended from Mississippi, Tennessee, and Texas to New York City; and for sustaining various other businesses that flourished before the Civil War.

Described admiringly by the local newspaper as "Selma's merchant prince," Philip Weaver started out running a general store, trading mostly with the local Native Americans. In 1827 he funded Selma's first newspaper, and in 1837 he pledged $100,000 (a lot of money in those days) to help build a railroad from Selma to Montgomery. In the 1840s he went to Germany to recruit skilled workers for his projects, and by the early 1850s at least three hundred German and Jewish immigrants had settled in Selma. He built a splendid house on the corner of Lauderdale and Water Streets,

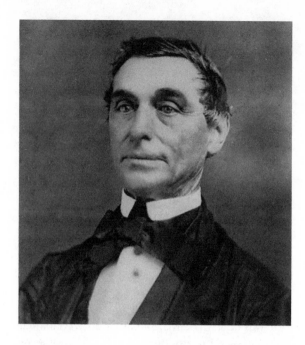

Philip J. Weaver
(1797–1865), founder
of Selma and patri-
arch of the Weaver
family, c. 1850. Photo
courtesy of Edith
Weaver Haney.

and from its veranda he could watch the steamboats carry his merchan-
dise from New York up the Alabama River to his dealers in Mobile. In
1823 Philip Weaver acquired a well-born wife, Ann Powell Gardner, with
whom he reared six children to adulthood (several more died young).
In the Marriage Records of Dallas County from 1818–1918, twenty-seven
Weavers were listed.

Philip J. Weaver's other claim to fame was, as for so many Southerners,
his role in the War Between the States, as they called it. The Battle of Selma
in 1865 was a defining moment for the town, which was the second most
important munitions depot in the South and the most crucial surviving
arsenal. The outcome of the confrontation in Selma between the crazed
but inspired Confederate General Nathan Bedford Forrest and his Union
counterpart, General James H. Wilson, was never really in doubt. The
Union Army was in fine shape, with 13,500 experienced troops supplied
with every kind of weapon and transport. The Confederates, on the other
hand, had lost so many soldiers over the years that Forrest was forced to
induct old men and young boys to help defend Selma's munitions base
and its strategic position on the Alabama River.

On April 2, 1865, Philip J. Weaver was sixty-eight years old. At around

5 P.M., he sat outside his large mansion in Selma and waited for the Union boys to arrive, which they did, in large numbers. There are several versions of what happened next, but probably the most reliable is told by Philip Weaver's granddaughter, Rose Pettus Weaver, who described the event in her diary: "Grandpa stood in the West door way facing Lauderdale St. watching the Yankee soldiers passing, when one of them slipped up and knocked him in the head and stole his huge open face watch, the first purchase he had made with his first earned money. He lay unconscious for an hour." (The soldier's aggression may have had something to do with the fact that Weaver had been an adviser to Jefferson Davis and a well-known financial backer of the Confederate Army over the years.)

Weaver did not die immediately from this assault. He lingered long enough to sign the Presidential pardon that all Southerners whose wealth exceeded $20,000 had to sign in order to escape being tried for treason. Weaver signed it on October 2, 1865, and died a month later, leaving 100,000 acres of land and between 700 and 1,000 slaves.

Since Philip Weaver had the best house in town, Brigadier-General Edward Winslow, whom Wilson put in command of the city, took it for his headquarters, giving the Weaver family further cause for complaint. According to Rose, "the dining table still bears Yankee tracks where his soldiers jumped upon it."

After the Battle of Selma, General Wilson met representatives of the defeated army to sign the surrender and exchange of prisoners. (Forrest escaped and surrendered later in Gainesville, Alabama.) Meanwhile, Robert E. Lee was putting up his last fight in Virginia. General Wilson and his triumphant troops moved on to Montgomery, and the war ended two months later, in June 1865.

Ann's paternal great-grandfather was equally involved in the myth-making that the Civil War generated. His name was Colonel William Thomas Minter. Colonel Minter was sixty years old at the Battle of Selma, and he, too, died during the battle, shot in the head with his sword in his hand, heroically defying surrender. Buried in a shallow grave, he was found by two of his slaves, a husband and wife, who travelled from Emerald Place, the Minter plantation a few miles outside Selma, to look for him. They dug up the grave and brought him from Selma across the Alabama River and thence by wagon to his home where his two daughters sadly awaited him.

Philip J. Weaver is buried in Selma's Live Oak Cemetery, along with

many other relatives and Selma notables. The cemetery is beautiful, a classically southern landscape of live oaks and Spanish moss, dominated by a central Confederate Circle monument where 155 soldiers are buried. At its four corners are four large cannons, and within the space a huge statue of a Confederate soldier stands surrounded by a small number of his fellow soldiers' gravestones. People like to point out that the cannons point toward the north, as though prepared still to defend the soldiers lying dead in the ground.

The Weavers, the Minters, and the Vaughans had all grown up in the manner expected of Southern upper-class families of the nineteenth century, when King Cotton turned them into millionaires and allowed them to enjoy the accoutrements of European taste and style. Ann Weaver's paternal grandfather, William Minter Weaver (1829–1898), was a serious scholar. (Philip Weaver educated his children well.) Surviving scrapbooks and Greek and Latin books show William's intellectual interests. He was a graduate of the University of South Carolina, spent several years traveling in Europe, and had been offered a position as a classics professor but chose instead to work for his father in Selma. Returning home from the war in 1865, he confronted the deaths of both his father and father-in-law and found their affairs in total disarray. Without hesitation he moved to take over the running of the family businesses. He was thirty-six years old.

The major Minter estate was Emerald Place, a surprisingly modest plantation in Dallas County (known later to the family as "Weaver Wallow" because of its natural spring-fed swimming hole). Before the war, William Weaver had married Lucia Minter, his second cousin, at Emerald Place, thus joining together two of the preeminent families of the region. They also owned a brick townhouse in Selma. The couple produced six children. Their youngest, William Minter Weaver II, Ann Weaver's father, was born in Selma on May 27, 1877.

William Weaver's major contribution to Selma was the construction for his family, starting in 1868, of a large brick mansion on the corner of Lauderdale and McLeod, known later as "The Castle." The story goes (and for those attempting to get a handle on the history of Selma, there are always stories) that it was designed in the style of a German schloss because Mr. and Mrs. Weaver had made a trip down the Rhine and apparently liked the architecture. There is no evidence for this. The house does not resemble in the slightest a German schloss. However, it certainly looks different from most of the more conventional Italianate or neoclassical townhouses

The striking Victorian and Gothic brick mansion later known as "The Castle," built in Selma in 1886 by William M. Weaver (1828–1898), Ann's grandfather. Photo courtesy of Edith Weaver Haney.

that were all the rage in the antebellum South and that adorned the leafy streets of Selma in the 1860s.

The Weaver mansion was built entirely of handmade sand bricks, with the kilns for making them set up on the site. The interior woodwork was walnut, cut and carved locally, with the help of imported German workmen (perhaps the legacy of Philip Weaver). William installed several unusual features, such as gas lighting (a new invention) and a dance floor "so my children don't have to go out to dance."

These details took some time to complete: William and his family did not move into the house until 1882. Seven years after they moved in, William's wife, Lucia, died of cancer, leaving William, already burdened by business matters, to raise his large family alone. The atmosphere may not have been very cheerful for the children. With its tall, narrow Gothic windows, high chimneys, ornate brickwork, and imposing portico, the house

had something of a Brothers Grimm fairy-tale look about it. Ghosts, never far from Selma's collective imagination, were said to haunt the place long after it had been abandoned, and some say they still linger there.

Ann Weaver's mother, Edith Vaughan, was the product of yet another important and wealthy Selma family, with connections to the Jeffersons and Henry Clay. Edith's father, Paul Turner Vaughan, was perhaps even more myth-worthy than the Weavers and Minters. Paul Vaughan joined the Confederate Army at the age of twenty-two, and unlike the others, he survived to a ripe old age, dying in 1916 at the age of seventy-seven. His war record was thrilling, having fought in battles at Bull Run, Manassas (both), Brown's Gap, and Gettysburg. He was also highly educated, with a law degree from the University of Virginia, as well as being a student of history and literature, and "imbued," as a memorial book said of him, "with all the chivalric ideals of the best people of the South." Such a grandfather is not to be taken lightly, particularly since he added five sons and two daughters to the ancestral mix.

So we come to the generation that produced Annie Vaughan Weaver (as she was known as a child in Selma). By this time, the number of relatives was quite considerable. What makes matters even more confusing to the amateur genealogist is that so many of them were given the same names. Ann, William, and Rose in particular crop up with alarming consistency. Moreover, they enthusiastically intermarry, particularly Minters and Weavers. As a child, Annie Vaughan could not have been blamed for doubting if any people lived in Selma at all other than her relatives.

She grew up in the classic Southern tradition, listening to the endlessly repeated stories of her legendary forbears, of those who died in the War, of those who built the great houses of Selma, of those who were buried in the Live Oak Cemetery, and awed, for a while anyway, by the reassuring repetition of these illustrious family names that she saw everywhere she looked.

But there were other forces at work, creating a counterbalance to these impressive male heroics, and none proved more inspiring or powerful drivers for Annie Vaughan's ambitions than her two aunts, Clara Weaver Parrish and Rose Pettus Weaver, who in their different ways were to have a profound effect on their niece's future.

2

Childhood in Selma

IF PHILIP J. WEAVER founded a dynasty, it was the female line that most distinguished it. His granddaughter Clara Minter Weaver was born in 1861, at the start of the Civil War, on the beloved Emerald Place plantation in Dallas County, which belonged to her mother's family.

While most old Southern families struggled to keep their heads high after the devastating financial losses the war caused, the Weavers survived better than most. After all, Clara's grandfather had been the richest man in Selma, and her father evidently inherited enough money to embark on the construction of his grand Selma mansion in 1868, only three years after the end of a conflict that left most of the South in ruins.

Not only did he have enough money to build this impressive mansion, but in 1871 he also donated land for the sanctuary of Selma's St. Paul's Episcopal Church, which was to be built after Union soldiers burned the original church. He sold the rest of the property to the church at half price. (William was a devout Protestant.) The distinguished New York firm of Upjohn and Upjohn, which designed Trinity Church in New York City, served as the architects.

Clara Weaver grew up, along with her five siblings, Anne, Lucia, Norman, Rose, and William II, as the big house was being completed. There was a certain amount of luxury. Clara's parents insisted that their children acquire a good education as well as enjoy the fruits of their family fortune. Norman developed a precocious interest in mechanics and electrical engineering and was encouraged to pursue it. When they weren't playing at Emerald Place, Clara and her sister Rose both showed a serious talent for art.

While few southern families could afford to take trips abroad anymore, let alone send their daughters "up North" for art's sake, in the 1880s Clara was sent to study at the Art Students League in New York. Once there, Clara quickly disabused her student friends of any assumption that she was a southern belle. Heaven forbid. Clara was a well-educated, ambitious young woman from a socially powerful and influential family, and she quickly began making a name for herself as an artist.

She had a studio in the city where she produced a large portfolio of portraits, watercolors, and etchings that pleased the public. People compared her to her mentor, William Merritt Chase. She exhibited at the Paris Exposition in 1900, as well as regularly in the United States. Her inexhaustible energies led her to the Tiffany Studios, where she began to produce the beautiful stained glass that is perhaps her most well-known legacy. She once said she dreamed of having her work in every church in Alabama. She didn't fall too far short of this dream—her stained glass can be seen in St. Paul's Episcopal Church and the First Baptist Church in Selma, the Church of the Holy Cross in Uniontown, and Christ Church in Tuscaloosa. She also designed the seven-panel window in the church of St. Michael and All Angels in New York City.

In 1887 Clara married a wealthy businessman from Selma, William Peck Parrish. They lived in New York, where he had a seat on the stock exchange, and travelled widely in Europe. In 1901 Mr. Parrish unexpectedly died, adding a considerable sum to Clara's already substantial fortune. Their only child, also called Clara, was born in 1888 but died when she was less than two years old. A lovely portrait that Clara painted of the child survives, along with a ghostly sketch, in which the grieving artist imagined how her lost daughter might look if she had reached seven years old (prefiguring what now can be done on the computer). Nothing could be sadder than that penciled, wistful dream.

Clara continued to work productively in her studios in New York and Paris but frequently returned to Alabama, organizing exhibitions of southern women artists, working toward her dream of starting a museum and school of art, and encouraging local women to pursue their artistic dreams. Clara was a force to be reckoned with in that struggling, conservative region. Certainly by the time Annie Vaughan was born, her aunt was legendary.

Clara's younger sister, Rose, while not as famous internationally as Clara, also probably studied in New York and began to develop her own

Ann's childhood home, 217 Church Street (now demolished), Selma, a gift from Paul Turner Vaughan to his daughter, Edith, Ann's mother, on her marriage to William M. Weaver. Photo courtesy of Edith Weaver Haney.

career as a sculptor in wood, mostly mahogany, a popular hardwood in the heyday of southern interior decoration. Her work, like her sister's, is of the highest quality.

Annie Vaughan Weaver grew up in a house at 217 Church Street, a gift to her mother from her grandfather, Paul T. Vaughan, who gave new houses to all of his children. According to several Vaughan cousins, in addition he gave a wedding present of $10,000 to each child. This was a considerable sum, indicating that the Vaughan side was also very prosperous indeed at one point. The Weaver/Vaughan house was not as formidable as the landmark Weaver mansion a few streets away, but it was well located in the center of town, and its architecture, with its tall brick chimneys, triple dormer, stucco façade, and massive arched porch, had its own idiosyncratic charm.

Annie Vaughan went to the local high school in Selma. No private schools for her; her father, William Weaver II, was not a moneymaker, and with his generation, apart from Clara, the Weaver fortune was beginning to disappear. (Annie Vaughan's mother, Edith, had brought prestige but no fortune to the union.) At school Annie Vaughan was by all accounts a lively and bright child, showing early on an interest in art and music.

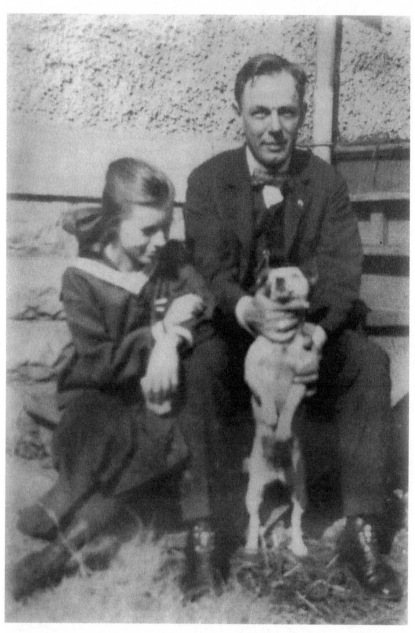

Ann as a young girl with two of her favorites—her father and her beloved dog, Potsy. Photo courtesy of ANSG.

Ann later told Jerry Tallmer, a reporter for the *New York Post*, that she had been drawing and painting since she was four years old. "Or I suppose befo' four, but a portrait I did then is the first one I remember," she told Tallmer, who noted "the tones of her native Alabama." Her cousins remember her always playing with chisels and clay or paint. She never stopped drawing. She made pictures on the tablecloth and on the walls of the house, and when her parents objected, she went to Potsy, her dog, to complain and drew pictures all over the inside of his kennel instead. Potsy, it appears, did not object. The pictures were of hard-boiled eggs, bones, things a dog would most appreciate in a mural.

No prizes for identifying from whom she inherited this talent. While many of her ancestors had artistic tendencies, it was Clara Weaver Parrish who was the dominant figure in Annie Vaughan's youth. Everywhere the young girl went in Selma, she would have been made aware of her aunt's towering presence. One block away from 217 Church Street was St. Paul's Episcopal Church, rebuilt thanks to Weaver money, and even closer was its rival, the First Baptist Church. Both churches featured Clara's stained-glass windows, and the First Baptist Church also had an exceptional mosaic by the artist that is almost Klimtian in its golden complexity.

During Annie Vaughan's school days, Clara was in her forties and at the height of her fame, producing a large body of highly regarded work, and was part of a circle of artists with international reputations. Annie Vaughan's aunt Rose was almost as well-known, remaining unmarried but leading an elegant life with her sister while producing fine wood carvings that collectors prized. While Annie Vaughan admired her aunt Clara's art, it may have been her aunt Rose's three-dimensional work that in the end most influenced the young girl.

"The [sisters] did not follow the normal behavior of young southern families of the time," observed the Selma historian Jean Martin. (Clara's drawings and paintings of nudes were burned after her death.) Clara and Rose were two powerful women, both of them talented, sophisticated, and fiercely independent, and they sounded a persistent obbligato throughout Annie Vaughan's childhood that was to shape her whole life.

Clara, now widowed and childless, took an intense interest in her nephews and nieces, urging them to rise to their full potential and live up to the family name. A clue as to Clara's influence may be gleaned from the memories of her niece, Rosalind (known as Rose) Tarver, who was born almost the same year as Clara's own daughter and in whom Clara took a

passionate interest after little Clara died, perhaps as a substitute for her loss. According to Rosalind Tarver Lipscomb, Rose's daughter, Clara tried to get custody of her little niece.

Clara took Rose to France and Italy for two years to expose her to European art. They lived mostly in Clara's Paris apartment. When Rose became a student at Columbia University in New York, she saw her aunt every Sunday afternoon and evening for four years. During that time Rose had to write a letter to Clara *every week*—letters that were carefully critiqued by her demanding relative. "Usually they went to the Metropolitan Museum for two hours of concentrated study from two until four o'clock. Then they attended some artist's showing or a tea or reception. This was followed by a late evening dinner. Aunt Clara had a very social life in New York. Her cards said she was home first and third Wednesdays."

Clara enforced a similarly demanding program on her nephew William III, Annie Vaughan's brother, who, as his daughter Edith dryly noted later, "was never going to be a businessman and remake the family fortune." Clara may have sensed this flaw in her nephew's character, constantly urging him to be more like his great-grandfather Philip J. Weaver. In 1922, while in Paris, she made an emotional appeal to William in a letter, writing, "Some day, if you go to the cemetery and look at Grandpa Weaver's monument and think of what he made of himself—a poor boy— and how, though so many years ago, he is still remembered as the great man of Selma, you may say to yourself as you stand there that, 'I aim to be his real successor. Philip J. Weaver will live again in me!'" (William was twelve years old at the time.)

Clara had not yet finished. She added that as well as making money, William must cultivate his mind and form the habit of reading. She suggested he learn Shelley's "Ode to a Skylark" and Gray's "Elegy," Clara's favorite poems, and if he could recite them to her or to his aunt Rose they would give him a dollar for each poem. It is not known whether young William ever earned those dollars.

The Weaver males seem all too regularly to have wilted under the pressure to live up to their sainted ancestor. When Annie Vaughan's father began showing a disappointing tendency toward being an indifferent student at Columbia University, he received fiery instructions from his own father, who urged him, in almost Clara's words, to remember their glorious Weaver name and warned him he would not "stand tall amongst men" if he didn't graduate.

The only Weaver boy with any serious talent was Annie Vaughan's uncle Norman, the most promising and beloved of the family, who showed signs of brilliance in the field of engineering. But sadly he died in 1897, at the age of twenty-seven, of Bright's disease. His father died a year later, it is said of a broken heart.

If the succeeding generations of Weaver males were showing dispiriting signs of ineffectiveness and the inability to live up to the god-like stature of their ancestor, the female line seemed to have inherited some of that original gumption. Clara Weaver Parrish was certainly a candidate for greatness. She was a very determined woman with advanced ideas on women's rights and strong ambitions for her family. Her dedication to her work and her desire to educate people of both sexes about art and literature surely rubbed off on the one family member who very early on showed genuine signs of artistic talent, little Annie Vaughan. It was a pity that Clara died unexpectedly early and—even more unexpectedly—bequeathed to her family a legacy that engenders bitterness to this day.

Clara's Will

On November 11, 1925, when Annie Vaughan was twenty years old, Clara Weaver Parrish died in New York City. She was sixty-four and was buried beside her husband and daughter in Selma's Live Oak Cemetery.

The Weavers were of course all deeply interested in Aunt Clara's will, for by this point she was by far the richest member of the family. How shocking they all must have found it! For Clara Weaver Parrish's will was as complex and unconventional as her life had been.

The gist was that she cut out her family almost completely. She gave her younger sister, Lucia Robbins, $100. She gave her older sister, Anne Tarver, who was struggling with a failing plantation and a growing family, $2,000, *on condition that Annie use the money to travel in Europe*, actually specifying that three-fourths of the sum not be paid "until after her steamer ticket has been paid for." "But my grandmother didn't want to go to Europe," her granddaughter Rosalind pointed out. "She was trying to bring up a family on a shoestring."

Needless to say, Annie Tarver never got that $2,000.

Rose, Clara's favorite sister, who was still unmarried, got Clara's clothes and laces (which were fine), her china, glass, and house furnishings (also fine), and most of the Minter and Weaver family silver.

An additional bombshell was Clara's decree that all the other silver, which she got as wedding gifts, "be sent promptly to Tiffany, in New York, to be melted and made into the upper part of a Bishop's crook . . . and that my diamond rings and pin, and whatsoever stones of value that I may be possessed of, be imbedded in their settings in the silver crook." This extraordinary object was then to be presented to the Diocese of Alabama, in memory of her husband, William Peck Parrish. (There is no evidence that the crook was ever made, and the presiding Bishop apparently said he did not want it anyway.)

But Clara wasn't finished yet. After making a substantial bequest to the Dallas Art League of Selma "to foster the art, spirit . . . and education in Selma" and to exhibit and store all of her work, she declared that the bulk of her vast fortune, which came from real estate in Alabama and Texas, along with other buildings, and from bonds, stocks, and mortgages, was to be placed in a trust with three trustees. Two of the trustees were her brother William II, Annie Vaughan's father, and the favored sister, Rose. The third was St. Paul's Episcopal Church in Selma.

So far so good. But the worst was yet to come. William II was to be paid one-third of the net income of this estate for his lifetime. As was Rose. At their deaths, their incomes were to revert to St. Paul's Church in a single trust—*forever*—for the following purposes: "namely, to use the net income, only, in relieving the poor, especially the sick poor, of Selma, Alabama, irrespective of race, creed or color." Other purposes included hospital beds to be kept available for charity patients, "having due consideration for the needs of colored as well as white patients." She also designated university scholarships for poor Protestant white youths of Selma to attend Yale, Harvard, Columbia, or the University of Virginia—places of learning that otherwise would not be available to them.

The endowment supporting this trust turns out to have been absolutely staggering. Today, thanks in part to some strategic Weaver investments in Texas real estate that later produced oil, the income from the Weaver-Parrish Memorial Trust annually distributed by St. Paul's Church amounts to approximately $200,000 a year.

While some might praise Clara's remarkable generosity, humanity, and racial sensitivity, members of the Weaver family were somewhat less enthusiastic. The lawsuits began almost immediately. In 1927, one of the wronged sisters, Lucia Robbins, along with her family, tried to break the will by proving Clara mentally incapable and unduly influenced by her

sister Rose. In 1928 Lucia tried again, telling Rose that she, Lucia, would dog her as long as she lived and that if Lucia could not have the money, then she would make sure Rose would not enjoy it either. (Sibling rivalry at its most attractive.) In 1930 Clara's oldest sister, Anne Tarver, took to the law courts in her turn in an attempt to break the terms of the trust, also claiming Rose's mismanagement. All these efforts failed. (They hadn't finished, however; there were to be other lawsuits down the road.)

While these nasty goings-on were scandalizing Selma, Annie Vaughan was elsewhere. In 1923 she became a student at Smith College in Northampton, Massachusetts. According to Selma artist John Lapsley, a close friend of Annie's, Clara supported her Weaver niece's education and paid the first-semester fees required for Annie Vaughan to study there. The specifics of the will prove in no uncertain terms Clara's belief in higher education for all. Unfortunately nothing in the will referred to further support for her niece.

However, Clara's substantial bequest to Annie Vaughan's father in the form of the three-way trust could have provided money to pay for his children's education and for all of them to live quite comfortably. But an unforeseen catastrophe wiped out this windfall. In 1928, just three years after Clara died, William II died unexpectedly at the age of fifty-one of a heart attack, at which point William's share of the trust reverted to St. Paul's Church. Annie Vaughan was twenty-three years old and had loved her father dearly, so the tragedy was twofold. Not only did she lose her father, but his death also terminated the potential income that would flow to his family from Clara's trust.

In her public life, Clara Weaver Parrish inspired a movement in Alabama that produced many fine artists in the late nineteenth and early twentieth centuries. Her influence was far-reaching in terms of encouraging local talent and transforming Selma from a cultural backwater into a thriving artistic community. In private, the climate wasn't quite so sunny. While she had dominated the lives of all of her Selma family for over sixty years, she had with one sweep of her pen consigned most of them pretty much to financial oblivion. If Annie Vaughan ever wondered why her aunt had not made some small gift to her talented, artistic niece, she found no answer from the grave. (There was in fact a reason, but it emerged only later.)

From now on, Annie Vaughan Weaver was on her own.

3

Early Success

IN 1923 ANNIE VAUGHAN WEAVER started her undergraduate career at Smith College, in Northampton, Massachusetts. She did well there. She was secretary of the Junior Class, and in her senior year she was a member of the student council, the Physics Club, and the College Song Committee. In her senior year she was also elected to Phi Beta Kappa. In 1927, she graduated as an honor pupil, one of three to address the "vast assemblage" at graduation. (These are her aunt Rose's proud words. With Clara dead, Rose became in essence the matriarch of the family.) According to a local newspaper, "The humorous speaker of the day was Annie Vaughn [*sic*] Weaver of Selma, Ala." One wonders what she could have said that was worth noting as "humorous." Like many southerners, Annie was a good storyteller. Perhaps she told some local anecdote in her southern accent that made her mostly northern audience laugh.

This was a very good record, but what is most interesting in terms of her future career is that at Smith, Annie Vaughan did not zero in on art as the focus of her college degree. In her sophomore year she took a course in the History of European Art and then abandoned art completely until her senior year, when she took Elements of Drawing and Painting. During this time, surviving college notebooks show that she was constantly sketching or making life drawings in her already identifiable blocky style. She was also interested in French and took several French literature courses in her junior and senior years. But from her sophomore year on, another interest began to take precedence: Biblical Introduction, Christianity and the Present Social Order, Development of Christian Thought.

Her major, which emerged in her junior year, had nothing to do with art at all but—rather surprisingly—with the Bible.

Annie Vaughan, turning her back on her aunts Clara and Rose and all the drawing and sculpting she had so passionately produced as a child, was intending to become a missionary.

The Weaver family had always been religious. Annie Vaughan's grandfather had helped fund the rebuilding of St. Paul's Church in Selma after the war, and Clara's will was largely a statement of her religious commitment. But Clara was also a freethinking and free-spirited artist. That Annie Vaughan, after an upbringing so biased in favor of women's higher education and commitment to the arts, should take such a different direction did not sit well with her indomitable aunt. In fact, Clara's sister Rose wrote in her diary that she believed that it was Clara's fretting about Annie Vaughan becoming a missionary to China or India "that so upset [Clara] that she changed her will."

Rose's interesting comment assumes that although Clara didn't leave anything to any other members of Annie Vaughan's generation, she had in fact planned to single out Annie Vaughan for a legacy, perhaps recognizing her as a potential successor to the Weaver women's artistic throne. Clara's "fretting" certainly indicates the disapproval the family felt for Annie Vaughan's unorthodox career choice.

Perhaps had Clara known more about Smith College, she might not have offered to pay any of her niece's fees. Smith at that time had a national reputation for religious studies. The college's oldest organization was the Missionary Society, founded in 1876. The Society continued to be an active participant in international missionary activities until 1926, when it was merged into the more general Smith College Association for Christian Work. A career as a missionary had therefore long been a tradition at Smith, and no doubt Annie Vaughan had done enough research to know this. Clara was dead when Annie Vaughan graduated magna cum laude in Bible in 1927. But the damage, in terms of Clara's proposed legacy, had been done.

If Annie Vaughan left Smith with plans to be a missionary, the idea quickly faded. Whether something happened at Smith or immediately afterward to put her off is not known, but her years at Smith later became for her a burden rather than a triumph. She appeared in only two reunion yearbooks, 1937 and 1957, both with equally terse entries. In applications for jobs and in her personal biographies for art shows later on, she never

once mentioned she had graduated from Smith. You might think it would look good on the resume, but Annie Vaughan clearly didn't think so. It seems that almost as soon as she came home, the whole missionary idea fell by the wayside, and with it, her years at Smith were to be erased from the record.

She was just twenty-three when she came back to Selma, and much was changing. Clara was gone and the lawsuits were starting. Her father, listed in the Smith College archive as a "traveling salesman," but perhaps more accurately a gentleman farmer, was not bringing in much more than the income he had inherited from Clara and was to die a year after she came home. Annie's two younger siblings, William and a much-younger sister Rose, were still at home. She loved her brother, disliked her troubled sister (and later rarely spoke to her), and was very close to both parents, but these relationships were not a solution to her problem. If she was not going to be a missionary, what was she going to do? She started to teach in Selma's high school, her alma mater, and to produce bas-relief portraits of local children, which were highly praised. But her real work at that time was of a different order entirely.

Frawg, Boochy's Wings, and *Pappy King*

In 1916, when Annie Vaughan was eleven, her grandmother, Ann Eliza Vaughan, gave her a copy of a book entitled *Mammy's Reminiscences*, written in 1898 by Martha S. Gielow of Alabama. Clara Weaver Parrish did the illustrations. The book was a collection of stories about plantation life and was written in extreme dialect: "Well, chillun, I gun ter giv up, an' I git so weak in de knees I couldn't stan' an' de fus' thing I knowd I wus down on de groun' er prayin' fer de'liverance uv Miss Sally's baby." This gift, clearly a proud Weaver possession, was to make a lasting impression on the young girl and deeply influenced her artistic future.

In 1930, fourteen years after receiving this little book, Annie Vaughan Weaver became a published author of children's books. She wrote three of them—very quickly—in almost the same extreme dialect as those of Mrs. Gielow.

This of course makes the present-day reader flinch. For a white writer to write about black people—using their dialect—is asking for trouble. The publication in 2009 of *The Help*, by Kathryn Stockett, who follows in her book the relationship between a young white woman and three black

Ann surrounded by chickens on the family farm, probably in Emerald Place (now demolished) outside Selma. Photo courtesy of Edith Weaver Haney.

maids in Jackson, Mississippi, caused huge controversy in the press and online. The controversy stemmed not only from the obvious racial issues but also from the author's choice to write in the language of the black maids. (The book became a best seller and was made into a film.)

But in 1930 there was no comparable issue, and the books were accepted without controversy. Indeed, their authenticity was what gave them their power. Annie Vaughan had grown up surrounded by children—not just her many cousins but also the black children of the former slaves who worked on her grandfather's plantation, Emerald Place. It was the latter that she chose to make the subjects of her books, telling the stories the way they told them, the way she had learned to understand them from earliest childhood. Her illustrations, like those done by her aunt Clara in Martha Gielow's book, vividly brought the characters to life on the page.

Frawg, Annie Vaughan's first book, was published by J. B. Lippincott in 1930. It was dedicated to "Dad." It is about a little black boy growing up in rural Alabama who dreams of buying a toy drum but has no money and no expectations of acquiring any. He gets into scrapes like any

young country boy, encouraged by a bad-tempered bullfrog, three pet hogs called Shadrack, Meshack, and Bednego, and is constantly hollered at by his family, including his sister whose name is Iwilla, short for "I will Arise and Go to my Father."

Her second book, *Boochy's Wings*, published in quick succession in 1931 by Frederick A. Stokes & Company, and dedicated to the author's mother, is another story of a dream, this time of a little boy's longing to fly. Boochy grows up on a farm, where he works at hoeing, planting, and picking cotton along with his family and two dogs named Trial and Tribulation. He adopts a scrawny chicken called Little Bit, who tragically ends up baked in a pie. But Boochy and his siblings know about death, and Little Bit's feathers are buried in a proper Christian ceremony: "Er Lawd, have mercy on Little Bit, Er Lawd keep de debbil erway, Er lawd, she aint quoiled or fit, But she needs you, Lawd, terday."

The third book, *Pappy King*, also published by Stokes, in 1932, is dedicated to Annie Vaughan's aunt Rose, who "knows and loves the South." In this story, Pappy King is an old southern character and a born storyteller. His stories are about animals—possums, roosters, foxes, rabbits, and their various antics in life and love. What sets it apart from the earlier stories is that the whole book is written in verse. Since the language in the books is sometimes difficult to understand, the author attaches asterisks to certain words and explains them at the bottom of the page. (Amusingly, one of the Stokes editors of *Boochy's Wings* helpfully added a footnote to "collards," explaining that it meant "cabbages." The editor clearly was not a southerner.)

Annie Vaughan knew the South and its history to the bone. In *Boochy's Wings*, for instance, she describes Boochy's cunning father: "He made money not only out of his cotton and corn and pigs and chickens, but also out of his children. Thirty-five easy dollars he made—this way: every time he got a new baby, he named it for some rich white person in town who, feeling highly honored, would give Charly some money for the little namesake." (Quite a clever twist on the antebellum custom of naming slaves after their masters.)

She shared much of her childhood with the farming families on the plantation at Emerald Place and did much of her writing in a cabin there. She knew the songs they sang and included them in her books. Here is her description, again from *Boochy's Wings*, of a visit to a church service at night: "No organ or piano—only the perfect music of two hundred voices

and the muffled rhythm of four hundred feet tapping the floor. The little building shook with each beat. It was a thrilling, beautiful sound." That is the writing of someone who had been there.

She knew the real Frawg, who loved most of all to spend his time fishing. She knew Pappy King, who, she said, had a child-like heart and was a famous gardener throughout Dallas County. "No one could raise such fine roses, violets, lilies and oleanders as Pappy King. No one could make them grow so strong and tall, or bloom so beautifully."

What comes through clearly from these stories and her own narrator's voice is her affection for the people she is writing about. The illustrations vividly back this up, reflecting her knowledge and powers of observation. Mostly in watercolor or pen and ink, they brilliantly capture a moment the author describes in the tale, be it the characters praying or passing buckets from a well up the hill, or a group of animals enjoying a picnic. The pictures are stylish, elegant, and witty, with a strong sense of line and design. When she illustrated these stories, Annie Vaughan was showing her potential as an artist.

In a revealing afterword to her first book, *Frawg*, Lippincott's editor Hugh Lofting describes his impressions of his new young author, named

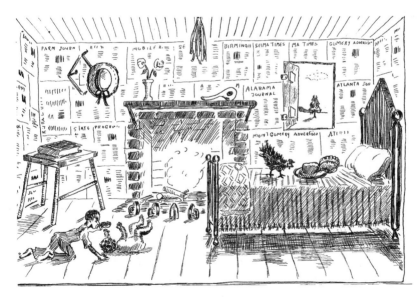

One of Ann's illustrations from *Boochy's Wings*, published in 1930, with charming details such as local newspapers decorating the walls. Photo courtesy of Edith Weaver Haney.

on the title pages as Annie Vaughan Weaver. First he remarks on how silent she is, unlike most authors he knows. "Getting her to talk at all is very hard work." He goes on to say, "but anyway she is the kind of girl who would sooner talk to the world by writing stories and drawing pictures than by sitting around chattering."

Lofting was clearly very taken by his southern find. "Annie Vaughan is very lucky," he declares. "The pictures she draws best are pictures of coloured people. . . . And not only can she draw pictures of them but she really knows them. She was brought up among them from the time she was born until only a year or two ago. These little stories you have just read are living, moving glimpses of the life, the thoughts and the talk of southern children."

Annie Vaughan Weaver was twenty-seven when this was written, and luckier, perhaps, than she realized. For Hugh Lofting was none other than the author of the best-selling Doctor Dolittle series of novels for children. Praise from him was praise indeed. With him in your corner, you could probably be assured of a pretty successful career in children's publishing.

Annie Vaughan might also have felt a certain satisfaction in knowing she had lived up to her family's expectations. All artists in Selma growing up in the early twentieth century lived in the shadow of Clara Weaver Parrish, and none more so than her Weaver niece. Now Annie Vaughan had both written and illustrated three successful books, something her aunt had never achieved. The three books were huge successes and sold all over the country.

But Annie Vaughan Weaver never wrote another children's book. Indeed, the only other time she officially mentioned the three she had published was in a letter she wrote much later to apply for a teaching post. When she saw copies of them in her mother's house in Selma, she threw them out. When she went to visit her brother's family in Decatur, Alabama, for her niece Edith's wedding in 1963, she saw copies of them on a bookshelf and—without telling anybody—took them away. This was a violent act for an author to commit against her own work.

It is possible that by this time the books' subject matter had become toxic. Hugh Lofting in 1930 saw no problems with Annie Vaughan's children's books. Neither did her readers. But thirty years later the scene looked very different. Certainly any white author writing such books in the 1960s would know he or she was inviting controversy. William Styron was heaped with scorn for publishing his fictionalized slave memoir, *The*

Confessions of Nat Turner, in 1967. Indeed, very little literature of this kind was written until Kathryn Stockett wrote her book in 2009, and she knew perfectly well the storm her book would provoke. She quoted a paragraph by Pulitzer-Prize winning author Howell Raines that encapsulates the dilemma:

> There is no trickier subject for a writer from the South than the affection between a black person and a white person in the unequal world of segregation. For the dishonesty upon which such a society is founded makes every emotion suspect and makes it impossible to know whether what flowed between two people was honest feeling, pity, or pragmatism.

While Annie Vaughan Weaver was certainly aware of the different climate her books inhabited thirty years after their publication, there was perhaps another equally pressing reason for her books to be "disappeared." She was not going to be dragged down by the public perception that she was a children's book writer and illustrator, however good. Graham Boettcher, curator of American Art at the Birmingham Museum of Art in Alabama, points out that illustrators in those days were not considered artists. "[Illustrations] were considered commercial art, and therefore completely outside of the art world." (Norman Rockwell famously struggled against this prejudice.)

At the time that she was writing and illustrating these Selma-oriented books, Annie Vaughan had already begun to study drawing and sculpture in New York. She was not going to be a missionary. She was going to be an artist, and her fear throughout much of her career was that she would be known for her illustrated books rather than for her sculpture. She once said it was like someone publishing a cookbook and then writing other things but never being remembered for anything else. She wanted above all to control her destiny, and that meant turning her back on the three children's books she had published before she was twenty-eight years old.

The book advances gave her enough money to pay her own way in the big city. If only Clara had lived to see this, her aunt Rose said regretfully, writing in her diary with pride, on September 15, 1928, "Today Annie Vaughan left for New York to begin her own career as a sculptor."

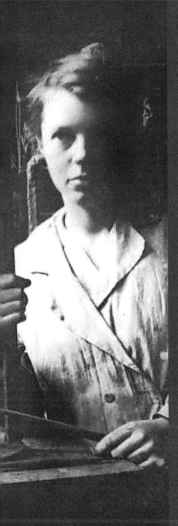

Part II

The Art
World
in Turmoil

New York, 1930–1942

4

A Tumultuous
Education

WITH AUNT ROSE cheering her on, Annie Vaughan Weaver slipped the chains of her southern childhood and headed for the city. On September 17, 1928, she applied for a place at the National Academy of Design in New York. She was admitted a week later.

The founders of the Academy in 1826, who included Samuel B. Morse, Asher B. Durand, and Thomas Cole, wished "to promote the fine arts in America through instruction and exhibition." Its members were the distinguished artists of the day and taught students anatomy, perspective, sculpture, drawing, and painting. Although women could be members, it was not until the end of the nineteenth century that they began to play a significant role in the school.

Annie Vaughan attended classes at the National Academy of Design for three years. According to school records, for the first two years she held a scholarship in the name of Charles C. Curran, one of the school's instructors. Curran was a well-known portrait painter, largely influenced by French impressionism. His favorite subjects were young women, "elegantly dressed, posed, and feminine, with uncomplicated and dreamy gazes," as the Gratz Gallery described them. Although Annie Vaughan never took lessons from Curran, she may have met and befriended him in Selma when he went there to paint portraits of well-known local worthies, one of which was entitled *Grandfather Minter*. For her last year, her patron was Louis Betts, although she did not receive tuition from him.

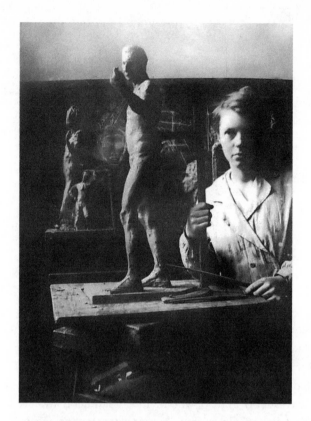

Ann Weaver during
her years as a
sculpture student at
Cooper Union in New
York City, 1932–35.
Undated. Photo
courtesy of ANSG.

The scholarships required that the candidate pass certain examina-tions. Records indicate that at the beginning of each year Annie was "on probation"—that is, she was admitted with an uncertain portfolio and on the promise that she would get up to par during the year. For her entire time there, Annie Vaughan would keep that promise. The school, then as now, does not grant degrees.

For one-and-a-half years, she studied from the antique (that is, from classical subjects) with Charles Hinton and Alice Harold Murphy; for the second one-and-a-half years she took drawing from life under Leon Kroll, Carl Thomas Anderson, and briefly Charles Keck. She also attended lectures on the history of art and architecture. But this was not enough for the eager young student. After the Academy closed each April she moved over to the Grand Central School of Art, where she took classes with Georg John Lober.

In the spring of 1930 she signed up at the Art Student's League, a non-accredited school of art that also does not grant degrees. Now she was

directly following in her aunt's footsteps. Clara Weaver Parrish had been a member of the Art Students' League in 1897 and 1898. Here Annie Vaughan's instructor was Homer Boss. She also took at least two uninstructed independent studio classes.

Not satisfied with the direction her studies were taking, Annie Vaughan gained admission to the Cooper Union Art School in 1932 and studied sculpture there for three-and-a-half years under Charles Rudy. (The school at that time was divided by gender: Annie Vaughan's section was called the Cooper Union Women's Art School.) Tuition was free, but admission was by competitive examination. Later she wrote that during those years the school, under the directorship of Mr. Austin Purves, "made it one of the finest and most progressive art schools in the country." There she modeled from life every day and took a regular composition class, also under Charles Rudy.

The names of Ann's first teachers in New York do not resonate much today, but their fields make for interesting reading in terms of her development as an artist. For unlike professors in many other disciplines, art teachers tend to have a very powerful effect on their students.

Alice Harold Murphy was a successful illustrator and engraver, often favoring religious subject matter. Leon Kroll was one of the best-known realist painters in America and won many awards in his lifetime. Carl Thomas Anderson was a illustrator and cartoonist. Charles Hinton was a sculptor, as was Charles Keck, who was highly regarded in the art world, with many institutional commissions. Keck had studied under the celebrated Augustus St. Gaudens and was known for his sculptures of famous figures such as Abraham Lincoln. Georg Lober, with whom Ann took classes in the summer, will be forever immortalized in New York City history as the sculptor of two famous figures—Hans Christian Andersen in Central Park and George M. Cohan on Broadway. Homer Boss, with whom Ann studied only briefly, was a highly praised portraitist and landscape artist, later of Western scenes in particular.

In looking at these artists' various specializations, one sees that before 1932 Annie Vaughan was focusing mostly on two forms of artistic expression—illustrative art and sculpture. The former clearly followed from the success of her illustrated books for children. Her dogged pursuit of sculpture teachers, however, indicates that illustrative art was beginning to lose its allure. Hinton, Keck, and Lober were big names in sculpture, working in the favored classical style, and she studied intensively with them.

But when she started attending Cooper Union, she sought out a teacher whose art was very different from that of her earlier instructors. Charles Rudy's work was realistic and dramatic, unlike the smooth classicism of Hinton, Keck, or Lober. Rudy was very versatile, good at making animals and insects, as well as ordinary people, rather than public personages or literary figures. He used welded steel, scrap metal, bronze, and all sorts of other materials. His first major commission was in 1938, three years after Annie Vaughan had left, a wonderfully vivid limestone statue of Noah that can still be seen on the facade of the Bronx Post Office in New York.

Annie Vaughan worked for three years under this nonconformist artist, which is sure evidence that by this time sculpture was to be her chosen art form. Forget illustration, forget painting, she would be a sculptor first and foremost. Her fledgling years watching her aunt Rose and working as a "chiseler" in Selma had already sown the seed, but it was probably Charles Rudy's influence at this stage that helped her commit exclusively to this medium.

As she began to hone her skills at these high-level art schools, she also began to hone her public persona. The cute, talented, young southern girl Hugh Lofting had fallen for had become a serious art student in New York. Now in her late twenties, Annie Vaughan was not a beauty, but her soft, delicate face with the generous Weaver mouth was attractive. She was shy and small-boned and looked younger than she was. Dedicated to her studies, she had neither the money nor the inclination to live a fast social life in New York.

As a sculpture student, she continued to downplay her publishing successes. Moreover, she no longer liked the look of the author's name on those books. Annie Vaughan Weaver? Absolutely not. In shaking off her southern past, she must also shake off her southern name. After three years in New York, she decided that the intimate, double-barreled first name of hers, so easy and appealing in Selma, had to go. She was now Ann Weaver, pure and simple, and it was as Ann Weaver, pure and simple, that she signed up for Cooper Union in the fall of 1932.

By the time she entered Cooper Union, she had already had a piece of sculpture accepted in the Museum of Modern Art's 1930 Group Exhibition of forty-six painters and sculptors under thirty-five years of age. It was quite a triumph for Ann. The subject was entitled *Negro Head*, which might seem controversial for a white southern woman artist in 1930, but it must be remembered that this was the height of the Harlem Renaissance.

Drawings executed in a notebook for an exercise on "Oriental features" when Ann was at Cooper Union. Undated. Photo courtesy ANSG.

Anne Goldthwaite, a highly regarded artist from Montgomery, Alabama, had that same year had a piece with the same title accepted by the Metropolitan Museum of Art, a much more conservative institution. In the context of the espousal of black culture globally at that time, their subject matter seems hardly controversial at all. However, their similar subject matter is an intriguing coincidence. Anne Goldthwaite was a contemporary of Clara Weaver Parrish, both of them making their names as pioneer southern women artists.

During her years at Cooper Union Ann continued to do remarkably well. She won highest awards in both figure modeling and sculpture composition. Even more impressive, she won an Art and Archaeology Scholarship from the Institute for International Education, supported by grants from the Carnegie Corporation of New York. These Carnegie traveling fellowships sent students to study at the Sorbonne in Paris and the Courtauld Institute of Art in London. Ann's 1932 fellowship allowed her to spend the summer in and around Vézelay, studying Romanesque sculpture, "which," she reported, "meant seeking out many old churches in Burgundy and Provence."

This was an exceptional fellowship and provided for all of her living expenses, allowing her to experience European art, architecture, and

Studies in Health

by

NONA L. BROOKS

A typical example of Ann's compulsion to draw on anything, c. 1930s. The sculptural shape indicates a theme that is to reappear many times in her later work. Photo courtesy of ANSG.

sculpture in a way she could otherwise not possibly have afforded. She responded enthusiastically to the exposure. In a letter dated January 1933, Edward R. Murrow, then assistant director of the Institute of International Education, wrote to Ann, "We receive a great many reports from both American and foreign students, but not for a long time have I enjoyed reading a report as much as I did yours. It is delightfully written and indicates clearly the many advances you received in addition to the formal instruction. . . . I only wish that recipients of all of our awards showed the ability to really travel rather than merely to be transported."

She received another traveling fellowship in 1935, this time for the study of garden sculpture in Italy and England. This was her last year at Cooper Union, and as she said goodbye that summer, she set off for what was to be one of her most magical trips abroad. She met her beloved brother, William, in London (his first trip to Europe), and they had a wonderful time together, visiting Kew Gardens, Hampton Court, and Windsor Castle. Ann went on to Oxford and William to Scotland before reuniting in Paris, where William noted in a letter to his mother: "They 'funnel' the wine here—they drink it instead of water." They loved traveling together,

Ann showing off her French to her younger brother and William absorbing everything, declaring to his mother that he loved Paris much more than London.

Coming back from France in the late summer of 1935, Ann began to seek out sculptors whose work most closely reflected her developing style. One of the most important was John Hovannes (1900–1973), who taught at both the Art Students League and Cooper Union during her time there. Hovannes was Turkish by birth and studied at the Rhode Island School of Design and the Copley Society in Boston.

Hovannes's influence on Ann was huge. Although not a world-famous sculptor, he was well regarded and admired, particularly for his focus on "ordinary" or real-life subjects rather than on the exalted or heroic figures that seemed to be what most sculptors of the time chose as their subject matter. Like Charles Rudy, Hovannes brought sculpture down to the level of ordinary human beings. Ann was very attracted to that idea. "In the summers, I learned to carve stone and wood in the studio of John Hovannes," she wrote later, "one of the ablest carvers in the country."

For one summer after her graduation from Cooper Union, Ann worked as a studio assistant for Alexander Archipenko (1887–1964), a Ukrainian-born sculptor who was already famous by that time. Archipenko started his career in Paris, becoming part of an artists' group called Section d'Or, which included Pablo Picasso, Juan Gris, Fernand Leger, Georges Braque, Marcel Duchamp, and other luminaries of the tumultuous, avant-garde Parisian art world of the early twentieth century. His innovative, unconventional ideas of sculpture caused a predictable outcry when he exhibited at the 1913 New York Armory Show (immortalized by Marcel Duchamp's *Nude Descending a Staircase*).

In 1928 Archipenko moved to New York and opened schools on both coasts. His attraction to cubism was reflected in his work at this time. He may have introduced Ann to Brancusi, whose studio she later visited in Paris and whose name and phone number she kept in her address book to the end of her life.

Rudy, Hovannes, and Archipenko, perhaps the three sculptors who most influenced Ann's development as an artist, represented in uncompromising fashion the new movements in sculpture, and art in general, that were swirling through New York in the 1930s, a time of almost unparalleled excitement and anxiety, not only for artists but for all young people who lived through this tumultuous decade.

5

The Emergence
of an Artist

THE TIMING OF ANN WEAVER'S apprenticeship as an artist in New York could hardly have been more challenging.

First of all, the early 1930s saw the start of the worst economic depression the country had ever experienced. Unemployment, bankruptcies, foreclosures, meltdowns, stock market collapses, suicides—from the cities to the countryside, nobody was exempt from what came to be called the Great Depression. For somebody trying to make a living as an artist, the conditions were dire, and much of Ann's early days in New York were about paying the rent and getting enough to eat.

The second crisis Ann found herself wrestling with originated within the art world itself.

During the first part of the twentieth century, the traditional institutions of culture and aesthetics in both Europe and America began to be attacked on all sides by a new generation of artists emerging after the First World War, and by the 1930s this clamor had become deafening.

The École Nationale Supérieure des Beaux-Arts, the most famous architecture school in Europe, dominated the discipline by insisting on teaching only the golden rules of classicism. Young architects, frustrated by this old-fashioned pedagogy, flocked to rebels such as Mies van der Rohe, embracing his dictum "less is more," and extolling the glass and steel boxes of the International Style.

In the autumn of 1929, the Museum of Modern Art opened its doors, showing the paintings of Picasso, Matisse, Braque, and Rouault, along

with many other Europeans who were doing work that astonished New York artists and audiences alike. Young American painters quickly responded to this new art, breaking away from the figurative formulas they had grown up with, and plunging into experiments with impressionism, cubism, and abstraction that threatened to topple the old icons of the art world.

Sculptors too were moving away from the traditional shapes of classical realism. One form their rebellion took was rejecting the customary method of modeling. The conventional approach to making a sculpture, and the one taught in most art schools at the time, was that you first made a model, or a maquette, of the piece you had in mind, a small version usually, that clients could examine, and then you hired a craftsman to transform it into a sculpture. Probably the most famous sculptor of the period, Auguste Rodin, produced all of his work this way.

Young sculptors, in contrast, wanted the feeling of producing the work with their own hands and tools. They urged a return to what might be called "primitive" art-making. They called it "direct carving." (Brancusi famously declared, "Direct carving is the true road to sculpture.")

This trend took hold during the first decades of the twentieth century, just as African art was being "discovered" and exhibited in Europe for the first time. Just as the exposure to Asian art had revolutionized nineteenth-century French and English painting, so these strange, African tribal figures and masks turned classical sculpture almost literally on its head.

Perhaps the earliest proponent of direct carving was Henri Gaudier-Brzeska (1891–1915), a young Frenchman who wanted to leave the marks of the hammer or chisel in the stone, unlike his nemesis, Rodin, who produced smooth and glossy marbles and bronzes with such success. Gaudier-Brzeska produced a body of provocative work before dying in the First World War at the age of twenty-three.

Romanian-born Constantin Brancusi (1876–1957) took these ideas further in his sculptures. (But not without resistance: when he came to New York in 1927 with some of his pieces, the customs officials refused to recognize them as art, therefore preventing the artist from claiming them as duty-free.) Soon many other sculptors began working in this new way, including Spanish-born José de Creeft (1884–1982), who became one of Ann's mentors and close friends. De Creeft spent time with Rodin in Paris but, like Gaudier-Brzeska, rebelled against the great man's devotion to modeling and never went back.

One of the earliest American pioneers of direct carving was William Zorach (1887–1966), who became very successful with this almost abstract form of sculpture and sold well throughout his career. He, like his direct-carver colleagues, believed in the art of subtraction, the art of simplification, the art of direct expression using basic tools—the chisel and the mallet. Zorach spoke and wrote eloquently about the art of direct carving. He liked to quote Michelangelo: "As the stone shrinks, the volume expands." Michelangelo's *Prisoners* at the Accademia Gallery in Florence were of course prime examples of the direct carving school of sculpture.

"The power and strength that exists in the stone reveals itself to you," Zorach said. "A student not aware of what is revealing itself to him can chip the whole stone away and make a lot of gravel for the road. You have to have an artist's awareness and vision." Another Zorach statement that surely resonated with Ann was: "Real sculpture is something monumental, something hewn from a solid mass, something with repose, with inner and outer form; with a strength and power." It's worth remembering these words in view of Ann's later work.

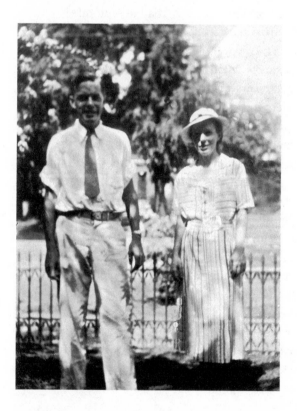

Ann and her brother William in Paris on her second scholarship trip to Europe in 1935. Photo courtesy of Edith Weaver Haney.

An examination of Ann's sculpture during the 1930s shows her continuing interest in figurative art but of a very specific nature. She made sculptures of what she knew, as she had in her writing—the plantation families, the children, the animals, rather than generals or presidents. This was Hovannes's gift to her, perhaps his most important—his preference for realism over romance, the "real" over the "heroic." In a newspaper article on Ann Weaver in 1940, the reporter commented on a squat sculpture of a woman with a parrot on her lap: "Ann found the inspiration for this down in the lower east side section where the streets are crowded with cars and vendors and unbelievably fat women."

Yet at the same time, she was deeply attracted to the blocky, cubist forms of sculpture that were appearing, like an entirely new art, in the studios of her young contemporaries. Like them, she was eager to embrace the ideas of Brancusi, Archipenko, and Zorach. Ann imbibed the work of these avant-garde artists like a thirsty runner. The *New York Times* art critic Holland Cotter, explaining the attraction of cubism to art connoisseurs like Gertrude Stein, said, "[cubism] shattered conventions of realism and beauty, and, with its cutting up and rearranging of ordinary things to create multiple perspectives, it altered perceptions of time and space." "Cubism" was the new buzzword, and teachers like Hans Hoffmann talked about it as the "push and pull" of space and light, translating nature into form.

This was food and drink to Ann. She was eager to abandon the traditions of art with which she had grown up and with which her famous aunt Clara Weaver Parrish had made her name. For Ann, the modern movement was a way to escape those powerful southern influences. Direct carving spoke to her deepest instincts, and it would lead her to independence as an artist.

The work she did at this time was still figurative, and her hope was that these sculptures would be successful as commercial garden art, in particular. (Her 1935 European trip focused specifically on this genre.) But her drawings during this period show her experimenting with more abstract and simplified lines and forms.

She was also learning how tough it was to pursue her vision. As an artist, she found that the world was mostly against you. You were fighting resistance to modern ideas. You were trying to persuade galleries to exhibit your new "modern" work or find clients who would commission such a work from you. You were up against entrenched values from the only people who could afford to commission you—the very rich.

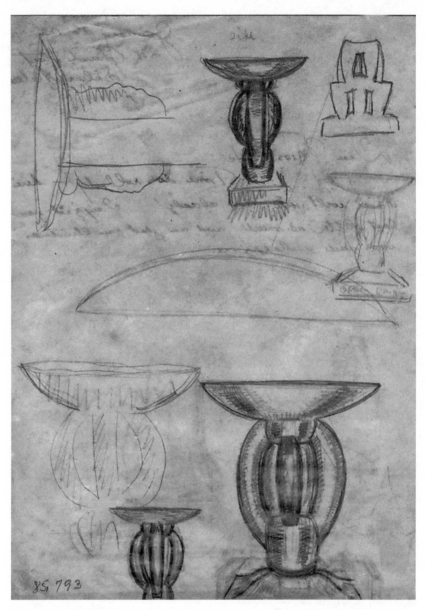

Ann's experimental sketches for a chalice or garden monument, 1936. The image in the top right-hand corner uncannily resembles her later sculptures in Florida. Photo courtesy of ANSG.

During Ann's years in New York, the most important (indeed the only) building to be erected in Manhattan was Rockefeller Center. While it was taking shape in all its stunning architectural glory (defying the economics of the Depression), 5 percent of its budget had been allocated to the most prominent artists known to the Rockefellers and to their architects and designers.

The problem with the art of Rockefeller Center was its focus on the "heroic." This was partly the fault of John D. Rockefeller Jr., the guiding spirit behind the Center, who tended towards such pomposity. Titles such as *Guided by Light, Heralded by Sound, Time Marches on Through the Ages,* or *The Abolition of the Painful Labor of Former Ages by the Creative Intelligence of the Machine* did not inspire creative brilliance in the artists stuck with representing these grandiose themes. Moreover, tension arose between the financial backers and the artists, many of whom had become social activists in the highly politicized years of the 1930s. Diego Rivera, the famous Mexican artist, when given his mural commission, *Man at the Crossroads Looking with Hope and High Vision to the Choosing of a New and Better Future,* dealt with the problem by adding a portrait of Lenin to the mural. All hell broke loose, he was asked to remove it, he refused, and the whole fresco was covered over.

Would Ann have admired the gilded Prometheus by one of America's top sculptors, Paul Manship, that took pride of place on Rockefeller Center's Fifth Avenue entrance? Many critics did not, observing its awkward horizontal shape and waving legs, calling it an amusement. "Let's tie up the rights to radiator caps." (Later Manship himself admitted he didn't think too well of it.)

For Ann, these artistic choices only confirmed her suspicion that the world was not ready for modern art. While several of her teachers had tried to steer their students away from the megalomaniacal, "heroic" role of sculpture, dominated by these absurdly overwrought titles, and towards a more realistic, human vision, the art delivered to Rockefeller Center must have filled her with dismay.

If the world was not ready, how could you earn your living? Making sculpture required having your own money. You had to purchase the material you then planned to hammer and chisel into submission. This problem haunted Ann right from the start. Since she had little money, how was she to get hold of the marble (or even simple clay) that she wanted to work with? How could she pay for the casting of her pieces?

Some suppliers and foundry operators would advance material to the artist in a sort of deal whereby if/when the artist sold the work, the supplier would get paid. When Ann worked in the studios of other artists like Archipenko and Hovannes, she could sometimes re-use their leftovers or work with abandoned pieces. But the ability to produce work and survive at the same time, the constant challenge of most artists, was made infinitely more difficult for someone like Ann who had to climb a very, very steep hill to achieve either the production of good work or, having produced it, recognition for it. This struggle would never leave her.

Picture then this young southern woman—shy, small, delicate-boned—working with recalcitrant material in an unpopular medium in a hostile market in the middle of the Depression. William Zorach describes in his autobiography his first encounters with Ann, when he had his studio on the top floor of 2 West 15th Street, a former private mansion.

There were a number of young women working in a large studio next to mine—talented, serious young women. One of them was a quiet, unassuming girl by the name of Ann Weaver. I used to drop in now and then for a chat and sometimes I'd give them criticism—more advice and discussion than criticism.

Listening to Zorach, absorbing his advice, quiet, unassuming Ann worked on. Yet beneath her subdued demeanor, she was grappling with a situation in her personal life that was to dominate the better part of her thirteen years in New York.

6

A Rare Friendship

"In 1938 I worked for several months in the stone carving shop of John Howard Benson at Newport, Rhode Island." This simple sentence reflects a large chunk of Ann's experience that deeply affected both her personal and artistic development. For it was here that a young woman, Adelaide de Bethune, lived and worked, and it was with Ade (as she was known) that Ann formed one of the most important relationships of her life.

Ade (pronounced Ah-day) was born in 1914 in Belgium to a prominent Catholic family that immigrated to the United States in 1928, some time after the traumatic occupation of Belgium by the Germans in the First World War. Ade, one of three children, showed talent as an artist when very young. She took drawing lessons in Brussels, and at age eleven, said, "the two things I like to do best are climbing trees and drawing pictures."

In New York her parents enrolled her in the National Cathedral School. Already determined to be an artist, at weekends Ade attended the Parsons School of Art. By 1929, when she was only fifteen, she was going to the Cathedral School in the mornings and attending the National Academy of Design (which took only students with evident ability) in the afternoons. Here Ade enrolled in a sculpture class, where it is most likely she first met Ann. Both young women went on to the Cooper Union in 1932.

"We became good pals," Ade wrote later. "She was amused at my accent [which remained quite French], and so was I with hers, a great, rich Southern sound from Selma, Alabama."

Ade was a fervent Catholic, and as a young girl had wanted to be a nun; her mother talked her out of it "until she was older." In fact it was with Ann that Ade found her calling in New York. Sometime in 1933 Ade discovered Dorothy Day and Peter Maurin, founders of the Catholic Worker movement, and from that moment on she became a devoted supporter, friend, and finally leader.

As Ade tells it, she first heard of the Catholic Worker movement at a Wednesday evening get-together of four Cooper Union friends, which included Ann Weaver. The young women were discussing the conditions of the poor and unemployed in the city during these terrible years of the Depression. One of the students had heard of two women who were taking in the homeless off the streets and offering them shelter, and Ade decided to search them out. At their modest office/storefront at 436 East 15th Street, she met the women, Dorothy Weston and Dorothy Day, two founders of the movement, who welcomed the young art student and gave her copies of their newspaper, *The Catholic Worker*. Looking through it, Ade quickly saw that the publication could be enormously improved by the addition of illustrations. With typical self-confidence, she submitted to them several examples of her etchings of religious subjects, accompanied by a modestly enthusiastic letter, which said, in part: "There is but one thing I can make: that is pictures."

Her work was just what the editors were looking for. "She brought us a number of black and white drawings of the saints, all of them working," Dorothy Day wrote later in *The Catholic Worker*. "We were delighted with them. They were exactly what we wanted, as Peter Maurin's concept of man as a co-creator with God." Day began publishing them immediately, to great effect. The illustrations were signed Ade Bethune, the editors mistakenly dropping the "de," and that is how she became known. She was then nineteen years old.

Ade's friendship with Ann Weaver was also blossoming at this time. Ade was dark, with a lively, open face. "She loved to laugh," remembered her godson, John Benson. She wore a braid around the back of her head in the style of Scandinavian women, and she exuded a kind of sturdy warmth that was very appealing in one so young. She was immensely charismatic, even then. Ann was small, tiny really, and very fine-boned. Photographs of her at this age show an oval face, with a straight nose and generous mouth and lips—the Weaver mouth, like her father's and brother's. But unlike Ade she was shy and quiet, with little of Ade's extrovert worldliness.

Ade Bethune with Ann in Newport, Rhode Island, June 1937. Photo by Ralph Arnold.

In the photographs taken at the time Ann looks away from the camera, or down, a little withdrawn.

Yet although the two women were so different in some ways, their friendship was founded on solid ground. They shared a passion for art and music. Ann was a good storyteller. Ade remembered how Ann would regale the Bethune family with tales about her trips to Europe in her seductive southern accent, Ade adding her own Belgian childhood reminiscences. They both came from what Ade liked to call "aristocratic" backgrounds, and both were deeply influenced by their family histories—Ade's European childhood with memories of family châteaux, Ann with her southern heritage of ancestral plantations and war heroes. Perhaps most important, at least to Ade, was that Ann had once wanted to be a missionary and expressed a religious sensibility that fed into Ade's own Catholic faith.

Today one might make something of the age difference—Ann was nine years older than Ade—but Ade's precociousness made that gap irrelevant. Ade, still a student, was already far more established in her career than Ann was. In 1933, Ade won a prize from the National Academy of Design for a stained glass medallion, which won her a trip to the Charles J. Connick studios in Boston, where the design would be executed. Charles Connick specialized in the medieval art of stained glass, and his studios made windows for churches, cathedrals, chapels, and libraries all over the world. (Ade's talent in stained glass was another bond. After all, Ann had grown up in the glow of the church windows designed by her aunt Clara.)

In 1934, Ade received a commission from Arthur Graham Carey to design a fireplace surround for his house in Cambridge, Massachusetts, based on one of her *Catholic Worker* drawings. It was to be carved by the John Stevens Shop at 29 Thames Street, in Newport, Rhode Island, run by Carey's friend, John Howard Benson.

Carey was an intriguing character. Married with children, he was a wealthy Catholic intellectual who jettisoned a career in architecture in order to devote his life to God. This meant designing liturgical objects, writing papers on the meaning of Art and Catholicism, and giving financial support to other artists in the field, including Benson. He also founded the *Catholic Art Quarterly*.

Carey and Ade began a correspondence that lasted until he died, producing torrents of words on the topics of Art and Work, Art and Success, and Creativity and God. At the beginning, Ade was the student learning

from the master. Carey was a tough critic of her art, and he let her know it. But very soon the emphasis changed, and Ade began editing and critiquing Carey's turgid and sometimes incomprehensible prose.

Carey's friend, John Howard Benson, was a celebrated stonecutter and letter-carver, mostly of monuments and memorials. As Ann later said, "As a craftsman, I daresay he has few equals." He was also a Catholic convert. (His wife, Fisher, was a Quaker.) He wrote in lyrical terms to Ade about her artwork for the *Catholic Worker*: "It fills a great need and has us much excited." He signed the letter, "Your co-worker in Christ, John Howard Benson." Benson was an excellent foil for Carey's religious and philosophical ruminations, Benson being grounded in the physical world and Carey roaming more cerebral pastures. Graham Carey and John Benson became Ade's mentors, collaborators, and friends for life.

These rapid developments in Ade's career had no counterpart in Ann's. Ann was still working at her sculpture, but not much success came her way. Her only achievement that had so far outstripped Ade's was the publication of her three children's books—those books she did not wish to talk about. She did, however, encourage Ade to try writing children's books herself. Ade's charming woodcuts were perfect for the genre, but so far Ade had written two, and both had been turned down. (Later she found great success illustrating and writing Catholic stories for children's books and comic strips.)

During the mid-1930s Ade was still based in New York where her parents lived, and she and Ann saw a lot of each other. But Ade began to spend more and more time in Newport, finding Benson and Carey and the constantly changing scene at the John Stevens Shop both exciting and stimulating. Meanwhile the two men were eager to encourage this young devotee of religious art, and Ade began to produce such work at a prodigious rate. She became a critical member of the small, intense society within the shop.

John Howard Benson's fame in the arcane world of stone-carving and lettering was well-known. But the John Stevens Shop in Newport was no ordinary monument factory. The people who were drawn to the atmospheric wooden-beamed studio (dating from 1705) were apprentices in sculpture, lettering, and printmaking. The shop produced handprinted and engraved books and pamphlets, aided by master typographers such as Eric Gill, a brilliantly gifted British stone-carver and founder of a Roman Catholic artists' commune in Ditchling, England. One of Gill's pamphlets

published by John Stevens, for instance, was titled *Sacred and Secular in Art and Industry*. All the young artists who dropped in and out of the shop during these years—and they came from many other countries as well as the United States—shared the same worldview: the issues revolving around their Catholic faith and how they could reconcile success in the material world of art with the life of the spirit.

Carey, for instance, was a believer in a loose creative philosophy known as "traditionalism." This did not mean "traditional" in the sense of conventional, tried, and true methods, but in the sense of going back to the origins of art in both Eastern and Western cultures. One of the chief proponents of this idea of a universal tradition, founded in ancient myths and symbols, was Ananda K. Coomaraswamy (1877–1947), a Ceylon-born philosopher and teacher who became a curator in the Department of Asiatic Art at the Boston Museum of Fine Arts, and whose books and essays published in the early twentieth century inspired a group of young artists searching for the connection between art and God.

Coomaraswamy, openly scornful of a university education, called for the redirection of art scholarship away from what he regarded as academic literalism and back to the myths and folklore of peasant cultures. His knowledge of the ancient religions of Hinduism, Buddhism, and Islam, and of Greek and Chinese philosophy, allowed him to draw on a vast trove of symbolic and mythological traditions, the study of which he believed would bring people closer to the sublime. Joseph Campbell was a later proponent of this idea of abandoning the constraints of modern scholarship and rediscovering the transcendent qualities of a universal mythology. Campbell's television series on the subject with Bill Moyers, which began in 1988, popularized these theories with a huge audience.

Ade was an enthusiastic follower of Coomaraswamy, as was Graham Carey and John Howard Nelson. Coomaraswamy visited Newport on occasion and became a friend of theirs. The direct-carving movement in sculpture was closely related to this belief in authenticity and a back-to-nature, hands-on art that Ann's teachers, particularly John Hovannes, had so assiduously promoted. Ann's growing commitment to direct carving came at precisely the time Ade was thrashing out these issues with Carey, Benson, and their friends, so Ade's reports of these discussions encouraged Ann to see that there was a strong philosophical basis to her growing commitment to this way of making sculpture.

In those days letter writing was a daily activity (witness the Carey-Bethune correspondence), and Ade and Ann often wrote to each other when they were apart. In 1935, while Ann was traveling abroad on her second Carnegie Fellowship, Ade wrote in these affectionate terms to her fellow artist: "The Lord be with you, Chile, and with your spirit. I have no notion of yore movements abroad. Neither had Lydia when I saw her last Wed, but she said I could safely write to Am. Expr. London." The letter goes on to say that Ade has been playing "the laziest tune ever" in the country where she is staying, "Very fine, wide, slow, silent." She ends with "Chile, I aint got nothin' t'say. But like you just the same, with much love."

In a letter in 1937, Ade writes, "Today feast of St. Anne and all my good wishes to you on your feast day. Been thinking of you all day. Did I ever tell you that Anne means: Grace?"

The letter is written, as all of them are, in Ade's beautiful, neat calligraphy, sometimes with illustrations recalling an illuminated manuscript. Ann's writing, in contrast, is large and scrawly, tumbling down the page, often almost illegible. A handwriting expert could have a field day analyzing the characters of these two hands.

Ade goes on: "It so fell that I have finally completed today a little 'work of love' I had been working on for you: a little book of the "Night Prayer: 'Compline.'" She comments how difficult it was to write the book. "Anyway, this is my first meager attempt at book-writing and it goes to you with all my love."

Ade's involvement in music is also something she likes to share with Ann, sweeping her friend up in her enthusiasm. The younger woman was taking piano lessons and passes on her knowledge in her letters: "(Kay) is getting on teaching me harmony and counterpoint. . . . As soon as you come back I shall teach it all to you. . . . But in the meantime wish you would practice for me the tonic chords of all 12 scales." (Here Ade writes out the music for Ann.) She signs it, as she signs most of her letters, with some form of "God bless you, Chile, and give you his love."

Another letter from Ade shows the increasing importance of their relationship. "Been thinking lots about our *béguinage*," she writes. (A *béguinage* is a convent-like building where lay sisters of the Catholic Church sequester themselves—lay sisters being women who wish to serve God without actually becoming nuns and retiring from the world.) "Found here in Gorham (Maine) a spot ideal. A little hill that commands the

neighborhood. A hill of stop-time grandeur." In another, she describes looking at a rose window designed by Connick as the sun sets: "There were clear reds, scarlets and crimsons, to your heart's content, marvellous yellows, and the most brilliant and rich greens you could ever imagine." After more lyrical descriptions of the setting sun changing the colors in the window, she adds, "I do wish, chile, you could have been there. But we will get a chance to see it again other years, and next summer we shall go to see sunsets in Chartres and Rheims and sunrises in Poitiers, O.K.?"

Ade and Ann were never to travel to these places together. In 1937 Ade went to Europe, but this was not one of Ann's fellowship years, and she surely could not have afforded it otherwise. But the hope remained alive, particularly for Ade. The letters continue during their separations as though their conversations never stopped. Ade continues to address her friend, "Dear, dear, dear, dear Chile," as she did to the end.

Like most personal letters, they reveal more than is at first apparent. The affectionate address "chile" is particularly telling. Ann's still-strong southern accent that so delighted Ade on their first meeting surely inspired this nickname early in their friendship. It is also clear that Ann did not dissuade her from using it. It was Ade's accepted term of affection for Ann for as long as they knew each other. The name "Annie Vaughan" also appears in Ade's letters; for Ade, Ann allowed the use of her otherwise-rejected Selma name.

The use of "chile," with its modestly infantilizing meaning, also sheds light on their relationship. If one reads the letters carefully, Ade seems always to be the dominant partner in the friendship. Although so much younger, she writes confidently of their work, their conversations about art, their doubts, their beliefs. As the mentor, the more experienced, mature partner in the relationship, she gives specific instructions about Ann's reading and music-playing. She writes about the discussions she has on an ongoing basis with Carey and Benson on subjects such as the difference between reasoning and seeing, symbolism and reality, and the many moral problems surrounding artistic endeavor.

Not surprisingly, Ade was eager for her friend to come to Newport and experience in person the heady atmosphere of John Howard Benson's studio, to participate in these high-minded religious debates, and to witness direct carving at its most sublime. As early as 1935, when Ann went to Europe, Ade was already planning to introduce Ann to the cultivated and eccentric individuals who inspired the work of the John Stevens

community. Learning that Ann was to include England on her trip, Ade wrote to Carey asking him to write a letter of introduction for Ann to visit Eric Gill at Ditchling. (It is not clear that Ann ever got there; Carey forgot to write and when he got around to it, it seems to have been too late.)

In June 1937 Ade wrote to Carey asking him this time to invite Ann to Newport:

"May I recommend ANN WEAVER to your 'bienveillance.' She is trying to chop stone and would like to come to John Stevens's in August." Ade goes on to say that she feels Benson

> seems a bit temperamental about this shy child. (But that may be my imagination.) Of course it is *his* shop. But I know yo'all will like her with further acquaintance. She doesn't say much, like Casimer [another apprentice], but has "aristocratic" background. (Moreover she is getting on the way to the Church.) She is still at the stage of making ABSTRACT sculpture, but will emerge from it, and at least has now a genuine desire to learn about LETTERING. She just wants to do her work in a corner of the shop and will bother no one."

Ade asks Carey not to tell Benson about her request while she tries to find out Benson's true feelings about the idea. Ade has in mind that if Ann and Benson could get along "chopping," Ann might later assist him as a teacher—and earn some desperately needed money. Ade adds again in this letter, "I shall be very grateful if you can use your prestige and tact to help my friend Ann. She is shy but worth while." A month later Ade writes again, "Have you been able to do anything for Ann Weaver?" Fortunately for Ade, Carey had. He writes a week or so later, "John is going to invite Ann Weaver to Newport."

What a revealing exchange. Ade makes herself very clear: she is hoping Ann will convert, she intends to redirect Ann's art away from abstraction, and she wants to get Ann a job. Quite a lot to ask, but Ade never shrank from a challenge, and all this was for the spiritual and material welfare of a woman she loved. (It is interesting that Ade feared Benson's hostility to Ann's visit. Was he afraid Ann would divert Ade's attention from her work? Could it have been a subtle form of jealousy?)

Ann came to Newport in June 1937, without an invitation. Ade and she spent time together, but the invitation from Benson to work at the school came later, and Ann started officially there as a "chopper" in the summer of 1938.

Was it a success?

Ann was thirty-three years old, Ade was twenty-four. By the time Ann arrived at the John Stevens Shop, Ade was already running the place, almost literally. She was surrounded by students, apprentices, friends, family (her parents visited often and moved to Newport in 1941), and the atmosphere there was loving, close-knit, and very focused on the making of religious art and the reasoning behind it—to serve God. This was thoroughly Ade's territory. Ann found herself a stranger in it, surrounded as she was by Ade's devoted and protective colleagues, all inspired by doing work that was on the whole not the kind of thing Ann wanted to pursue. It must have been more than a little daunting. But Ade had pulled a lot of strings to get her there.

Ade wanted Ann to be with her. The young women shared so much—artistic talent, strong musical interests, and perhaps most important, a deep spirituality and desire for religious meaning in their lives. Ann's early belief that she would enter the religious life was reignited in the glow of Ade's lifelong commitment to her Catholic faith, and to the expression of this faith in her art.

The younger woman's letters read like love letters. (Most of Ann's letters to Ade have not survived. One wonders why Ade, who kept almost every piece of correspondence during her long life, did not keep Ann's letters during this critical period.) Today, we read such affectionate communications between women of the early to mid-twentieth century as suggestive, to say the least. But the controversy over whether most of these female correspondents were actually having physical sex with each other seems now to have faded into an acceptance that this passionate language was simply how women of the time who were close friends addressed each other.

Clearly Ade loved Ann. She loved Ann's shyness, her southernness, her commitment to her work, her sense of humor, her religious spirit, her elusive beauty. Mostly they were polar opposites—Ade was a paragon of confidence and energy, surrounded by family, an embracer of the world, and a devout servant of her God. Ann was uncertain, diffident, torn between many opposing forces, alone, far from Selma, and in the shadow of her younger friend.

The two women had a powerful bond, but it seems most unlikely that they had a physical relationship. In another age, they might have. But Ade's life with and for God had been carved out for her very early. She

Undated bas-relief by Ann, an interesting confluence of modern and classical styles. Entitled *VII The Women*, it seems to have been part of a Stations of the Cross series, probably carved under the religious influence of Ade Bethune. Photo courtesy of ANSG.

never married. There is no evidence that she ever had a physical relationship with a man or a woman. In her apartment above the John Stevens Shop, where she lived for much of her early life, she slept in a simple cot, like a nun. It's true that she surrounded herself with young female apprentices, but if there was speculation, it never went anywhere. She wrote

on an almost daily basis to Graham Carey, particularly in the early years, but nothing in their vast correspondence gives any indication of anything more than intense friendship, and Carey was surely far too immersed in questions of the Catholic faith to stray from either of his two wives. (The first one died; the second worked in Benson's shop.)

As for Ann, no names appear in the records to suggest that she had an intimate relationship with anyone, male or female, during her years in New York. Much later, Ann confided to a friend that there was a boy in France whom she rejected, but it's difficult to believe this counted for anything. One senses that Ade almost completely dominated Ann's emotional and creative life from the moment they met at art school until Ann left New York.

This exceptional friendship was positive in almost all ways for Ann. Ade made her friend confront her beliefs, her commitment to art, and her understanding of the artist's role in the world. But at the same time Ade's work was flourishing in ways that Ann's was not. Ade started teaching at Portsmouth Priory School (now Abbey) in New Hampshire. She began illustrating bibles, missals, saints' stories, and so forth, under her own imprint, St. Leo's Shop. She was becoming known as a religious leader and inspirational speaker in Catholic circles throughout America.

Ann went back to Newport several times, but while she was watching her young friend's career expand so confidently and significantly, she was painfully questioning her own.

7

Career Challenges

DURING ANN'S NEW YORK YEARS, she visited Selma regularly over the summer months. If Newport was becoming the center of her new intellectual life, Selma remained the emotional core of her identity. One of the issues their mother was struggling with back in Selma was the behavior of Ann's younger sister Rose (born fifteen years after Ann), who was showing signs of rebelliousness as she became a teenager. In 1935, William, with Ann at his side, wrote a letter to their mother from Paris urging her to send Rose to boarding school. William even offered to help pay for the school, saying he could easily advance his mother $400 (almost $4,000 in today's money).

How did William have this money? It probably came from his aunt Rose, who adored him and slipped him funds whenever he needed it. (In her diary, she confesses that she fears she "loves him too much.") Ann was not so lucky. There is no evidence that Rose sent her niece anything at all. And Ann would never have asked for it.

It is difficult to gauge the extent of Ann's poverty while she lived in New York. She moved from rental to rental, constantly changing addresses, mostly finding studios with other struggling artists. But apart from trips to Selma and Newport, whatever money there was went to pay for her very expensive carving and casting work, leaving crumbs to eat.

There was some money in Selma—her mother owned real estate in town, and of course Aunt Rose was doing fine with Clara's legacy. But William was clearly worried about Ann, and said once he would have force-fed her in New York if he had to. A family friend in Courtland

remembered that he sometimes ate peanut butter and crackers as an economy in order to send his sister money. It seems that Ann was creating a small drama here. It was important for her to be seen as a "starving artist," rather than as a member of the southern gentry. She wanted to live as her fellow artists lived, and that was on the poverty line. Her identity as an artist depended on it. Her family could probably have helped her much more, if she had only asked them.

The troubles at home with Ann's younger sister were not the only issues that kept Selma in the forefront of Ann's mind. The two men she was probably closest to in New York were John Lapsley and Crawford Gillis, both born in Selma. Crawford Gillis was born in 1914—nine years younger than Ann, like Ade—but they grew close when he moved to New York to enroll in the National Academy of Design in 1935. The other member of this trio (as Ann herself referred to them) was John Lapsley, born in Selma in 1915, a year after Gillis. Lapsley was also an alumnus of the National Academy of Design.

Ann Weaver, John Lapsley, and Crawford Gillis became inseparable in New York during the first few years of the 1930s, but their careers soon diverged. Lapsley returned to the South in 1936 to attend Birmingham-Southern College, where he continued to study art. He became increasingly interested in mural painting, as did Gillis.

Both men were very conscious of their southern roots and took the toxic situation in the reconstructed South as their subject matter, exploring both social inequality and racist persecution. By 1938, both men had left New York for Alabama, where they joined the New South School and Gallery, which was founded in 1938 and based in Montgomery.

The New South School was formed to summon artists and writers back to the South, which its members saw as isolated from the country's cultural life and which they wanted to bring into the world at large. The school became, briefly, a showcase for the Social Realist painters of the South, with Charles Shannon one of the founder-members. Lapsley worked with him on murals. As well as nurturing socially conscious southern artists, the New South School was instrumental in exhibiting the work of black artists such as William Traylor (now highly regarded by collectors as a leading "outsider" artist), a radical decision in those segregated days.

But the members of the school disagreed on policy and were divided by personal ambition, so the organization was short-lived. After it disbanded in 1940, both Gillis and Lapsley remained in the South. Gillis joined the

Civil Service and painted in his spare time, dying in 2000. Lapsley became an art teacher at Auburn University and continued to paint and show his work until his death in Selma in 2005.

Ann refused to have anything to do with the New South School in spite of her two friends' commitment to it. Why? She certainly had the credentials, and the Art Students League, where she studied, was a hotbed of young artists involved in the social and political issues of America, including those of the South. Moreover, she could hardly have been unaware of the avalanche of art the South was generating, particularly as the Depression deepened. Walker Evans, James Agee, Dorothea Lange, Charles Burchfield, Thomas Hart Benton, and Charles Shannon, amongst many others, all embraced the region in their work during the 1930s.

Like many politically conscious artists and writers, Ann had sympathies with the Communists and spoke out for the poor and dispossessed. Why did she reject the New South School? Did she simply wish to disassociate herself totally at this time from her background, practicing the art of compartmentalization that was becoming a signature of her psychological makeup? Did she fear that an association with this politicized art would damage her career? Or was it a more fundamental alienation?

According to Crawford Gillis, Ann was totally dismissive of Social Realism, which she saw as a patronizing attempt by middle-class artists to romanticize the plight of the proletariat. She said to Gillis that it was an idea suitable only for "Jewish girls in gingham dresses who dance to folk tunes." John Lapsley remembers her remark differently. According to him, her remark was not about art but about politics, saying that Bolshevism was "social consciousness for Jews dancing in gingham to prairie schooner tunes." This comment would not be taken very well today, and Lapsley was at pains later to point out that Ann "was very conscious of incongruity." He added that "She was not in any way racist, but she had a wonderful sense of humor and didn't mind being un-PC." Lapsley himself soon began to share Ann's disenchantment with Social Realism, calling it the "pappy-pass-the-biscuits" school of art.

Was there perhaps another reason for her rejection of Social Realist art? Could it have been Ade's influence? Was Ade attempting to seduce Ann away from politics and toward the life of the Spirit? Ade certainly had little time for the likes of Lapsley and Gillis, as the following exchange makes clear. Lapsley had often talked to Annie Vaughan (as he still called her in the old Selma way) about the murals that he and Gillis were working

on for a new community building for blacks in Selma. He was anxious to learn about techniques for prepping the walls and the kind of wash to be used. Ann suggested he write to Ade, which he did. Ade, as usual, sends on the request to Graham Carey, with the following explanation:

He and Crawford Gillis are two queer concoctions who somehow, in their dump of a small town of Selma, Ala. have managed to learn all about "modern art" from books, having never had a chance to see any of it at first hand. . . . A. V. [Annie Vaughan] says both boys are very good. I suspect they are arty and somewhat communist as A. V. herself. But they are inveterate readers and starved for good reading matter. . . . Pretty soon the boys may be ready for some of the J. S. [John Stevens, religious] Pamphlets.

Anyway, bad as his procedure towards subject matter and composition is, I think his attitude towards technique is good, and he is worthy to be helped with it.

So much for the Selma boys! Ade saw them as a bad influence on her friend, either because of communism or "artyness," or just because she thought they weren't very good artists. She can't have objected to their cause; she was herself trying to find jobs for black children in Newport.

Her reference in this letter to Ann's birthplace sounds uncharacteristically patronizing and unfair, particularly since Selma was becoming a center for artists who brought regional painting to the national consciousness, fueled originally, of course, by Clara Weaver Parrish and her contemporaries. Ade's letter was written in early 1939, when Ann had returned to New York after her first visit to Newport. Perhaps things hadn't gone so well there after all.

Despite Ade's disapproval, Ann remained in touch with the Selma boys, writing to them about the various cultural events she had attended in the city. In May 1939, she argued with Crawford about Martha Graham, the revolutionary modern dancer/choreographer, whom both admired greatly. Ann, disagreeing with Gillis, liked Graham's two new dances *Frontier* (1935) and *Deep Song* (1937) more than *American Document* (1938), which she found "too hybrid—dance + theater. I think she lost in intensity, and the ballet technique of the male dancer didn't harmonize so well with her style." Ann was to follow Martha Graham's career throughout her life, although they do not seem ever to have met. Graham's austere, ritualistic worldview was very much to Ann's taste. There was even some

discussion, which came to nothing, about Ann doing a sculpture for one of Graham's dances.

Ann also continued to attend many of the major art shows in the city. The Museum of Modern Art's 1939 summer show she found "grand" and wrote to Ade about it, urging her that it would be well worth making the trip from Newport, although Ann thought the sculpture very poorly displayed. She attended an illustrated lecture by Leo Katz on the Guadalajara murals of noted Mexican muralist José Clemente Orozco and found the images "stupendous." For a year, starting in April 1939, she received a permit to sketch in the galleries of the Metropolitan Museum of Art.

The most momentous event in her work life that summer of 1939 was a commission she received from Dr. K. E. McSweeney for a statue of St. Francis for the doctor's garden in Vermont. "It is a real jenu-ine commission," she wrote excitedly to Ade, "and I hope I do a good job of it—in my own way." (Note the last four words: Ann was not interested in compromise now, or ever.) "Am dying to start another standing garden figure," she told Ade, "column-like—but St. Francis has to come first." She finished the St. Francis piece, and it was placed in the doctor's garden in Burlington. Dr. McSweeney was delighted with Ann's work and wrote her a letter of praise and admiration for her skill. Ann was also excited about working on a sculpture of dancing birds that she hoped someone would buy for a garden. This work was eventually exhibited at the National Sculpture Society, in 1941.

The idea of garden statuary was very much on her mind at this time. It was really her only hope of making some money from her art. Garden sculpture was gaining in popularity in the United States as wealthy homeowners looked to European styles of garden landscaping to enhance their properties.

But nothing came easily. She was lonely, with no romantic ties. After Ade's departure to Newport, the two friends she most depended upon, John Lapsley and Crawford Gillis, also left New York permanently. Not that there was anything physical between Ann and either of these men. Lapsley was certainly gay, though not overt about it. Neither Lapsley nor Gillis ever married. (A telling incident concerning Gillis involves a painting he exhibited at the New South Gallery in Montgomery in 1939. It was a full frontal nude of a male dancer from a traveling minstrel show. It shocked the locals so much that it was removed.)

Ade was now a fixture in Newport, becoming more and more involved

with the John Stevens Shop and her own printing business there. She produced illustrations for pamphlets, essays, and religious books, including a missal that sold thousands of copies. In 1940 she bought a house at 36 Thames Street in Newport, close to the shop. By this time she was a well-known speaker and teacher, addressing the Catholic Art Association and becoming involved in the Liturgical movement. In 1940 Ade was only twenty-six years old, but her meteoric rise within the Catholic Church and her increasingly busy life as an artist were taking her away from Ann both literally and psychologically, and they both knew it.

In March 1941, Ade wrote to her from Newport after Ann had complained that she was not writing regularly enough. "Honey Chile," she writes, in the form of a prayer, "I am heartily sorry to have offended thee. I detest all my sins, because I dread the loss of heaven + the pains of hell but most of all because they offend thee who art all good + deserving of my love. I firmly resolve, with the help of God's grace, to confess my sins, to do penance, + to amend my life, + to write thee both more lengthily and more often. AMEN."

There is a note of irony in these lines, but clearly Ade was stung by Ann's reproach. Ade continues the letter in less emotional terms, responding to Ann's questions about the nature of drawing, declaring it to be always two-dimensional: "There being strictly no such thing as a 3-dim drawing." She also describes an amusing moment when the shop's resident photographer, King, an absent-minded fellow, comes into Ade's room in order to talk to her about something, just as she is in the middle of undressing. "Oh! horrors! Oh! agony! Oh consternation!" (He retreated politely and continued the conversation on the stairs.) This little story has an intimacy about it that shows the continuing tension of the two women's relationship.

Ann managed to find some artists in New York to spend time with. Through her internships with John Hovannes, she met a woman sculptor, Margaret Brassler, another alumna of the Art Students League, who also chose to follow the direct-carving path taken by Hovannes. She was four years younger than Ann but already producing serious work. In 1936 Margaret and Ann decided to get a studio together, first at 2 West 15th Street, and later at 3 West 29th Street. A third sculptor, Frances Mallory Morgan, joined them. Ann left this studio in May 1940 (it is not clear why) but kept most of her work there. Ann remained a good friend of Frances Morgan and later sometimes stayed with her in New York.

The work of Margaret Brassler Kane (as she became known after her marriage) has received some recognition in her long lifetime. (She died in 2006 at the age of ninety-six.) One of her early pieces is perhaps most interesting in the context of her friendship with Ann. It is called *Harlem Dancers*. Kane made it in 1937, and in 1938 it was awarded an honorable mention at the Whitney Museum of American Art. Comprising so-called primitive, blocky figures cast in marble, the sculpture—and its subject matter—is very similar to the work Ann was beginning to produce at the time.

A surprising appearance from a famous figure might also have qualified as a brief distraction for Ann. Anne Morrow had graduated from Smith a year after Ann. In 1927 Anne Morrow wrote to her mother that she was very much enjoying a Bible class. This is where she might have connected with Ann Weaver. The two women also studied French, another opportunity for connection. When Anne Morrow and Charles Lindbergh became engaged, the couple found it almost impossible to get together without being hounded by the frenzied paparazzi. The story goes that when Anne visited New York briefly in early 1929, she arranged to meet Charles in the downtown studio of her impoverished artist friend Ann Weaver, where nobody would think of looking for them. (Ann liked this story, perhaps for its incongruity, and related it more than once; it was repeated by several other people over the years.)

Only one other name jumps out from the records of Ann's New York life as a close friend. Lilian Leale was a wealthy spinster from a prominent New York family. Her father was Dr. Charles A. Leale, whose name entered the history books for his role as the first doctor to be admitted to the Presidential Box at Ford's Theater in Washington, D.C., in 1865, after John Wilkes Booth shot President Lincoln.

At an early point in her life Lilian worked for her father as his secretary, but her main passion was religion. She was very active in Protestant Episcopal Church work and was on the boards of several charitable organizations, such as the Orphans' Home, the New York Women's Bible Society, the Church Women's League for Patriotic Services, the New York Altar Guild, and the Cathedral Guild of St. John the Divine.

Lilian and Ann met in 1934, perhaps through Ade and their charities. Lilian was a much older woman, and Ann may have become her protégé. Ann certainly admired Lilian's philanthropic work. They spent many hours together over the next eight years, probably working for the church.

But by the end of 1941, with the war escalating in Europe and the atmosphere at home in wartime mode, things began to look bleak. Nobody was commissioning anything, let alone expensive pieces of garden sculpture. Ann began to think seriously of teaching as a way out of her increasingly desperate financial situation. She asked Ade's advice, saying that she'd like to teach modeling and wood and stone carving. Ade thought this a good idea but wasn't sure she could help her find a place. She told Ann that the only institutions where Ade could help her would be those supporting the ideas so often discussed in the John Stevens Shop in Newport.

"They wouldn't care a scrap whether you were Catholic or not," she wrote to her in December 1941. "But they would care very much whether you are interested in debunking 'Art', 'Art for Art's Sake', 'industrialism', 'esthetics', 'exhibitionism', 'escapism', etc." Ade suggested they go over these points to try to make Ann understand more clearly why these currently fashionable, artificial categories of art should be debunked. "Meanwhile I'll send you some Coomaraswamy to read so you get better acquainted with the *traditional* view of art, towards which you with your whole being long so much." Ade conceded that he was rather tough to read but assured Ann that "when I can help you with understanding the proper meaning of his vocabulary, you'll find him APPLES!"

In other words, at this point Ade was still attempting to bring Ann into the John Stevens community, and Ann was still not convinced. But Ade perhaps knew Ann better than Ann knew herself. The teachings and writings of Coomaraswamy were indeed "apples" for Ann, particularly his emphasis on the universal embrace of Hinduism, Buddhism, and Indian and Tibetan art. Moreover his ideas fed directly into her sculpture teachers' belief in direct carving as the purest—that is, most "primitive"—expression of their art. The time Ade so devotedly spent talking to her friend about these matters was amply rewarded as Ann's life and art evolved after she left New York.

But for the moment, Ann wanted a job, not any more philosophizing. By chance, another friend directed Ann to an advertisement from the newly formed Norton School of Art in West Palm Beach, Florida, which was looking for permanent staff. In July 1942, with Ade's encouragement, Ann took a deep breath and applied for a post as sculpture teacher there.

In her application, she sent photographs of her sculptures to Helen Burgess, director of the summer school, knowing full well how unconventional they might appear. She conceded that they were "in the modern

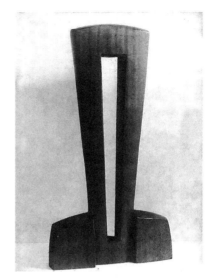

Plant Form (*left*), 1935 (20" high), a mahogany sculpture described by the artist as an adaptation of a hyacinth bud suitable for a memorial monument. Geometric design for a heroic monument (*right*), 1935, mahogany. Photos by Soichi Sunami.

vein" but quickly added that she had had a thorough academic training. In this case of special pleading, she also admitted to writing children's books and enclosed copies of them, explaining that they were done to pay for her art training and that she did not claim to be an illustrator or author, "as I have had no training in either."

She listed where her work had been exhibited and enclosed five letters to support her application. The first was from Edward Murrow, who wrote about her excellent scholarship response; the second was from her old teacher Georg Lober, who had liked the carving of birds she exhibited at the National Sculpture Society in 1941; a third was from L. P. Skidmore, director of the Atlanta Art Association, expressing how much he believed in her work. He also wrote, "although I am Yankee born, I am wholeheartedly for southern art. I believe that the great things in American art will be produced in the Southland." One wonders what Ann thought of that.

William Zorach also wrote a positive letter on her behalf. He was familiar with the Norton Museum of Art since it had recently bought one of his life-size marble groups entitled *Youth*.

Lilian Leale wrote a glowing letter: "In my opinion Miss Weaver would make an excellent teacher. She has a charming personality, is sincere and faithful in her work and to her duties. She has a cheerful and companionable disposition and a very fine character. . . . I consider her a dear and valued personal friend in addition to her many talents." Ann added two more names as references without accompanying letters—John Howard Benson and Charles Rudy.

Interestingly, Ann did not name Ade in her list of recommendations. She may have thought that her friend's very specific philosophical/Catholic agenda might count against her. Yet Ade could have written a brilliant letter without referring to God at all.

Mrs. Burgess noted after receiving these materials, "This girl seems very desirable to me."

Ann spent July, August, and September 1942 in Selma, continuing to correspond with the Norton people. She did not hesitate to engage in the topic of her salary, suggesting that a "minimum average of 10 pupils at $15 each would be necessary in order to make expenses. That would give me an income of $135 per month which after taxes are removed would leave about $120. This, it seems to me, should enable me to meet actual living expenses, transportation, and some art materials if I am very economical." She added, with a note of desperation, "I really want this job and would do the very best I could to build up a good interested class and give them a foundation and appreciation of sculpture."

This was her last lengthy visit home before starting her new job. On September 29, 1942, she sent back from New York a signed contract to the Norton, asking permission to start work on January 1, 1943, so she would have time to finish some complicated carving projects at the John Stevens Shop in Newport. She also requested that the proper supply of materials be made available to her pupils: wood carving tools, stone carving tools, sharpening stones, clay and Plasticene modeling tools, and other sculptural equipment. She was worried (rightly) that these items might not be available in West Palm Beach. The director of the Norton School of Art, Mary E. Aleshire, wrote back reassuring her on all counts.

A few days later Ann left for Newport and Ade. It would be one of their last extended times together.

It is tempting to divide Ann's life into geographical stages, charting her movement from Selma to New York to Florida, and there is substantial

evidence that each of these transitions, as is true for many people who work in very different environments, developed and extended her as a person and as an artist. But it is beyond debate that her decision to take a position in Florida was the most life-changing. When at the end of 1942 she left New York for a new career as a teacher at the Norton School of Art, the move totally transformed her life, her art, and her legacy.

8

A Turning Point

ACCORDING TO JOHN LAPSLEY, when Ann left New York, she had fifty cents in her pocket, a battered suitcase that wouldn't close until Lapsley supplied some rope, and little else. When she arrived in Florida, she was almost forty years old and had been working as a sculptor for most of her adult life. What, at this time, did she have to show for it?

Not a lot.

She had started very well. As early as 1930 she had exhibited her *Negro Head* at the Museum of Modern Art. Three years later, while at Cooper Union, she won a silver medal for advanced modeling. The other women students that year won medals for decorative design, pictorial design, fashion illustration, and interior architecture. In other words, Ann was already setting herself apart from most of her colleagues' more "feminine" artistic pursuits. In a book published in 1934, *Art in America in Modern Times* by Holger Cahill and Alfred H. Barr, Ann Weaver was one of twenty women singled out for mention as "doing very good work."

She exhibited a limestone doorstop (later entitled *Lady with a Bird*) in a group show of young Americans at the Jacques Seligmann Galleries in 1934. She showed a mahogany *Plant Form* at the Clay Club Galleries in 1939. In February 1940, a cubist-inspired piece of hers entitled *Design for a Memorial Monument*, made of Tennessee marble, was accepted for an exhibition at the National Sculpture Society in New York. (The President of the society was Paul Manship.) A year later this marble memorial was exhibited at the Whitney Museum of Art. She also completed the commission from Dr. McSweeney for the St. Francis garden figure.

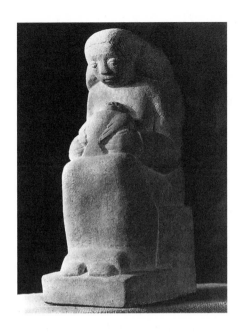

Woman with a Bird, 1933. This limestone sculpture, originally called a doorstop, was later given its present title. Photo by Soichi Sunami.

Several of these pieces were photographed by Soichi Sunami (1885–1971), an important Japanese-born photographer who worked in the MOMA archives and was the friend and photographer of many preeminent artists of the time, including Brancusi and Calder. Sunami's attention was flattering for Ann and showed that she was at least on the periphery of the New York modernists' inner circle. But although she exhibited at the highest-quality venues, these shows were few and far between, and her modest output failed to engender financial rewards or personal fame. In fact, she suspected as much, conceding, perhaps somewhat disingenuously, to Mrs. Burgess in her letter of application to the Norton School that she could have shown more. "I could have exhibited a great deal more often but I have so far concentrated my time and energy on the quality of the work rather than on publicity."

What was her sculpture like? Like a lot of different things, really. A layperson looking at her body of work would have seen a mixture of styles, materials, and subjects. This wasn't necessarily a bad thing. Robert Hunter, director of the Norton Gallery of Art, and Ann's later friend, defended her output. "Many artists achieve an acceptable (and successful) style and stick to it. Ann [Weaver], however, continued to develop all of her life, her progress supported by her essentially sculptural approach as opposed to modeling."

Part of the problem was that she was constantly in a tug-of-war between social realism and abstraction. Some of the work she was doing in New York at the time was realistic, in the Hovannes manner, although by the late 1930s, as she may have realized, social realism was going out of style. Lapsley and Gillis, entrenched social realist painters, were to discover that lifelike scenes of working-class life were regarded by the modernists as sentimental and retrograde, and the two artists came to change the direction of their work to some extent in their later years.

Along with her realistic work, Ann was clearly moving toward the abstract. The *Lady With a Bird*, made in limestone in 1933, definitely had a primitive quality—indeed, its earlier description as a doorstop reflects its blocky appearance. Her *Memorial Monument* is an organic, Brancusi-like image typical of the 1930s. In the judgment of William U. Eiland, director of the Georgia Museum of Art, who wrote a brief biography of Ann Norton in 1989 that was published by the Ann Norton Sculpture Gardens, Inc., Ann's works at mid-career were heavily indebted to her teachers and friends in New York. "Invariably the figures, as grotesque as some appear, are grounded in Archipenko's Cubism as surely as they reflect the expressionistic, pre-Columbian qualities of Hovannes and de Creeft." If one looks at these more famous sculptors' works, their influence on Ann at this time is evident. She was still, in other words, struggling to find her "voice."

Where she appears more confident and liberated as an artist is in her drawings, which continued to be impressive. As the contemporary artist Claudia Aronow points out, to be a sculptor, you must be able to draw. "Sculpture is three-dimensional, so you must be able to see the object from all sides." This was Ade's argument also. Throughout the 1930s, Ann's drawings, pastels, and watercolors in fact became far more abstract, more focused on space and shape, than her sculptures were.

"You need to draw using your eye," wrote the great Italian sculptor Gian Lorenzo Bernini (1598–1680). "That is, imprint everything in your mind—and always make sketches and drawings of your different ideas." While Ann's sculptures remained locked in the subject matter of the human condition and acts of daily life, the ideas she expressed on paper reflect her increasing distance from the figurative art in which she had been largely groomed.

The images she produced also highlight her interior struggle with these issues. One recalls Ade's rather disapproving tone when she describes

Ann's abstract work in a letter to Graham Carey. Ade shared many cultivated Americans' dislike of this new, formless art. But abstraction was constantly luring Ann into dangerously provocative territory. Her commitment to direct carving was as much the embrace of a philosophy of abstract art as it was of a technical one.

There was no way for her to remain on the sidelines. The politics of the conflict swirled around her, in studios, in art classes, in galleries, in museums. By the mid-1930s the prejudice against abstract art had exploded, prompting a wonderfully impassioned brochure published in 1940 by a group calling themselves the American Abstract Artists. The brochure attacked American art critics for their "systematic campaign" to prevent abstract artists from exhibiting their work and for their relentless "misstatements and contradictions" about abstract art in general.

While most of Ann's sculptures through the mid-1930s and 1940s continued to be representational, there's no question that she had more advanced artistic ambitions, and the clues to these ambitions are most evident in her works on paper, where she seems to have been able to let herself go. Ann Weaver's definitive creative work at this time was on the page, not on a pedestal. The fact that there was no market for these works was the price she had to pay.

There was also the elephant in the room—her gender. Ann had committed to an art form that was not generally associated with women. Sculpture required strength, particularly if you were a direct carver—all that hammering and chiseling of hard thankless material such as marble, cement, and granite. There were successful female sculptors in America in the early twentieth century, such as Gertrude Whitney, Ann Hyatt Huntington, and Malvina Hoffman. These artists had broken the sex barrier and were highly regarded, but they either came from wealth, married into it, or had wealthy mentors, thus allowing them to do their work as they wished. The counterstory was that of Camille Claudel, Rodin's muse and mistress, who produced work not unlike the Master's (some say better in many cases), and who ended her life in a sanatorium.

The more interesting comparison is with Louise Nevelson, who was born six years before Ann in 1899 and who died in 1988. Louise Nevelson and Ann Weaver could in some ways have hardly been more different. Nevelson was the child of a Russian Jewish immigrant family, often on the poverty line, who grew up in Rockland, Maine—a hostile, mostly anti-Semitic bastion of Puritan New England.

Nevelson was very tall and dark, with flashing eyes and a flamboyant personality, the opposite of Ann. However, their careers as young women were remarkably similar. Louise Nevelson went to the Art Students League in New York in 1929, at the same time as Ann. Nevelson studied drawing and painting, while privately experimenting with small sculptures in clay, often under the guidance of Chaim Gross, another passionate proponent of direct carving, who was making a name as a wood carver, Nevelson's ultimate material of choice.

The most pressing issue for both Louise Nevelson and Ann Weaver, apart from money, was the art world's hostility toward women artists, and in particular, toward women sculptors. Nevelson told the story of being in a coffee house with a group of male artists, who were discussing art. "They were kind of laughing at me because I was supposed to be a sculptor," she recalled. Then one of them turned to her and said that you had to have "balls" to be a sculptor. After a pause, Louise responded, "I've got balls." That shocked them into silence.

When Nevelson had her first solo show at the Nierendorf Gallery in New York in 1941, a reviewer wrote: "We learned the artist is a woman, in time to check our enthusiasm. Had it been otherwise, we might have hailed these sculptural expressions as by surely a great figure among moderns." Nothing in the show sold.

Nevelson's constant rejections and financial struggles would have felled a lesser mortal, but she didn't give up, and gradually her work became more focused, more aggressive, more original. In the 1950s and 1960s, when she started producing her extraordinary works in painted wood, she truly found her voice. The big black boxes, the black and white walls, the majestic pieces created out of found wood and other objects, all became uniquely hers and at last highly desirable to collectors and museums.

Like Nevelson, Ann was always a "sculptor," not a "sculptress." Ann's work was also outside the classical tradition most commercially successful sculptors hewed to and the establishment accepted. Her figurative works represented ordinary people, workers, mundane activities—not the heroes, saints, or legendary figures thought appropriate for the medium. (Her statue of St. Francis was an exception.) Her more abstract sculptures were simply difficult for the mainstream to grasp. Ann's aunt Clara had found a far more hospitable climate for her charming portraits, landscapes, and religious works. Ann's art was a challenge, and she knew it. She felt so anxious about this that she covered up her pieces in her West

Palm Beach studio so that people would not see them. Either way, without money or artistic fame, during her long years in New York she was not able to sell, and therefore live off, her work.

But the move to Florida had a galvanizing effect on her creative life. Ann was now hundreds of miles away from the New York art world, and this in some sense liberated her. She no longer had to bend to the influence of the New York art world, or struggle to be accepted by the sculpture societies that had sprung up in the city, or hope to be invited to exhibit her work in galleries such as Peggy Guggenheim's newly-formed Art of This Century, which opened in 1942. The pressure was off, both artistic and financial.

She could start doing her own thing without the big boys back in New York breathing down her neck. She could be free of the conflicting currents of fashion—abstract expressionism, surrealism, and all the other "isms" that Ade had so acidly listed for her. Ann Weaver was now in West Palm Beach, Florida, a world away from the competitive nastiness of the New York art scene. She was in a sunny backwater, where she could make her art as she wished.

She wrote to Lapsley and Gillis about what she was doing, which clearly excited her. "Composing in space offers so much. My subjects are such simple little every day things—you know the old home themes—'cutting hair,' 'brushing hair,' 'washboard musicians,' 'mother teasing child,' and so on." She included some drawings in one of her letters to Gillis. "These drawings are nothing," she warns him. "I mean they don't give any idea of the sculptures which are really very 3 dimns [dimensional] and lively."

As well as enjoying this creative freedom, she was now earning a regular if modest salary. Almost the first thing she did with her newfound savings—after buying a cotton dress or two—was to open an account with the Anton Basky Foundry on 39th Street in New York. (Louise Nevelson was also a client of Basky.) Between 1943 and 1948 Ann made regular trips to New York City during her school vacations in order to follow up on a continuous series of sculptures cast by Basky. A major series was *Casualties*, bronze sculptures inspired by the war: *Casualties I (Mother and Child)*, modeled in 1944 and cast in New York in 1945; *Casualties II*, two bronzes cast in 1946; *Casualties III (Three Widows)*, modeled in 1946 and cast in 1948; and *Casualties IV*, cast in 1947.

Non-war subjects were a large *Haircutting*, modeled and cast in bronze in 1946 and again in 1948 and 1949; *Children Pumping Water*, modeled

and cast in pewter in 1946; two *Dancers* modeled and cast in bronze in 1943 and 1946; *Kneeling Figure*, carved in marble in 1946; *Beauty Parlor*, cast in 1946; *Washboard Musician*, modeled in 1943 and cast in 1948; *Machine I and II*, modeled and cast in bronze in 1947; *Machine III and IV*, modeled and cast in bronze in 1948; and *Seated Figure* cast in marble in 1948–49.

While these sculptures were still in the "transitional" vein of her early post-New York period, they expressed a feeling and emotion that were often stirring. Ann herself was conscious of their complexity. Her instructions to Basky were always highly detailed. "These are the most important pieces I have done," she wrote of the *Casualties* series, "so I am specially anxious for good casts. Take your time with them. I wish I could talk to you personally about them, as there is one section on each of them where I do not want you to put seams or vents. I have stained these parts pale green so you will recognize them. . . . These pieces mean more to me than I can say. And I specially want the parts I have stained to be reproduced perfectly and exactly." In another letter, she wrote, "I specially want the casting of the arms to be accurate, as they are very abstract." (This about a piece called *Dancers*.)

She also explained her working methods: "The plaster cast is now coated with lacquer containing a little Paris Green to protect it from the plaster bugs of Florida. It is a very thin coat, though, as it is very important to get a good cast of the texture and I would like the surface filled as little as possible."

Basky responded willingly to Ann's demands, assuring her that he would do the best for her. Unfortunately she was still very short of money, and these ambitious pieces cost more to cast than she had envisioned. She arranged to pay "over time" and tried to economize by asking him if he would save the crate and sawdust in which she sent the pieces to him, so they could be recycled.

She experimented with other materials, consulting Basky about the properties of aluminum, lead, and pewter as well as bronze. He told her he could cast what she wanted in any of these materials, but that bronze was always best: "Lead is dull and not good for fine details, pewter is much more expensive than bronze and unless it is lacquered it turns to lead color."

Finally, her hard work began to pay off. In 1946 she told Basky that a prospective client of hers was coming to New York: "I would appreciate

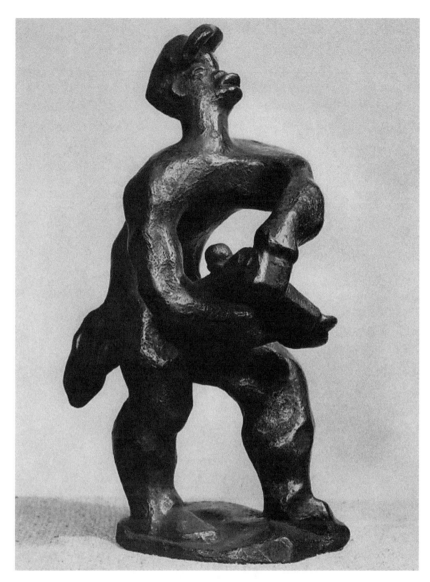

Washboard Musician, 1943, bronze (12½" × 4¾" × 7½'), one of the series of works Ann embarked on after she moved to Florida. Photo courtesy of ANSG.

it if you would show her the *Haircutting* cast." This client was Gertrude Schweitzer, a Palm Beach winter resident, who, Ann said, "was a very fine painter, having work hanging in several museums." This was no idle claim: Gertrude Schweitzer (1911–1989) was represented in the Metropolitan Museum of Art, the Whitney Museum, and the Chicago Art Institute,

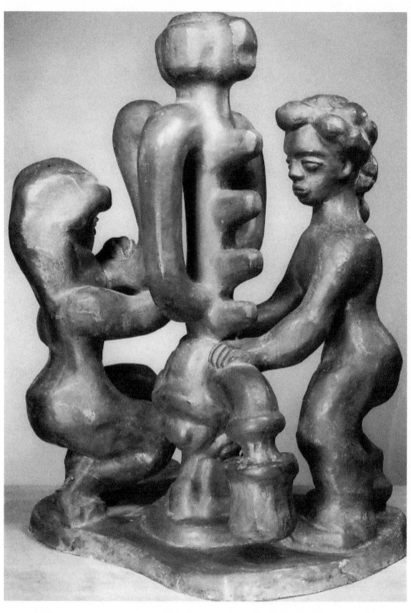

Children Pumping Water, 1946, bronze (21½" × 16 × 14"). Also cast in pewter. Photo courtesy of ANSG.

among other venues. She worked in the modernist vein and would have understood Ann's art.

Acquiring this admirer reaped benefits: Mrs. Schweitzer's friend Mrs. LeRoy Berdeau became interested in one of Ann's *Dancers* pieces, but she wanted it in black bronze instead of Ann's proposal of aluminum. If Mrs. LeRoy Berdeau were your client, you would certainly try to give her what she wanted. Mrs. LeRoy Berdeau was a very fashionable person who graced the cover of *Vogue* in her very fashionable sunglasses in the summer of 1943, this triumph putting the crowning touch to her very fashionable presence on the Palm Beach social map.

These were good omens, and the success spurred Ann on. She alerted Basky that she had decided to get a number of pieces cast, "perhaps 4 or 5 more, so that I can have a New York exhibition as soon as possible. This of course will not be easy and means I will use my savings a little, but I have sold a piece of work and think that I will be able to finance it all right."

As things turned out, her relationship with Basky faltered over precisely this, her anxiety about paying his bills. She felt Basky was overcharging her. Basky in fact was having his own troubles and closed his business in July 1947. ("My nerves could not take it!") But the foundry would continue, as the Bedi-Rassy Arts Foundry in Brooklyn. Ann continued to maintain a close relationship with her foundry assistants, rushing up to New York in the summertime to discuss casting methods and examine their work for her. She was a perfectionist, and every detail of the foundry work was of enormous importance to her.

Perhaps the most exciting thing of all to Ann during these first years at the Norton, apart from her productivity and her paycheck, was that she was finding a market for her work. In Palm Beach there were quite a few rich artistic types who liked to spend money on art and sculpture. Moreover, in that part of the world there was little competition for the kind of sculpture Ann was producing. Her subject matter of scenes from ordinary life, while still representational, appealed to people. To her list of clients, which included Schweitzer and Berdeau, she later added Norton Gallery Director Robert Hunter, who bought *Beauty Parlor* in 1946 and *Machine II* in 1947. In short, Ann Weaver was getting noticed.

One person in particular was beginning to notice her in a major way and to buy her work. He was none other than the top man himself, Ralph Hubbard Norton.

Part III

From Annie Vaughan Weaver to Ann Norton

Florida, 1943–1953

9

The Savior from Chicago

WHEN ANN WEAVER MOVED from New York to Florida, the Second World War was raging and America had finally entered the conflict. However, Palm Beach, then as now, was not exactly in the mainstream of contemporary international politics or culture, and Ann soon found that it was not the war that preoccupied people there but a social world that was light-years away from the one she had left behind in New York.

"Gift of $500,000 Galleries Rocks Palm Beach Social Set"

The agitated headline published in the *Palm Beach Post* in April 1940 about the gift of $500,000 was occasioned by the announcement that Ralph H. Norton and his wife, Elizabeth, had donated this sum for an art museum to be called the Norton Gallery and School of Art. What "rocked" the Palm Beach social set was not the amount of money donated—Palm Beach was used to that—but where the galleries were to be built. For Ralph Norton had done a startling thing. He had turned his back on Palm Beach and decided to build his gallery elsewhere—West Palm Beach, to be precise. *How could he?*

Ralph Hubbard Norton came from a large and prosperous Midwestern family. In 1868, his father and four uncles founded a tinplate manufacturing firm in Ohio, which became one of the first companies to make tin cans for the preservation of food. A few years later, they moved the firm

to Chicago, where Ralph was born in 1875, one of three siblings. Ralph's father, Oliver, a Union Army lieutenant in the Civil War, was a passionate music-lover and helped found Chicago's Orchestra Hall. He also became involved in the Chautauqua Institution, in New York State, where religious and education leaders would gather in the summertime to attend seminars and enjoy concerts and visiting arts companies. The Nortons built a house on the lake there, and the whole family would take the train up every summer.

Ralph entered the University of Chicago in 1896, studying engineering and music (violin and guitar). In 1904, rather than go to work for his father, he joined the Acme Steel Goods Company and never left, moving up the ladder and becoming president in 1923. The Acme Steel Company (as it was renamed) became a hugely successful producer of steel strapping for reinforcement of ships and cargo, and Ralph became very rich. He also inherited some of his mother's fortune, estimated at over $3 million in 2010 dollars.

In 1908 Ralph married Elizabeth Calhoun, a southerner born near Montgomery, Alabama. She came from a family just as distinguished as the Weavers, if not more so; her great-uncle was John C. Calhoun, the political theorist, senator, and vice-president from South Carolina, who was a firm believer in states rights and slavery. However, as Ralph Norton's biographer William McGuire wryly observed, "Oliver Norton's devotion to the Union cause apparently did not overshadow his regard for his daughter-in-law."

Elizabeth, heir to a large part of the Calhoun fortune, was educated at the University of Chicago like her husband and was a keen musician. She was a leader in musical activities throughout their marriage, serving as director of the Chicago Chamber Music Society and in many executive capacities at the Norton Memorial Hall in Chautauqua, which was built at enormous cost by Ralph and opened in 1929 in honor of his father and sister. A beautiful art deco building with fluted pilasters and a series of sculptures, it reflects Ralph's taste at the time. Ralph and Elizabeth had four children, and they lived in a fine house on Woodlawn Avenue in Chicago, spending summers on the lake in Chautauqua.

Ralph's interest in art was inspired by visits to Italy before the First World War. He became a member of the Art Institute of Chicago in 1915 and a life member in 1917. He described how he started buying paintings: "Mrs. Norton and I moved into a new home and decided to buy some

Ralph Norton with one of his treasured violins. Undated. Photo courtesy of ANSG.

original oil paintings for decorative purposes. We had not bought any paintings before, and knew very little about what was available. After exploring the art galleries in Chicago we bought two or three landscapes." According to his daughter, Beatrice Richards, when the artworks arrived, one painting in particular didn't look at all like the one her father had

liked and bought. He telephoned the gallery and asked what they had done to it. They explained that they had cleaned it. Ralph sent it back and bought another one.

Ralph did not remain so naive for long. He soon became an avid collector—passionate, obsessed even, always searching for new works to acquire. Before long the whole house in Chicago was filled with paintings. It was when they began showing up on the walls of the bathroom that his wife told him he would have to find somewhere else to hang them all.

Later he explained his collecting strategy: "We were not partial to the paintings of any one painter, or paintings of any special type, or of any particular period. Our aim was to select pictures which gave us aesthetic satisfaction, regardless of whether they were painted by one of the old masters, or by a representative of the school of Paris, or whether the painter was an American or a European." This meant there were works by Italian, Spanish, Flemish, and Dutch Old Masters, English nineteenth-century paintings, watercolors, classical and modern sculptures, and a fine collection of Chinese jade.

Like many other prosperous, aging Midwesterners, the Nortons began turning their eyes to Florida as a retirement destination for the winter months. In 1935, when Ralph was sixty, they bought land in Palm Beach but sold it shortly afterward, preferring the less hectic social pressure of West Palm Beach—a characteristic move by this unconventional millionaire, and incomprehensible to readers of Palm Beach's social daily, known as *The Shiny Sheet*. West Palm Beach at that time was a working-class neighborhood, a cultural wasteland, separated by the inland waterway from the grand mansions of Palm Beach, many of them built by the legendary architect of Moorish and Mediterranean fantasies, Addison Mizner. Norton and his wife bought a modest lakefront house at 253 Barcelona Road, in the El Cid development that had been started in the 1920s.

Marion Sims Wyeth (a contemporary of Mizner's who also built many mansions for the rich snowbirds in Palm Beach) was brought in to redesign the house. He simplified the architecture and opened it up, adding southern-style wrought-iron verandas and porches, perhaps influenced by Elizabeth Norton's Alabama background. No "Spanish abortion" (as critics called the Mizneresque palaces in Palm Beach) for a man whose roots were so solidly Midwestern. The interior had finely detailed cypress panels with dentil moldings in the living room, which incorporated

floor-to-ceiling bookcases, and unpretentious furnishings. They kept the original 1925 floorboards and fireplaces.

Norton's first order of business was to create a home for his artworks. Most of the Palm Beach winter residents who owned art collections would not have dreamed of transporting them down to such a difficult, humid climate and then abandoning them to hot and hurricane-tormented summers while they returned north—for it must be remembered that air-conditioning was still then a rarity. Norton thought differently. He wanted all of his art in one permanent location. He would find a way to deal with any problems of weather that might arise.

The most obvious place for the Nortons' art was an extension of the Society of the Four Arts, a nonprofit arts and literature center on Royal Palm Way in Palm Beach that showed loan exhibitions and invited artists and writers down to speak during the season. But the Society's board, saddled with a large mortgage, feared the expense of building a new space without a bigger financial commitment from Norton, which he was not prepared to give. Furthermore, there was limited space for a new building, unless it encroached on the fiercely protected Four Arts garden. Finally, they felt that other collectors might be inhibited from contributing to the Four Arts exhibitions if Norton's large and eclectic collection was taking up all the air in the room, so to speak. Anyway, after much back and forth, they turned Norton's gift down.

He quickly turned elsewhere. The Palm Beach Art League, located in West Palm Beach, invited him to build on Pioneer Park, a piece of land that ran down to the inland waterway between Olive and Dixie Avenues. Working closely with Marion Sims Wyeth, now a friend after his successful remodeling of the Barcelona Road house, Norton fulfilled his dream by opening the Norton Gallery and School in 1941. He had always wanted it to be an educational as well as a cultural center, so the addition of an art school was essential to his total concept.

The white stucco gallery building, under Wyeth's and Norton's guidance, was modernist and art deco in appearance, again in striking contrast to the ornate, exuberant Spanish/Mediterranean architecture favored by Addison Mizner that seemed de rigueur elsewhere. It is a reflection of Ralph Norton's evolving taste that he selected such a plain, minimalist building to house his art. (His Memorial Hall in Chautauqua was somewhat less austere.) The interiors were large and cool, with high ceilings,

skylights, and efficient overhead lighting for the paintings. ("Better fewer exhibits than bad installation," Ralph Norton, always the engineer, once said.) In a practical—and expensive—gesture, he insisted that the galleries be air-conditioned, a radical decision at the time.

An open-air patio and sculpture garden, with colonnades and a cloister, created a focal point for the galleries and provided cooling air circulation. The patio was landscaped with four symmetrical beds planted with orange trees. A limestone fountain in the center by Wheeler Williams, (entitled, perhaps ironically, in view of its proximity to Palm Beach, *Fountain of Youth*), was commissioned for the space and installed in 1942.

To design the sculptures for the niches in the two front wings of the building, Wyeth persuaded Norton to choose Paul Manship, the perpetrator of the gilded flying object in front of Rockefeller Center in New York. Manship's work for Ralph Norton was considerably more appealing. Three bas-reliefs, *Inspiration*, *Imagination*, and *Interpretation*, and two seven-foot-high figures representing Diana and Actaeon, cast in nickel-bronze, were placed in niches on the north and south facades and at the entrance.

The art school and studios were separate from the main building, which remained accessible to students who wished to study the collection. The studios were thoughtfully designed with extensive north light and furnished by a local atelier. The museum also included a theater and music workshop, reflecting the Nortons' musical interests.

The first director of the Norton Gallery was Mary E. Aleshire, former executive director of the Society of the Four Arts and a working artist. The head of the school was J. Clinton Shepherd, another artist who had run a successful art academy in Palm Beach. (One of his murals depicting the Everglades was installed in the bar of the Clewiston Inn on Lake Okeechobee, where it can still be seen.) The gallery officially opened in February 1941, to much fanfare, with Norton's one hundred paintings and twenty pieces of sculpture on display.

In making this generous gift to the town, Norton began to transform a cultural desert into a respectable center for artistic study. Not that it was easy. In the early years, in spite of the director's efforts, there was a defensive aspect to the institution's relationship with the public. The difficulty was that its location was not conducive to the serious study of anything, let alone the arts. Just over the bridge shimmered the hugely rich and glamorous resort of Palm Beach, which for roughly five months of the

year offered a nonstop round of parties, benefits, and balls. For the rest of the year it was deserted, except for the scores of mostly Hispanic gardeners who invaded the town to restore, replant, and prune their clients' gardens in time for the next season.

The unique marketing angle that the Norton Gallery could promote was its permanence. While the Society of the Four Arts had seasonal exhibitions, Norton's collection was open for visitors all year round. In a statement, E. Robert Hunter, who became director of the Gallery in 1943, emphasized the value of what Norton had done: "Students and public alike have the metropolitan advantage of being able to study not only the well-balanced group of exhibitions which is presented each year by the Norton Gallery and by the Society of the Four Arts in Palm Beach, but they also have the unparalleled advantage of having the Norton Collection at hand every day of the year."

So this in brief is the story behind the Norton Gallery where Ann Weaver was to take up her post as sculpture teacher. On December 15, 1942, Mrs. Aleshire sent out a press release announcing that Ann Vaughan [*sic*] Weaver, "nationally known sculptor of New York and Newport," had joined the faculty and would be teaching sculpture, wood and stone carving, and life drawing in both class and private instruction. Her duties were to teach Mondays, Wednesdays, and Fridays from 10 A.M. to noon; hold life-drawing classes most Tuesdays and Thursdays from 10 A.M. to noon; and teach Friday afternoon from 2 P.M. to 4 P.M.

This was a fairly heavy daily schedule. For the first time, Ann was working to a timetable with an employer. Even Aunt Clara might have been impressed. Annie Vaughan Weaver had come a very long way from Selma.

In many ways the Norton appointment was a good one. Since there had not yet been a teacher specifically for sculpture at the school, Ann could carve out, so to speak, her own destiny, inventing her duties and responsibilities as she went along, without having to follow any previous set of rules. Her teaching load left her some time to do her own work, a critical condition for her. She was able to work on her sculpture in the studio after the students had gone home.

Ann's biggest challenge in those early months was how to get her students to take her seriously. She was small, soft-spoken with her southern accent, and lacked the confidence of an experienced teacher. But she was thirty-seven years old and had fourteen grueling years of the New York art world at her back. And she was nothing if not determined. She began to

assert her authority immediately, becoming a stern taskmaster, proclaiming to her students that sculpture was the greatest discipline in the fine arts and that the goal was to "get it right." She promoted direct carving as the ideal, indeed essential, method of sculpture production, and remembering her own lessons, encouraged her classes to study Michelangelo's work, for instance, as well as working from live studio models.

As is usual when one starts a new job, the first few months were the worst. She was lonely and anxious about finding time to do her work. She had never taught before. She had never been to Florida before. Everything was new and strange. Moreover, the atmosphere at the school was poisonous, rife with personnel problems with which Ann had little experience. Her direct boss was J. Clinton Shepherd, who had his own agenda as an artist. He had an extremely tense relationship with Mrs. Aleshire—a question of two directors battling egos. According to E. Robert Hunter (who replaced Mrs. Aleshire as director in 1943), Shepherd was not pleased with the appointment of Ann Weaver. It's not clear why. Perhaps he felt his turf was further threatened by this new sculpture teacher showing up from New York. Grievances quickly accelerated. Hunter called the scene a "snake pit." In 1943, soon after Ann's arrival, Mrs. Aleshire resigned "to pursue other interests," and a year later Shepherd, no doubt to Ann's relief, also departed.

By the greatest good fortune, during this unsettled time Ann came to the notice of Robert Hunter, the new director, who arrived like a deus ex machina in 1943 and by the end of the year was the most important person at the Norton. Hunter (1909–2011) was Canadian, with a strong background in art. His grandfather helped found three of Canada's great art institutions, including the National Gallery of Canada in Ottawa. Hunter studied at the Courtauld Institute in London and then gravitated to the Art Institute of Chicago, where a friend pointed him to the position at the Norton Gallery.

He was young, dashing, enthusiastic, and an experienced art historian and connoisseur. He knew the Chicago art scene well. Ralph Norton immediately took to him. Before long Hunter began ruthlessly pruning the collection, getting rid of the duds and adding new and important works acquired from dealers all over the world. Norton was delighted with Hunter's taste, judgment, and confident decision-making, and they quickly created an exceptional partnership of mutual respect and passion

Ann at home in West Palm Beach, late 1960s, unusually dressed up. Photo courtesy of Lane Weaver Byrd.

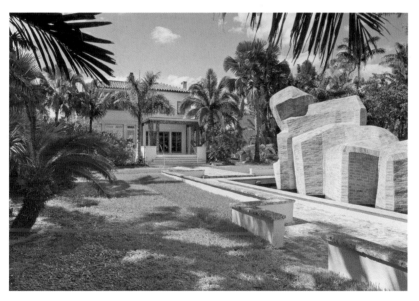

The Barcelona Road house, 1970, with Ann's untitled sculpture, made with hand-made Mexican brick in the former forty-seven-foot-long swimming pool. Photo courtesy of ANSG.

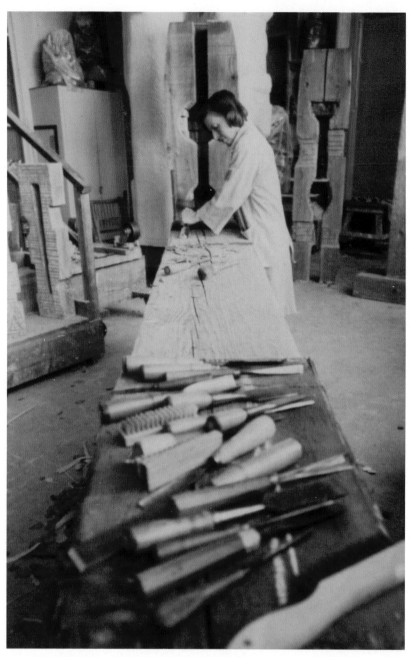

Ann at work carving with a chisel in her studio. Photo courtesy of ANSG.

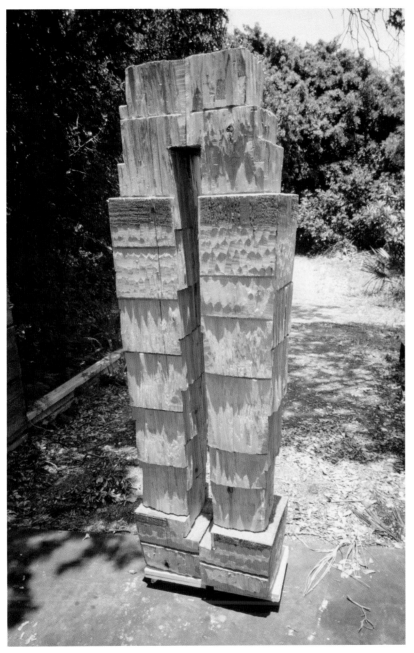

Gateway, c. 1974, northern cedar (18' high), the sculptor's chisel in evidence. Photo courtesy of ANSG.

Four examples of Ann's increasingly abstract charcoal and pastel drawings. All from the *Tibetan* series, 1960s to 1980. Photos courtesy of ANSG.

Four untitiled works demonstrating how Ann's experiments with color in watercolor, pastel, and charcoal increased in complexity between 1960 and 1980, while her figurative works on paper remained wonderfully direct. Photos courtesy of ANSG.

A splendid example of Ann's modern style in figurative work, 1970s. Photo courtesy of ANSG.

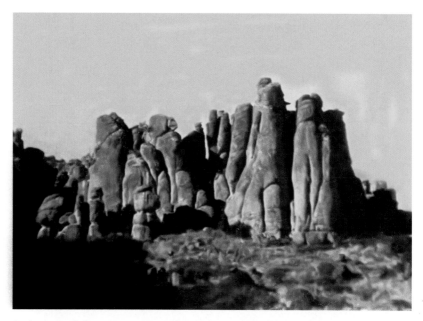

A photograph found in Ann's papers of Bryce Canyon, Utah. Photo courtesy of ANSG.

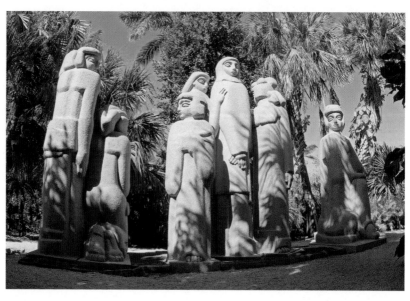

Seven Beings, 1965, pink Norwegian granite (12' high). Inspired in part by her experiences in the Southwest. Photo courtesy of ANSG.

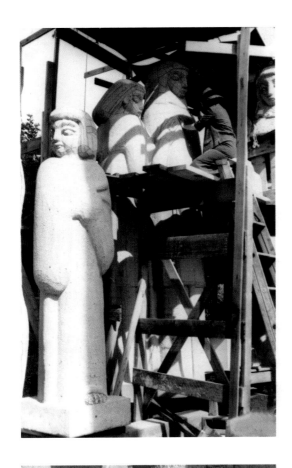

The diminutive artist perched atop a ladder working at one of her monumental figures. Photo courtesy of Lynn Leofanti Cole.

Every detail of Ann's work is animated by her monumental vision. Photo courtesy of ANSG.

Gene Leofanti with Ann's posthumous masterpiece, *Gateway to Knowledge*, c. 1984, Boston brick (20' high), from the original in Brattle Square. Photo courtesy of Lynn Leofanti Cole.

Gateway No. 4, 1975, hand-made North Carolina brick (20' high). Photo courtesy of ANSG.

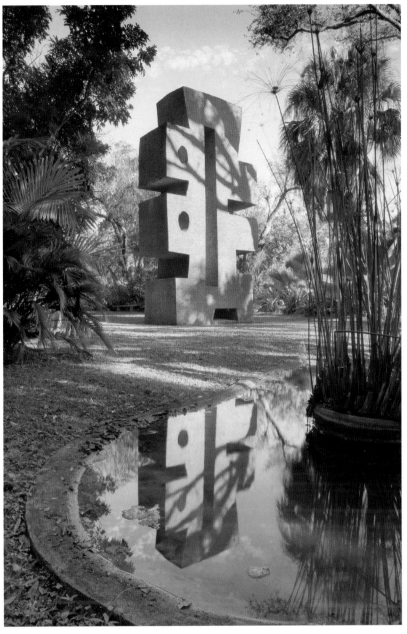

Gateway No. 5, 1977, handmade North Carolina brick (20' high). Photo by Jim Fairman.

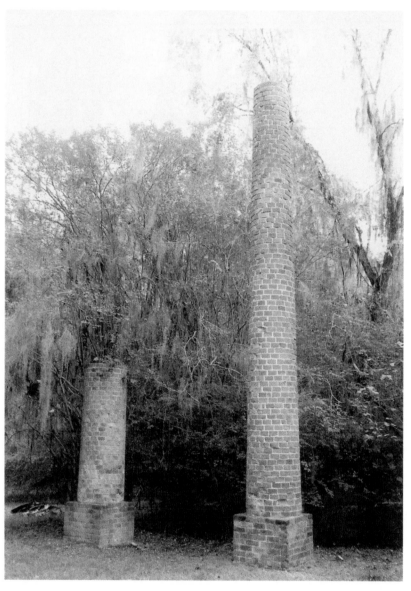

The ruined brick towers of Crocheron Hall in Cahawba, Alabama, near Ann's childhood home in Selma. Photo by Caroline Seebohm.

for art. Robert Hunter always said Ralph was a good picker, whether it was a nineteenth-century English landscape or a Braque.

Hunter took Ann Weaver under his wing. He could see that she was uncertain and shy in her new role and that her negative exposures to Shepherd at the start were not making it easy for her to adapt to this alien and uncomfortable environment. The new director of the school was a big improvement—Eric Lundgren, who was an artist, art director of *Esquire* magazine, and a friend of Hunter's from Chicago. Hunter's wife, Frances, was not only southern but came from Montgomery, Alabama, which created another bond. "Ann used to come to our house to rest," Hunter remembered. "She'd sneak over at weekends and stay in our guest room. She was very quiet. Sometimes we didn't even know she was there."

Hunter sensed how lonely she was. "She was intellectually a shade above the average," he recalled. "It was difficult for her to find a buddy. Just as it was difficult to get anyone to go to the museum." (This of course was Norton's most challenging issue—how to get people across the bridge.) Ann's loneliness was compounded by the fact that, thanks to the war, her closest friends were now dispersed. Both John Lapsley and Crawford Gillis were drafted in 1941. Gillis went overseas in 1942 and at the end of the war was awarded the Bronze Star. Lapsley was inducted into the U.S. Army Air Force and remained in the United States for the duration of the war.

The continuing hostilities overseas must have increased Ann's sense of unreality and isolation. She wrote many letters to Gillis and Lapsley during her first few years in Florida. They are full of terse observations. "People at beach generally. I haven't even been." She describes to Lapsley a visit to the home of one of her rich students. "I lunched in the imitation Italian palace with many patios, private swimming pool, etc, etc. These places are exactly like you would imagine—lots of display—little beauty." She goes further: "They had a right nice Sir Joshua over the mantel and 2 quite lovely Mexican (Colonial) religious figurines. . . . Potted orchids all over the place—small Murillo Madonna (not good even for Murillo). The chief charm (outside the two figurines) were the grand swimming pool (wouldn't you and me enjoy it) in the patio and the glorious ocean in the front yard."

She describes another pupil, "a lady with beautiful gray hair—coarse and wavy—and she always looks like a Dresden piece. Does good sculpture

too for someone who never knew 'art' before in any way." Later she writes, "Not quite so lonesome now because 2 of the office people (women) are friendly and we go to a movie every weekend almost."

But in most of the letters she makes desperate pleas for them to visit. "Your letters hungrily devoured," she writes to Lapsley. "I'm like in a desert, and these morsels and jugs of water are thrown to me." She says she could put him up in her house for $15 a week. "How I long for good music," she sighs. "Write and come." To Crawford Gillis she is equally candid. "There is nothing here but money and water and a few palm trees and cheap homes (great & small)," she complains. "Come on down as soon as you can. Tell Uncle Sam you has to have a res! [*sic*]" Or, "These folks are lovely to me but whenever I'm out with 2 of them (women) they talk to each other and just sort of dismiss me. So don't *fail* to come pull-ease." Or, "Your letters are grand. *When* are you coming down here?" She wants them both at her side. "Am starved for good music and good companionship. How I miss our good old times." When Lapsley agrees to visit, she writes to Gillis: "Only wish you were here to join us. Reunions are never complete without the third member."

Ade was not quite lost to her. In the summer of 1944 Ann went with Ade to Vermont, accompanied by John Howard Benson and Graham Carey, and she described the trip to Gillis in lyrical terms: "It was wonderful to my soul. Rolling country, wooded hills—pastures—sheep, cows, apple orchards. Ade and I wandering over them helping gather the fruit and just 'taking it in'—lying down on the ground—the good ground. How different from resorty Florida." Of all Ann's letters that survive to or about Ade, this is by far the most affecting. That year she also went to Newport for a while and then on to New York.

She started making a few valuable connections in Palm Beach. One was a student of hers, Ouida George, who went on to become a well-known artist. Ouida described Ann as "a little person but a powerful teacher." Ouida looked up to her, recognizing in her an experienced, committed artist, with a great deal of knowledge about other artists that Ouida could learn from. "She admired Gaudier-Brzeska and José de Creeft very much," Ouida remembered. Ann and her pupil would sometimes venture out together. "The other students were mere Palm Beach ladies," Ouida said. "We would go to the circus when it came to town and make drawings. She was drawing all the time." Ouida was a far more extrovert, flamboyant person than Ann was. At one time she had a cockatiel, which Ann loved.

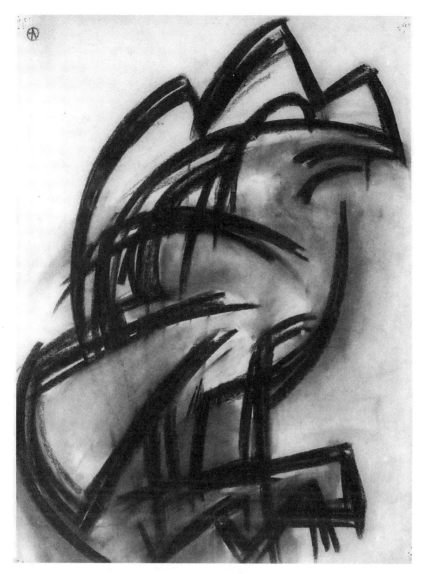

Charcoal drawing, 1939, probably a preparatory sketch for her sculpture, *Rooster*. Photo courtesy of ANSG.

Ouida's art was very different from Ann's—it was all about color and light, and she moved on to a successful career painting lavishly colored flowers, children, and society portraits.

Of course, for Ann the work came first. Once she had settled in, she didn't waste a minute in getting back to her sculpture. She told John

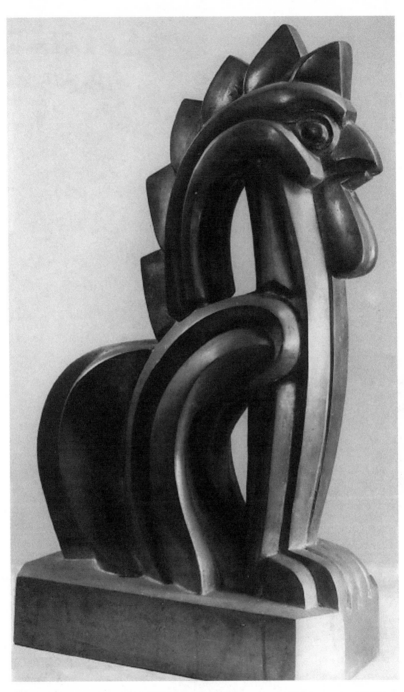

Rooster, 1943, bronze (18" × 11" × 6"), winner of the twenty-fifth annual exhibition of the Palm Beach Art League. Photo courtesy of ANSG.

Lapsley that she was working on a rooster called Roscoe and other works but added that she kept them hidden from her students, worrying about getting a bad reputation at the school for her "modernism." "Keep them covered," she told Lapsley. "Don't want the authorities here to discover them." She knew well enough that outside of New York, her work might be regarded as provocative or worse.

Two months after her arrival, she finished *Roscoe* (also known as *Rooster*) and entered it into the 25th Annual exhibition of the Palm Beach Art League, where it won the sculpture prize, about which she was modest. "Had no competition to speak of," she admitted to Lapsley. (She was probably right. The other competitors were mostly amateur members of the League.) But she was glad of the prize money—$75. "Now I can pay off my debts and get a cotton dress or 2."

This small success was very significant. *Roscoe* is a wonderful bird, lyrically formed in waves and curves of polished bronze, with sweeping art deco lines that are a little reminiscent of her *Memorial Monument*. It shows Ann's growing confidence in the material and her developing sense of line and proportion. She had made many sketches of the bird, and they also show increasing skill. This local award gave Ann a sense that she could really produce good work in Florida and become an accepted artist not only in the eyes of the world but also in her own.

10

A Reticent Romance

WHEN ANN ARRIVED TO TEACH at the Norton School in 1943, Ralph Norton had already added to the Gallery's holdings, buying, among other lesser-known works, a Courbet, a Childe Hassam, a Gauguin, a Joshua Reynolds, and a sculpture by José de Creeft. He also built two new galleries (without air-conditioning) to house the expanding collection, including a remarkable collection of Chinese jade that had just arrived.

Ralph Norton acquired the jade through one of those chance encounters that lead to a sensational result. In 1942, he met Stanley Charles Nott, an English dealer in Chinese jade. For $150,000, Norton, not heretofore particularly interested in Chinese antiques but encouraged by Robert Hunter, acquired a large collection of Nott's finest jade carvings, most of it from the seventeenth and eighteenth centuries. He built a special gallery to house the pieces. He said later he wanted to exhibit in this new Chinese Room, "in groups which would be small but of the highest quality, most of the things for which the Chinese were famous." These purchases came to be regarded by connoisseurs as one of Ralph Norton's most brilliant acquisitions.

Robert Hunter's influence was omnipresent; Norton's acquisitions after his arrival became more modern and adventurous. Hunter also brought in traveling exhibitions, including several from the Museum of Modern Art in New York. "Mr. Norton had a good grasp of what painting and sculpture were all about," he said, "and it is to our eternal good fortune

that he never followed the inbred and myopic 'popular' types of art that all seem to derive from colored photographs or sentimental illustrations."

In the first years after the Gallery's opening, the Nortons still spent much of their time in Chautauqua, where in 1945–46 Ralph was president. They would go regularly to Chicago for business meetings and also take the train to New York to visit art dealers. But Elizabeth Norton became increasingly ill at this time, and by 1945 she was often unable to travel with her husband.

It was sometime after Ann's arrival in West Palm Beach that Ralph began to get to know her. Perhaps he noticed this diminutive figure, so serious and dedicated, working away in her studio when the students had gone home. He began to sit in on her classes, finding out about direct carving (about which he knew nothing) and the art Ann cared about (about which he knew very little). The relationship rapidly developed.

By July 1946, Ralph was writing to Ann from Chicago about her vacation visit to Selma, addressing her as "Ann." He tells her that he plans to be in New York in September and that it would be interesting for them both to visit some of the art galleries. "I am sure you would enjoy it."

By this time it sometimes happened that if Ralph was in New York, Ann would be in town to visit the Basky foundry, and they would sometimes arrange to see each other. When they were in New York together, they usually spent some time visiting dealers with Ralph's friend William McKim. McKim was exhibition chairman of the Society of the Four Arts in Palm Beach at the time and a major promoter of contemporary art. (He greatly admired Alfred H. Barr Jr., the first director of the Museum of Modern Art.) McKim was another big influence in bringing Ralph into the modern era. Not surprisingly, when Ralph introduced Ann to him, Ann and McKim found much to talk about, and they became fast friends.

Ann immediately realized how helpful McKim could be professionally. She wrote to Crawford Gillis in 1945, while he was still fighting overseas, suggesting that when the war was over he get in touch with McKim, because McKim could help him find a dealer for his work. "I know that seems very remote and trivial now," she wrote to him, "but when you get back in the art world these things count." Ann also asked McKim to take John Lapsley's work around the United States.

Ann was always loyal, looking out for her friends' interests. She was also loyal to her most influential teacher, John Hovannes, hoping to get him to Selma to meet her two friends and their more well-known ally

from the disbanded New South School, Charles Shannon. She believed Hovannes would find good material in the local life of rural Alabama. (It's not clear whether Hovannes ever got there.)

The letters between Ann and Ralph began to intensify as they learned more about each other's artistic tastes. Ann was never shy about expressing her opinion of other artists. After visiting a show at the Society of the Four Arts entitled *Americans 1942* (originally organized by the Museum of Modern Art), she described her responses in no uncertain terms to Lapsley and Gillis. "I can't see Francis Chapin [a landscape and figure painter]. Can you sell me on him? So veddy dull." She was equally scornful of Fletcher Martin, whose work graced the pages of *Life* magazine. About Morris Graves, she said, "I think Morris Graves is cuckoo—I mean his paintings with a few exceptions are repulsive."

Her feelings about representational art, and in particular Social Realism, had coalesced into a general hostility, and she openly disparaged the American "half-baked" painters who espoused it, accusing them of being little more than "illustrators," a hot-button word she had so determinedly erased for herself as a children's book author. She lumped together in this category a score of others including John Steuart Curry and Thomas Hart Benton—"all that Lucky Strike crowd," she called them. She gave grudging credit to Gustave Courbet, "too academic, good but not great," and also to John Singer Sargent, remarking shrewdly if bitterly, "the virtuoso always gets the applause." Of course she admired the latest de Creeft sculpture—a head of Rachmaninoff.

These outspoken, uncompromising opinions about art intrigued Ralph Norton enormously. He would write to her about what he had seen, and what he might buy, seeing how she might respond. He admired, for instance, a brass Brancusi he saw at the Pierre Matisse Gallery, which he knew she'd like, but "his best gallery price was $7,500 which puts it entirely out of the running." (He was later to buy a Brancusi, one of the finest sculptures in his collection, *Mademoiselle Pogany II*.)

The dialogue between the two art-lovers often became quite contentious. In a letter, she urges him to consider a Gaudier-Brzeska work. "Gaudier was one of the pioneers in the modern movement," she tells him, professor-like. "He, Maillol, Lehmbruck, Epstein, Brancusi, Archipenko, were the most influential sculptors during those years 1910–1920."

"I am interested in your enthusiasm about the Gaudier sculpture of the *Two Stags*," he replies. "I saw it again in Mr. Lustgarten's house about a

month ago, and did not care for it any more than I had before." However, he does not hold this against her. He tells her he is having trouble in the handling of *Mid-Summer*, a very large sculpture by Brenda Putnam that was to be transported to West Palm Beach. Admitting that it might be too representational for Ann, he adds with a twinkle, "I am thinking of putting you in charge of this job as chief engineer."

Discussions of art dominate their correspondence. She insists he must spend more time in New York. "New York is the capital of the art world, and it would be grand for you to see the Modern Museum and the best galleries." (How revealing of his personal taste that he had not yet once visited the Museum of Modern Art.) She adds teasingly, "We won't let them know who you are unless you wish it."

Ralph gradually became emboldened enough to make pithy references to her own work. "I am glad you have gotten the casualty series out of your system," he wrote to her in July 1946, "although I shall be glad to see the last one when it is all done."

There is no mistaking the cozy, intimate tone of these letters. It is both affectionate and respectful, candid and carefree. Ralph Norton is enjoying himself.

Ann's letters to Ralph are more cautious: in 1946 she is still addressing him as "Mr. Norton," and writes carefully, "I have thought of you and Mrs. Norton many times this summer." She suggests Mrs. Norton should also come to New York to join them. "She would get a kick out of it I know, and we could go easy so she wouldn't get tired."

In a later letter, postmarked from Newport, she tells him she couldn't find a hotel room in New York and had to stay in a convent, arranged by Ade. "I had never seen the inside of a convent before and not being a Catholic I was afraid of making a blunder," she tells him. Ralph loves this. "I was much interested in your winding up in a convent and hope none of those nuns have sold you on the idea of staying there because you know we have to teach sculpture down in the Norton School of Art." He then adds, "I am sure there would be no danger of the nuns taking you on if they could be present at some of the sessions in your classes. You know what I mean."

What did he mean? Fortunately for us, a young man who attended Ann's sculpture class wrote down his experiences in a letter to a friend: "One time she had me come in and copy castings of parts of Michelangelo's *David*'s nose and eyes using clay. In the same studio was a lady

working on a sculpture of a nude. The nude model was the sexiest redhead I had ever seen. It was all I could do to work on my boring project. I suspect that Ann, my instructor, the young lady artist, and the model had set this up to see what effect it would have." No doubt Ralph had also been exposed, as it were, to these stimulating sessions in Ann's studio.

In the same letter about the nuns, Ralph tells her that he has bought three paintings in New York—one by Braque, one by Rouault, and one by Bellows. Ann is thrilled. "I just can't take it in that 'we' have now a Rouault, a Braque and a Bellows." She explains to him that she has re-ordered Ralph's list of the artists intentionally, and added the underlines, to indicate how she rates these artists. This letter is particularly interesting in that for the first time Ann lets down her guard—no shrinking violet here. The "we"—although she puts it in protective quotation marks—reveals a striking admission of how far they have come in their relationship. Like Ralph, Ann is enjoying herself.

In 1946 and 1947, Ann regularly met Ralph in New York. He was usually accompanied by Robert Hunter, who was on hand to help him scout for acquisitions. They would meet up with the other member of this merry group, William McKim, and all four would have dinner in the city arguing furiously about art, "going at it hammer and tongs," in Hunter's words. In this company Ann was just as outspoken about her opinions as were her companions, and Robert Hunter usually supported her views. "Ann and I belonged to the Roger Fry generation," he said later. "We despised the figurative school of art. We called it 'Love me, Love my dog' art. It was art that escaped us."

By this time, the war had ended, and the mood of the country was, like the mood of these friends, uplifted by the notion of peace and prosperity. Ralph Norton loved Ann's independence of spirit and feisty approach to art. He was delighted by her radical views and raw intelligence. He was still an active, energetic man. He had been a yachtsman and golfer and only gave up the sports because he suffered increasingly from migraine headaches. Art collecting had become a way for him to develop a new and challenging interest that was less physically demanding, and Ann opened his eyes and mind to new ideas about the paintings and sculptures he was looking at. "Once she brought him a big book on Paul Klee," Hunter recalled. "Ralph looked through it with non-committal remarks, then wound up with three of them."

Through 1946 the letters become more substantive. Concerning the

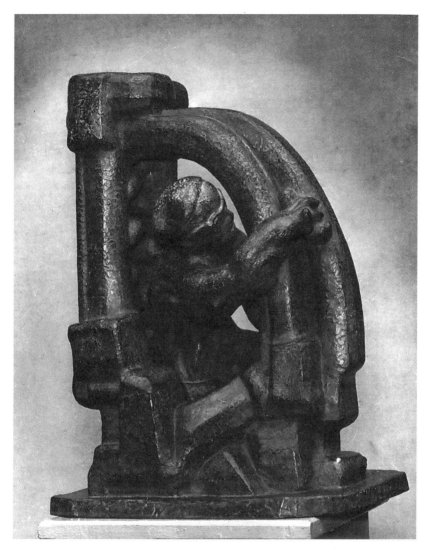

Man and Machine, c. 1947, bronze. The striking vertical and arched lines prefigure Norton's later work. Photo courtesy of ANSG.

search for a new art teacher for the school (difficult, not least because it was such an out-of-the-way place for an ambitious artist), Ann tells Ralph the new one would have a lot to contend with, inheriting so many pupils from the former instructor, all of whom were on the wrong track. "It's harder to deal with pupils who have been taught wrong than with brand new people who don't have any prejudices."

Perhaps the most material confirmation of Ralph's interest was through his pocketbook. In 1945, he began buying Ann Weaver's work. First, *Casualties I (Mother and Child)*, for which he paid $1,000. ("Profit: $447" Ann wrote proudly in her meticulously documented expenses notebook.) In 1947 he bought her *Machine I and II* ("profit: $1,367") and *Casualties IV* ("profit: $829"). These prices were perhaps a little on the high side for a little-known artist, but he was happy to pay them. By 1947 he was slipping her the odd check in addition to making these purchases, ostensibly to cover her expenses for the bronze castings that cost her so much. He was touched to see that that the money he gave her went straight back into the work and the foundry. ("I hope to show you two new bronzes—made possible by you," she wrote.)

Ralph, increasingly lonely without the company of his invalid wife, spent more and more time with Ann in her studio, watching her chisel and hammer, eagerly talking to her, fascinated by this small woman with a southern accent and large ambitions, Alabama-born just like his wife, yet so different.

He discovered that as well as art, he and Ann shared a deep interest in music. Ann was very impressed with a Stradivarius violin that Ralph owned and of which he was very proud (in 1945 he had sold a Guarneri violin to Isaac Stern), and they began listening to music together on records and discussing it with the same intensity as they discussed art.

In early March 1947, Elizabeth Norton had a stroke, and on March 17, she died. Just over a year later, Ralph Norton asked Ann Weaver to marry him.

11

Marriage and
a New Life

RALPH NORTON PROPOSED to Ann on the afternoon of April 11, 1948. Almost immediately afterward, she rushed over to the Hunters' house to tell them. "She was white as a sheet," Robert Hunter remembered. "I told her, 'Say yes quickly before he changes his mind!'"

Ann did not take his advice. The momentousness of Ralph's proposal was too overwhelming for any such rush to judgment. She started running a fever. She could not sleep. She began praying to God. She summoned her mother from Selma to come to her side as soon as she could. Ann's whole world had taken an astonishing turn, and she would need all the advice and support she could get to make the decision asked of her.

Ann was not quite forty-three years old when Ralph proposed. He was seventy-two, almost exactly thirty years older. That, however, was the least of her worries.

After he asked her to marry him, Ralph left almost immediately for his home in Chicago. As soon as he arrived, he wrote her a letter that replayed some of their conversation on the afternoon of the proposal. This letter is one of many that he and Ann wrote to each other during the whirlwind courtship, a poignant and fascinating documentation of a remarkable couple struggling to come together. He admitted his own impetuosity. "I really was not definite about it in my own mind till a day or so before I left. When I realized how I felt toward you, and have come to the conclusion that we could make each other happy, I just could not wait to tell you about it. And then we had that wonderful afternoon together."

Portrait of Ann at the time of her engagement to Ralph Norton, c. 1948. Photo courtesy of ANSG.

Ralph goes on to remind her of the telephone call she made to him after he had left, reassuring him that she was very happy and "don't worry, it is going to be all right."

But Ann at this point was not at all sure that it was going to be all right. Although she had surely seen the way the wind was blowing in the previous two years, with his constant attentions, his purchases of her work, and his generous support, the idea of marriage was probably far from her mind, and marriage to him almost too remote to contemplate. She wanted more time before she made a definite commitment. She wanted advice from her mother, and, consistent with her religious history, she wanted guidance from "the Lord."

Ralph's response to her resistance was characteristically practical and brisk: "Under the new tax law, if you marry me, it will save us about twenty thousand dollars a year in taxes. You are doubtless a good mathematician and if you get out your pencil you will find that every day we don't get married costs us about sixty dollars. Under the circumstances, perhaps you and the Lord would be willing to put in a little overtime on the job."

At the end he wonders whether he has been writing her a love letter. "It might seem so. I haven't done that for a long time and am a little out of practice."

Ralph had no doubts about his decision. He was completely infatuated by Ann and wanted to have the marriage as soon as possible. He wrote again from Chicago: "You told me you loved me, and once you said, 'I adore you.' I suppose that is a little stronger word. What you said reminded me of the couplet in French: 'Je vous aime—je vous adore, Que voulez-vous encore?' And if you were asking me that question, the answer would be, nothing, nothing at all!"

For Ann, the struggle was only just beginning. She responded that same night:

My dearest, you told me not to write unless I had reached a definite decision and I am disobeying. It is all so stupendous and completely unforeseen (certainly no lead-up on your part). I have hardly slept or eaten at all since you left (and will probably be so thin and haggard when you return that you will hasten to call the whole thing off!) In fact I've been running a little fever too which however has acted as a stimulant and kept me going. I list these not because they are at all

interesting but they might show you that I am not taking the matter lightly.

First let me say simply that I love you deeply and want to become your wife. Also that I have prayed and prayed to God and the answer comes thundering so clearly: "Go ahead, you must accept—I will take care of the doubts and fears."

God may have told her to go ahead, but at this point she was not quite willing to accept His suggestion. She was waiting for her Selma reinforcements and less heaven-sent but perhaps more realistic counsel.

Ann's mother and a close family friend, Grace Jones, prepared at once to leave Selma together in response to Ann's urgent call, but since Ralph's proposal was a deathly secret, the two women had to make the hurried journey from Selma to West Palm Beach without explaining why—an extremely difficult proposition in a small town like Selma. They were finally hustled onto the train after cloak-and-dagger efforts at concealment by Ann's old friend Crawford Gillis.

So Ann kept Ralph hanging, the Lord notwithstanding. Ralph grew impatient, even though it had been only days since he had popped the question. "Apparently you expect to get advice from your mother and your friend," he wrote a little testily. "That makes four, working on the problem; you and the Lord, your mother and your friend. There might be a deadlock, two to two. In that case, I will step in and decide it."

But she wouldn't quite commit. "I still cannot complete the step with a definite final 'yes,'" she wrote to him, anguished.

Why not? Knowing Ann as we do at this point, we can only assume that her most basic fear was that marriage would interfere with her work. She knew how busy a life Ralph led, with his responsibilities in Chicago and Chautauqua and his social commitments connected to the Norton Gallery of Art. The Palm Beach set was already in an uproar. Once again Ralph Norton had rocked the little island: all those rich widows, whose hopes had become fixed on this charming if reclusive Midwestern millionaire, suddenly so tantalizingly single, were now disappointed. Once again he had shunned the sparkling jewels and purring Rolls-Royces that gleamed so seductively in the Florida sunshine. For whom? Did anybody really know? A sculpture teacher from Selma, Alabama? Surely not.

Ann knew well the pressures of the wealthy ghetto across the waterway.

Would she have to be a society wife, going to parties on his arm, opening fetes and generally being Mrs. Ralph Norton? He was a member of the Everglades Club, the Bath and Tennis Club, the University Club, and the Union League of Chicago. She had spent most of her life on the thankless, stony path of the artist, a member of no clubs except the club of poverty. This was the direction she had chosen, and she was not going to veer from it. No compromise was possible. "If you are willing to take an artist for your wife and one like me then I am yours," she wrote, "gladly yours."

Ralph seized the bait and responded without hesitation: "About your work. I would never have asked you to marry me if I had thot [*sic*] it would be detrimental to your progress as a sculptor. Your devotion to your work, and the sacrifices you have made to carry it on, have been an inspiration to me. I feel sure that our proposed new life would make it much easier for you."

Well said, Ralph. It hit the spot. Ann was impressed.

"I think you instinctively feel the need for the freedom and simplicity that an artist has to have," she told him, "and I know you will protect me so that my work can go on even better than before." But she was still uncertain—of him as well. The social and financial distance between them seemed insurmountable. Her insecurity was almost palpable as she wrote, "When you come back we can talk over the things we omitted last time—and if you get cold feet at any time you can withdraw!"

He continued to reassure her. "I have wondered whether you might have the idea that an opinionated and argumentative husband would be a millstone around your neck in doing your sculptural work. He might be inclined to inject himself into the development of your pieces. You might feel obliged to show him your little sketches—if he were your husband—before you wanted. Well, if you do have any such apprehension, please set it aside. I believe the best works of art are the brain-children of only one individual."

He also sensed her anxiety about the social consequences for her if she married him. He told her he had no time for the cocktail party circuit. "I do not like it and avoid it if I can." When she told him in no uncertain terms, "I can't do society," he responded, "I don't do that either." Certainly she would know that was true from observing him for five years. Those Palm Beach widows were no threat. (Much later, after Ralph's death, *Town & Country* magazine published a list of the wealthy—and available—widows

of Palm Beach. Ann Norton was one, although the article conceded, "Mrs. Norton is rarely seen at social functions." The fact that she was listed at all made Ann furious.)

Sometimes Ralph found the strain of Ann's continued doubts to be almost unbearably frustrating. He knew that time's winged chariot, for him, was hurrying ever nearer. He still had passion and energy and desired desperately to exercise them while he still could. In a wonderful aside, he tells her he is going to a Chicago Symphony Orchestra concert under the baton of their new conductor Artur Rodzinski. The program included the Love-Death theme from Wagner's *Tristan and Isolde*. "There is going to be a Norton love-death," he warns her.

But gradually the wrinkles were ironed out. Gradually the idea of marrying Ralph seemed possible. Gradually Ann came to believe that she could do it and that it would work. "Relax and know that I love you and that you are the only man in the world I have ever said that to." She added rather flirtatiously that others had wanted her before he knew her. Ralph retaliated by describing "three eligible widows on the loose in Chicago" who were after him, but after listing their flaws in witty and meticulous detail, he told her cheerfully they had no hope.

These almost daily exchanges show in endearing detail how Ralph ultimately won his reluctant bride. "I am sorry to have been so unromantic in my courtship," he wrote to her shortly before the marriage. "Perhaps my age and business training can be used as excuses." In fact Ralph's daily letters helped his cause almost more than anything else—certainly more than the money, which only began to enter into the dialogue after she had agreed to marry him. It was probably one small remark Ralph made to her that finally swung the balance. "When I saw you had such devotion to your work," he wrote to her, "I thought I might have a little bit of that devotion."

Such a cri de coeur would have melted the hardest heart. It melted Ann's; she never forgot it. When she quoted Ralph's words to a newspaper reporter twenty years later, she drew a deep breath afterward and said, "That you can put down."

She sent her breathlessly awaited acceptance telegram to Mr. Norton at the Union League Club of Chicago on April 18, 1948. It was typically coded and obfuscating. "THE WORK WE DISCUSSED LAST SATURDAY HAS BEEN COMPLETED IN THE WAY YOU WISH IT LETTER

FOLLOWS = THE SCULPTURE DEPARTMENT NORTON ART GAL-
LERY." An unusual acceptance of a marriage proposal, to say the least. But
nothing about the courtship had been ordinary.

Ralph didn't care. The countdown to the wedding was about to begin.

First of all, they decided it had to be kept secret until Ralph's children were
told. Ann was actually more worried about Ralph's loyal servants in Chi-
cago, for whom this would be as major a disruption to the household as
an earthquake. ("Will they like me?" she asked.) Ralph, humoring her, as-
sumed Sherlock Holmes mode and suggested she write to him disguising
her handwriting and refraining from putting her name on the envelopes.

Then there were the decisions about announcements, which caused an
inordinate amount of discussion. Ann told him that if he wanted to send
out announcements, then it was up to him. She told him she didn't want
any for herself since she had only about twelve close friends. He told her
that the McKims thought it was a good idea, but if she didn't think so,
then whose initials should go on the announcements? Ralph found all this
fussing quite lovable. "I think the bride's wishes should prevail," he told
her. "She is the important one at the wedding. Of course the groom has to
be there, but he doesn't count for much."

What about the wedding presents? Ann shrank at the thought of ex-
pensively wrapped boxes of silver and china arriving from Tiffany's and
Saks. She asked Ralph if they might ask guests to create scholarships in
lieu of presents. Whoever in Palm Beach had ever heard of such a thing!
Ralph gently pointed out the impracticability of such an idea, and she
apologized. "Don't pay any attention to most of my ideas (foolish ones.)"

Ann also had to think about her wardrobe, a subject that was almost
entirely unfamiliar to her. She expressed her doubts and confusion about
what to buy. "I don't want to spend so much on the clothes and just the
barest essentials—underwear, shoes and a few dresses and coats. . . .
Mother and Grace are such a help."

Later she told him her shopping list: "a small case for cosmetics, very
cute. . . . Hat box. The two together cost $46.18, I believe. Boxes for stock-
ings, handkerchiefs, new rims for my dark glasses so the lens wouldn't
always be falling out like they did that Sat. at your house." Ralph offered to
help her pick out her clothes, knowing she would refuse. He knew his girl
pretty well by now. A year earlier he had offered to send her a mechanical

chipper for a difficult piece of sculpture. "I am making this brash state-ment because I know you will not want me to do it."

Ann was equally worried about buying a wedding dress, seeing gown after gown, most of which were ugly and expensive. She shopped all day in Miami. "I am trying so hard to find a dress to be married in so you won't be ashamed of me—but all look junky. I bought a pretty coat for $75!"

"Please be a good girl," Ralph urged her, "and don't economize too much. The need for that is over. . . . Do what you want, without regard to the expense of it." What delightful advice! Imagine having to encourage your wife-to-be to spend more money!

Ralph had by this time spelled out the financial rewards he was bestow-ing upon her, so she would have some idea of what was coming. This was one of the most businesslike letters he ever wrote to her.

"I gave some thought this morning to the ante-nuptial agreement that I spoke to you about. I know you would trust me to see that you were properly provided for after my death but you ought to know something definite about it."

Ralph's plan was to leave a trust for Ann's benefit in the sum of $350,000, to be managed by his bank in Chicago. (This was not so huge, but he had four children also to take care of.) She would get the income from this after his death, which he estimated would be roughly $12,500 a year—something over $80,000 in 2010 dollars.

He then continued, "You could make a will disposing of $100,000 worth of the trust in whatever way you liked. The other $250,000 would go, at your death, into a new trust, which I'm about to set up, for the principal purpose of new buildings and new works of art for the gallery. You would be one of three to say what works of art should be bought, the other two being the director and the director of the Chicago Art Institute. In doing it this way the Federal Inheritance tax on the $250,000, which would be very substantial, would be saved."

As if she might not realize the value of this gift, he adds that her health would be better without money worries; she would not have to teach, and she could do her work under the best possible conditions. "It would be a joy to me to take care of any expense necessary to bring this about."

Ann was stunned by this beneficence. Of course she knew there was money, lots of it, but seeing it spelled out was beyond anything she could have imagined. He began to alert her to the importance of keeping her check stubs for receipts and other financial details she had never had

enough money to think about. "You are very very generous," she wrote to him, adding that she would try to learn about the stubs. It was all somehow unreal. Twelve thousand, five hundred dollars a year! Trusts! Check stubs! Hardly believing any of it, she confesses rather touchingly, "I think when I take your name it will be easier to be good about it."

Taking his name was an important psychological milestone for Ann, the singular, independent-minded artist. In one of her surviving address books she has written on the left-hand page, "Mrs. R. H. Norton," and opposite it, "Ann Norton, Sculptor," as though she is testing her new identity. Interestingly, it seems there was never any question of her keeping her own name.

In spite of all these distractions, business did not entirely come to a standstill. The day after Ann's telegram, Ralph resigned as chairman of the board of the Acme Steel Company, after forty-four years. In a company announcement of Norton's resignation, it was stated that under his leadership the company had grown from an annual volume of $235,000 to a record $55,000,000, when sales peaked in 1947.

He was now free to concentrate on his new marriage and his reinvigorated commitment—thanks to Ann—to buying art. One painting in particular created a little flurry between the now-engaged couple. Two paintings, actually. Norton wanted a Cézanne for his Gallery in West Palm Beach, and Ann agreed with him. He saw one he liked in the Silberman Gallery in New York, a 1901 portrait entitled *Portrait of the Artist's Son*. (The painting's title was later corrected to *Portrait of Alfred Hauge*.) It was priced at $35,000. He also saw a landscape that he actually preferred, going for the even higher price of $50,000. The Norton Gallery up to this point had never paid more than $18,000 for a painting, and Ralph was very anxious about paying so much more even for the less expensive Cézanne, saying he and Ann would have to eat "beans and meatballs" to pay it off. Still hesitating, he asked for her vote on the portrait, and Ann, sight unseen, made the call: "Buy it!" He did.

Ann was ecstatic when it arrived at the Gallery, along with a Paul Klee that he had also purchased and that she loved. "They are both beauties," she told him, "congratulations on finding them! The Cézanne specially is a wonderful one and I am amazed it was on the market."

He asked her why she loved it so much. "I can't explain the Cézanne to you," she told him. "Life love beauty art—these things can be seen & enjoyed but not explained." She then said she didn't really relish eating beans

Ann Weaver and Ralph Norton at their wedding in Chicago, June 14, 1948. Ralph's four children stand behind the couple, backed by a mass of white flowers. Photo courtesy of Lane Weaver Byrd.

and meatballs, "but if you can, I guess I can too!" These are happy, joyful words from Ann; she was beginning to relax into her new role. Mrs. Ralph Norton was coming to life. Ralph's response was, as always, a charming one: "It is nice to have it, but I have something much more important to me and much nicer. You can guess what it is. You."

On June 2, Ralph wrote to her one more time before their marriage. She was about to get on the train to Chicago, and he would meet her. "Have a redcap take your bags, and I will either see you on the platform or at the gate." Ending this letter, he says, "You know I have never liked to write letters. I have enjoyed sending this daily flash to you, but believe me, it is not like having you right next to me where I can talk to you and kiss you and love you and listen to that wonderful Alabama accent. Goodnight sweetheart, Ralph."

The marriage took place quietly at 4930 Woodlawn Avenue, Ralph Norton's house in Chicago, on Saturday afternoon, June 12, 1948. (Ann insisted on an afternoon wedding: "10.30 am would be just too drab.") Her wedding dress in the end was a very simple rose-colored, street-length dress with a white corsage. Her mother and her friend Grace Jones represented Selma, along with Ralph's four children, some of whom were a little guarded, not surprisingly, about their father's sudden and rather shocking decision to marry someone thirty years younger, barely a year after their mother's death.

The wedding was reported in the *Palm Beach Post* with admirable restraint. The ceremony, after all, was restrained. Ann had chosen the music. She explained her selection with typical coolness: "I couldn't bear any sweet, sentimental music, but some Bach would be beautiful." If Ralph felt in his heart any of the sweet sentiments Ann couldn't bear, he kept them to himself.

In the few photographs of the event, the second Mrs. Norton is mostly looking down, clearly uncomfortable. Only to be expected, perhaps. This was not an easy moment for Ann, posing in a formal manner with Ralph's children behind her (at least they showed up) and wearing a strange formal dress with an oversize flower arrangement pinned to her shoulder. Many brides have felt equally uneasy at such a moment of truth. But Ralph was by her side, smiling, a happy man, and soon it was over.

The honeymoon was spent in Los Angeles and Hawaii. If people suspected that it was a *mariage blanc*, Ann and Ralph's letters prove them mistaken. Very frank discussions passed between them about all matters physical, in particular, Ann's fear about getting pregnant. Ralph consulted his doctor in Chicago to get advice on this matter. The doctor reassured him that Ann would certainly not get pregnant, not only because of her age but also because of her unusual anatomy (unexplained, but she could not use a diaphragm). The odds, the doctor said, were next to infinite, and anyway, he would take care of any problems if they occurred. A very progressive fellow! He encouraged Ralph and Ann to enjoy each other whenever they could—at whatever time of the month—without any worries. On delivering this delicate but reassuring news, Ralph added, "I suppose you have a wastebasket for this letter." (She didn't.)

The couple returned to Florida in late 1948, ready to begin their new life together.

12

A Growing Confidence

As the winter of 1948 approached, the widows of Palm Beach dusted themselves off and began preparing for the busy round of parties that opened the season. "There probably will be great social doings there," Ralph told Ann, "but fortunately I think we will be on the outside, looking in." If they were—happily—outside the Palm Beach social set, within the Weaver family their marriage was welcomed with enthusiasm.

Over the years since Ann had left home, the Selma world of the Weavers, the Minters, and the Vaughans had managed to sustain some of its antebellum magic, in spite of the straitened circumstances the families endured after the losses of the Civil War. Aunt Rose was the flagship, so to speak, the unmarried, wealthy matriarch of the Weaver clan. In 1935 she sold the big Gothic castle her father had built in Selma, not for financial reasons but because of a heavy heart. Two of her sisters had distanced themselves by bringing cruel lawsuits against her, and both Clara and their brother William had died, leaving her alone in that echoing mansion. Emerald Place was also sold and later demolished.

Rose never went back to the family house in Selma. Putting most of her possessions (and Clara's) into storage, she moved into her widowed sister-in-law's smaller house at 217 Church Street where Annie Vaughan Weaver had grown up, and stayed there until she died.

Rose never married, and like her sister Clara, the other grande dame of

Selma, she was always loyal to the South. When Annie Vaughan dedicated her children's book *Pappy King* to her aunt, writing that Rose "knows and loves the South," Rose responded in clarion terms. "True," she wrote in her diary, "for no Greater Rebel lives today below the Mason-Dixon line, whose heart beats for Dixie and who still lives in the glory of the Old South. I love every breath that blows on Alabama and a strong grip holds me when I cross the Dallas County line." This is the same woman who a few years later became a passionate supporter of Franklin D. Roosevelt and who on meeting Eleanor Roosevelt in Washington in 1935 took her hand saying, "Please tell the President the South loves him for all he has done for it."

Rose spent her later years buying and restoring old furniture and acquiring a reputation as a respected antiques dealer. She could also be ruthless, particularly in hunting out treasures from former slave families who had inherited pieces from their masters. Once she spotted a genuine Duncan Phyfe card table "in a negro open hallway used as a water bucket table." Such finds excited her, and getting them, she says, restored "my greatest joy in life." Rose was looked after by her longtime maid and traveled around swathed in fancy clothes and furs in a chauffeur-driven Buick, a very impressive figure in town. She was still very much alive when Ann and Ralph were married, but sadly she stopped writing her diary in 1945. It would have been bracing to read her comments on her niece's unexpectedly effective restorative to the fading glory of the Weaver family. As she once said presciently about her niece: "Ann will always land on a feather bed."

Edith Vaughan Weaver, Ann's mother, was less flamboyant than her sister-in-law, but she was also quite a character, learning to drive at the age of seventy and having breakfast in bed every day. Her young nieces remember running into the kitchen of her house after swimming one afternoon and asking for some bread for sandwiches, and their grandmother looking round vaguely and saying, "Why, I would have no idea where the bread is!"

Edith Weaver regularly visited her youngest daughter Rose, now married and living in Pittsburgh with three children, Edith, Elise, and William. Mrs. Weaver also occasionally visited her son William and his family. William had married Jeanne Dubose in 1941; her family owned a fine house in Courtland, in northern Alabama, not far from Decatur, where William lived until his death in 1957. They had three children, Edith, Lane,

Ann Norton with her mother, Edith, in West Palm Beach. Edith visited regularly until she died in 1961. Photo courtesy of Lane Weaver Byrd.

and William. (In good southern fashion, the names seem to repeat themselves like a drumbeat through the generations.)

Edith Weaver saw her most independent, unmarried child on a regular basis. During Ann's lean years in New York, her mother occasionally visited her there; more often, Ann found a way to get back to Selma in the summertime, continuing to work at her sculpture ("chipping and modeling" as her aunt Rose put it) while at home. When Ann moved to Florida, it was more difficult for her mother to visit, so on her vacations Ann shuttled between New York and Selma. She and her mother were close, best friends really, as is shown by Ann's urgent summons for her mother to come and be by her side after Ralph's proposal.

After adjusting to the rather dramatic difference in the couple's ages, Ann's relatives saw that the benefits were considerable. Ralph evidently liked southerners: both his wives came from Alabama, and like Ade Bethune before him, he openly paid tribute to the seductive sound of Ann's southern accent. Ann's mother and her longtime friend and companion, Grace Jones, found Mr. Norton a hospitable and easygoing man (they were also closer in age to him than his new wife was), and Mr. Norton recognized their qualities as readily as they did his. (So much so that he left both Edith Weaver and Grace Jones money in his will.)

A letter in Ann's papers reveals touching evidence of Ralph's warm relationship with his mother-in-law—and pride in his wife. The letter was written to Ann in 1940 by the doctor who commissioned Ann's sculpture of St. Francis, describing its perfect placement in her garden in Vermont. The doctor added, "thank you sincerely for the interest and love you put into the work—besides your skill and art." Ralph sent a copy of this letter to Edith with a covering note: "I intended to send this . . . so you can see what a distinguished daughter you have, in case you don't know. Ralph."

But perhaps the family member who most appreciated Ann's surprising marriage was her beloved younger brother, William. Ann and William had always been very attached to each other, and William, now in his late thirties, found that he had a brother-in-law who was rich, successful, amusing, and wise, a delightful mixture that had something of a father figure in it. William's own career had been less than impressive. Like his own father, William II, young William had never fulfilled his aunt Clara's clarion call to greatness. Her reminders to him of their legendary ancestor, "merchant prince" Philip J. Weaver, failed to inspire the young scion of the family. In fact, he had not managed so far to bring any serious funds, princely or otherwise, into the Vaughan/Weaver coffers, a matter of silent regret to the family.

The Weaver dream, however, persisted. When William's wife, Jeanne, produced a son in 1951, Aunt Rose announced, "Now we can have another Philip J. Weaver." Jeanne retorted, "If you want another Philip Weaver, you're going to have to produce him yourself." Since Rose was about seventy-eight at the time, the discussion promptly ended.

After his sister's marriage, William began to make regular visits to West Palm Beach and Chicago, where the Norton houses offered agreeable guest bedrooms and live-in staff. Ralph was happy to welcome him.

William was charming, educated, and witty, and Ralph could see how Ann loved having her brother around. The two men became good friends. Every year, Ralph received a new set of custom-made suits, and every year he would give William his old ones ("old" being a relative term). William would joke about his sudden sartorial elevation. "Daddy was the best-dressed man in Northern Alabama," his daughter Edith commented dryly. William was indulged on all fronts. On one occasion when he went to Palm Beach, he mentioned that the reflecting pool in the garden at Barcelona Road was too shallow for him to do laps. Ann lowered the pool by 3 feet. "She'd do anything for him," his daughter Edith said.

Not all members of the Weaver family shared William's enthusiasm for Ann's new life. There were always the Robbins and Tarver branches, who, having failed to get any of Clara's money after several lawsuits, now had to endure the sight of Ann becoming rich. They probably felt the way Aunt Rose felt after her niece had won the first of her two European scholarships: "Annie Vaughan is like a cat, she always lights on her feet."

Ann and Ralph shared their newly married life mostly between Chicago and Barcelona Road. In both places, Ralph immediately started building a studio for his young wife. He was not going to renege on his promise to her about her work. The new studio in Barcelona Road was designed by Wyeth and King, the firm of their friend Marion Sims Wyeth, who created a fine workplace for the sculptor on land to the northwest of the house, with wooden beams, good interior light, and high ceilings, not unlike the stone-carving studio of John Howard Benson in Newport. Ann was in on all the decisions, asking Ralph for his advice on everything from light fixtures to the height of the sink to closets for her sweaters and smocks. "Anything you decide is all right with me," he told her.

Ann felt more comfortable in Florida than in Illinois. Chicago was the old stomping ground of the Norton family, from which she naturally enough felt excluded. She also preferred the southern-style Barcelona Road architecture to the more formal, neo-Georgian brick townhouse on Woodlawn Road. She later described the Barcelona Road house as a "beautiful old broken-down house. Adjacent to it there were some woods that Mr. Ralph bought to protect the house. I took those woods to do my work in."

Ann had been lonely for many years in New York. Her closest friends, Ade, Lapsley, and Gillis, had left her. She worked hard, year after year, with steely commitment, in isolation, feeling the cold. There was no Weaver

warmth in the city to sustain her. Marrying Ralph changed all that. She had a companion, she had family, she had a welcoming house, and most important, she had the unconditional love of her husband.

Married life was busy and fulfilling. They continued to indulge their love of music, attending concerts in both Florida and Chicago. They visited galleries in New York and elsewhere, to see and to buy. Ralph tactfully ceased his trips to Chautauqua, where his first wife remained a very important figure, her name prominent on concert series and buildings. He had resigned as president of the Chautauqua Institution in 1946 "because of ill health," according to the press release, becoming honorary president for life. (One wonders whether there were more pressing reasons for his wish to spend less time in the farther reaches of New York State.) His children picked up the baton, making regular trips to Chautauqua with their families.

As Ralph had promised, Ann never went back to teaching. Her old friend and mentor José de Creeft was hired to teach her course at the Norton School, leaving Ann free to do whatever she wanted. Which was, of course, work. In 1950 her *Jitterbug Dancer* was exhibited at the Pennsylvania Academy of the Fine Arts' annual show. She was in good company, with Archipenko and Hovannes also in the show. Her piece was priced at $600. Between 1949 and 1950 she made two bronze casts of *Machine IV*, three casts of *Seated Figure 1* and *2*, and a marble *Mother and Child*. In 1950 she showed *Machine IV* at the thirty-second annual members exhibition of the Palm Beach Art League. She did not enter it in the competition so there was no prize; it was up for sale for $800.

Another interest surfaced, thanks to Ralph's bounty. She could now afford to travel, one of her most longed-for pursuits. In the summer of 1951 and 1952, she went with her mother and Grace up to New Hampshire (where they visited the de Creefts), and on to Quebec and the island resort of Pointe au Pic in Canada. During these separations Ralph and Ann telephoned each other whenever they could, and he constantly wrote letters and postcards to her. He called her "L. S."—"Little Sweetheart." He kept firm tabs on them all, sending Ann blankets, for instance, when she complained of the cold. Sometimes on these trips she ran out of money and asked him to wire her some. He always responded immediately and generously.

Ralph was not eager to travel, even with Ann. The crippling migraine headaches he had suffered throughout his life were by now far more

regular, and he had trouble with his eyes. During Ann's absences, he would visit his children and their families, but he did not enjoy these expeditions. After a visit to St. Louis in August 1951 he confessed that it had been a little strenuous. "My eyes haven't been very serviceable since." So while she was suggesting trips that she was longing to take—out west to Carson City, Nevada, or to see art galleries in Omaha or Denver—he had to concede the difference in age: "My inclinations are to be sedentary."

Sedentary, but not entirely out of action. In 1947, Ralph had bought forty-six pieces, including a Renoir, a Rouault, an Utrillo, two Vlamincks, and several American paintings and drawings. In 1948, the year he was busy wooing Ann, he slowed down considerably, partly because of the onerous cost of the Cézanne portrait that was one of his wedding presents to her. In 1949 the list of acquisitions was still very small, but it included a Picasso, and the spectacular Brancusi sculpture, *Mlle. Pogany II.* He also bought a small Modigliani, a new artist for him, which delighted Ann. "I *love* the Modigliani," she wrote to him. "It is *wonderful* and a famous one. I have often seen it reproduced." (It is indeed a beautiful gouache and crayon sketch called *Rose Caryatid*, very modern and sculptural in style. One can see why Ann liked it so much.)

In 1950 an extraordinary number of Chinese archaic tomb jades was brought to Ralph's attention. Some of them were part of an exhibition organized by Robert Hunter at the Norton Gallery in January and February 1950, from the collection of C. T. Loo, a well-known New York dealer and connoisseur of Chinese art. This show was Robert Hunter's swan song: in late 1949 he left the Norton to become director of the Atlanta Art Association and High Museum of Art. (His successor was Willis Franklin Woods, who found working with Ralph as exciting and gratifying as Hunter had.)

Ralph fell in love with the jades in the exhibit and ended up buying thirty-four of them. Later that year, hearing that Loo planned to sell his whole collection, he went to New York, accompanied by Ann and the new director Willis (Bill) Woods, and bought nine Chinese bronzes. "It was a one-hundred-thousand dollar purchase that is priceless today," Woods said later. Ralph and his party then went on to buy a collection of ceramics from Loo dating from the second century BC to the eighteenth century AD. (In conjunction with the Nott collection he bought in 1942, these exceptional Chinese objects are one of the highlights of the Norton Museum today.)

In 1951 he added a Dürer, two Rouaults, a Picasso, and a Rembrandt to

the collection, and in 1953 he went on a binge, adding works by Matisse, Miro, Monet, O'Keeffe, Charles Sheeler, as well as sculptures by Alexander Archipenko, Jean Arp, Alexander Calder, José de Creeft, Edgar Degas, Chaim Gross, John Hovannes, Jacques Lipschitz, Theodore Roszak, and Henry Moore. (Let us not forget, of course, the works he purchased from Ann Weaver during these years, on prominent display in the Gallery: *Draped Figure* and *Seated Figure* were both installed in the hallway immediately outside the director's office.)

The list of acquisitions Ralph made after his marriage is as revealing as a series of diary entries—not only because of the number of names familiar from Ann's pantheon but also because of the number of sculptures—more than Ralph had bought in any previous year. There is no getting away from the fact that by this time Ann's influence was having a major effect on his choices. As he said to his New York friends, the McKims, before his marriage, "I can't buy any paintings now until my boss gets on the job."

Of course, Ralph, being a thoughtful sort of person, was not exactly a pushover. He took a great interest in the controversy surrounding modern or abstract art in general and how it affected his recent purchases. These explorations were noted in a remark of Palm Beach gossip writer Emilie Keyes in her December 16, 1951, column: "Maybe some folks don't care for the experimental sculptures at the Norton Gallery." (Surely she couldn't have been implying something about the second Mrs. Norton?)

In a talk to the Norton museum staff in December 1950, Ralph himself grappled head-on with the debate over representational versus abstract art. He mentioned to his audience works by Winslow Homer and Maurice Prendergast he had bought that year, along with a Dufy landscape. "The first two, are of course, representational," he explained to them. "The third is a so-called modern painting . . . characteristic of Dufy's non-representational manner." Ralph then said he had two confessions to make. "The first one is that I get much pleasure from looking at some nonrepresentational paintings, particularly those of the French painters who originated the current movement. The other one is that I believe I get more pleasure from a fine representational painting of equal quality." However, he conceded, "the Gallery is somewhat short of paintings in the so-called modern manner, and it is possible that more of this kind may be added." (While mentioning only paintings, he certainly included sculpture in the same way.)

In a talk he gave two years later to the members of the Palm Beach Art League, Ralph expressed himself slightly more judiciously. "To me," he told them, "there appears to be no particular merit in non-representational painting per se. Every painting, regardless of the degree of realism with which it is painted, must have two qualifications, if it is to be considered a good painting. It must have pleasing color, and it must have a pleasing design, pattern or composition—whichever you choose to call it." He explains how the two Braques and the Picasso in his collection all depict the motif of a guitar. Yet the artists' nonrealistic way of representing them makes them all completely different and much more interesting.

Toward the end of his talk, he said, "The fact that most directors of important museums in this country have placed their stamp of approval on non-representational painting as a medium of artistic expression should be considered significant in any appraisal of such painting." He continued, "Most of what I have said has been with reference to painting, but it also applies in general to sculpture." He then quoted favorably Ann's mentor Zorach, who stated that his aim sculpturally was "to achieve unity and solidity, a sculptural arrangement of masses and forms rhythmically bound together." Ralph, the good husband, concluded, "Much non-representational sculpture is being produced today and I believe it is likely to be of artistic significance if it conforms to the Zorach formula as stated above."

Was Ann present when he said these words? If she was, she would have been mighty pleased. Ralph may have admitted his ambivalence toward modernism, but he recognized its place in any self-respecting art museum, just as he recognized that his wife was squarely in the modernist camp. He had married her for her opinions and her taste as much as her commitment to her work, and he enjoyed the continuing dialogue. It is clear that Ann had a very good eye. Many museum directors and curators have since remarked on this. What Ralph purchased for his museum under her tutelage is perhaps the most important legacy of her marriage to the founder of the Norton Gallery of Art.

In spite of making major speeches and continuing to search for acquisitions, Ralph was not well. He suffered increasingly from the migraines that had dogged him for so long. Gallery Director Bill Woods remembered how Ralph would sense a migraine coming on and would make plans with Woods for the next few days when Norton knew he would be unable to function. According to Woods, Ralph had designed a chair he would sit in to endure the attack, as lying down did not help. Ann's

brother, William, would write to his wife from Barcelona Road with dispatches on Ralph's health. "He feels good one minute and bad the next. Never knows when a headache is going to start. Can't read or be around strong lights or a lot of noise and excitement for any length of time."

Apart from these problems, there was no warning of anything terminal. However, he died suddenly in West Palm Beach in December 1953, shortly before his seventy-eighth birthday. According to his wishes, there was no funeral.

Tributes poured in, a notable one coming from Pierre Matisse, his longtime dealer, who said in a telegram: "This is a great loss to the arts and to all the people for whom Ralph Norton had done so much in bringing together for their enlightenment so many outstanding masterpieces." A fond memory came from the sculptor Theodore Roszak, who was touched by Ralph's last phone call to him when Roszak's sculpture *Sea Quarry* was sent out on loan. Ralph wanted the artist to know how he, Ralph, would miss it in its usual place in the gallery. Alfred Barr, the director of the Museum of Modern Art, wrote to Ann: "Certainly Palm Beach and indeed all Americans interested in art are his debtors."

The most telling epitaph, perhaps, was the show that opened at the Norton Gallery a few days after Ralph died. It was a joint exhibit of the work of Winslow Homer and Fernand Léger—two artists who almost perfectly represented the schism between realism and abstraction that was roiling the waters of the art world. Ralph must have enjoyed planning it with his wife, his director and his curators, anticipating a lively reaction from the locals. It's a pity he was not there to witness the results. (Ann had kept a clipping of the announcement for him, but he died before she could give it to him.)

When Ralph died Ann was forty-eight years old. They had been married for only five years, but the consequences for her and her art were beyond imagining.

Part IV

The Journey
to the Source

Florida, 1954–1982

Previous page: Ann Norton at work on one of the massive figures for *Seven Beings*, 1965. Photo courtesy of Lynn Leofanti Cole.

13

New Freedom, New Work

ON JANUARY 18, 1954, Robert Hunter returned to the Norton Gallery of Art to deliver a eulogy for the man with whom he had worked for so long and so happily. Mentioning Ralph Norton's approachability, his eager quest for knowledge, and his aversion to publicity, Hunter said, "His very reasonable and down-to-earth philosophy was 'Why should I miss something?'—and so it is that in these short few years a typical American business leader found out why a Paul Klee could be as beautiful as a Gainsborough; why a sculpture by Jean Arp was as exciting as a Maillol. . . . He never bought a picture because someone said it was good. He had to like it himself."

In February 1954, the first of what would become an annual Norton Memorial Concert was performed at the museum by an invited string quartet. The program included a selection from Ralph Norton's list of his ten favorite works of chamber music. Among Ann's papers was a list she had drawn up of "Favorite Movements from Quartets selected by Mr. Norton," which were mostly the slow movements from quartets by Borodin, Boccherini, Haydn, Tchaikovsky, Grieg, Dvořák, Smetana, Debussy, and Ravel. It was presumably from this list that the concert program was selected each year. (If there was any doubt about Ralph's deeply romantic nature—which, judging from his letters, there is not—these music choices unequivocally confirm it.) Each year thereafter, Ann continued to submit works that her late husband had particularly enjoyed.

Ralph's will was duly probated, and Ann's share of his fortune made

public. Her income and trust funds were to be handled by the Continental Illinois National Bank and Trust Company of Chicago. One aspect of Ralph's will, however, came as rather a shock to Ann. He did not leave the Barcelona Road house to his wife. He left its contents to her, and the beloved Cadillac car—but he left the house to his four children.

The reason was explained to her by her trust lawyer in Chicago, Cecil Bronston. He told her that Ralph did not want her to stay in the house and thought she would not want to stay in it either. It was old-fashioned, not at all in the modern style that was her taste, and it would be filled with memories that she might prefer to leave behind. In the words of the lawyer, "Live in the future as Mr. Norton wanted you to do. Plan and build the new, clean, modern home designed for your particular needs, which Mr. Norton visioned for you and would have planned with you. . . . Do not return to the house again, or even think of it further as a place for you to live. This is what Mr. Norton thought best for you, or he would have devised it to you. You will be paying him the greatest sentiment and respect in honoring the wisdom of his decision."

But in this case Ralph had misread his wife. In spite of Mr. Bronston's aggressive argument, Ann wasn't at all sure she wanted to leave the house on Barcelona Road and move into a "clean, modern home." She was happy where she was. She had a beautiful studio and a garden. "Southern girls like a little land," her niece Edith observed later. There was room for her mother to stay with her. For a few months she was deeply agitated by the uncertainty of the situation. Would Ralph's children sell it to her? Would they lease it to her? Would they insist she leave it? Could Ann afford the house if she bought it? It could probably be justified, the lawyer told her, if she sharply reduced the servant load. But while he continued to urge her in strong terms, "give up the premises—now," Ann continued to stall. (As Ralph had once written to her, "you are very small and very stubborn, but I miss you.") Her stubbornness paid off. She started out leasing the house from Ralph's children, but in 1955 she managed to buy it from them at a good price, to her great satisfaction. On the front of the folder containing the lease and sale documents she wrote in triumphal green ink: "1954 I rent this house and finally buy it from children."

While all this anxiety was consuming her in West Palm Beach, Selma suddenly demanded her attention. On July 10, 1954, Ann's aunt Rose Pettus Weaver died at home in Selma at the age of eighty-one. With her went the last of the generation of powerful southern women who had inherited

the mantle of the legendary Philip J. Weaver. Like her sister Clara, Rose was one of the stronger members of the Weaver/Minter line, outpacing the males, all those charming, feckless Williams, who failed to step up to the plate and "stand tall," as their women had so desired. Was there ever going to be another "great man of Selma?"

When it came to Ann's generation, there was only one male to continue the Weaver name, William III, her brother, and in a strange twist of fate, he died shortly after Rose, in 1957, of a heart attack. Ann's younger sister, Rose, led a troubled life at home and ended up isolated from her southern roots in Pennsylvania. Aunt Rose Weaver's departure indeed left a huge hole.

Staying true to at least one family tradition, she also left, needless to say, a whole slew of scandals concerning her will, giving rise to wicked gossip, inaccuracies, and calumnies.

Rose's Will

After Rose's will was read, claims against the estate once more started flying around the circuit court of Dallas County, Alabama. Rose's will, like Clara's, was full of perversities. She left only $500 to her Tarver niece Rosalind Lipscomb, plus china and odd pieces of furniture that she had bought from Rosalind's mother, and a silver pitcher and goblets. She left $1,000 for the education of her great-nephew, Norman Robbins, "as long as he enters a college of recognized standing and provided he enters a college or art school before he reaches the age of 25 years." She left silver and some P. J. Weaver furniture to Ann's brother, William; to Ann she left a diamond cluster ring and an inlaid secretary.

Ann refused these bequests but retained something much more meaningful to her—Rose's collection of carving tools. She brought them back with her to her studio in Florida, where they remain to this day.

Much of the rest of Rose's estate, including 807 Selma Avenue, where Rose had her antiques shop, and the residue of her property, real and personal, went to her sister-in-law, Edith Vaughan Weaver, who was also named as co-executor with Selma lawyer Harry Gamble.

Perhaps the bequest that most riled up the Tarver family was the codicil gift to Rose's longtime friend and nurse, Christine Pritchett, of some real estate in Dallas County that included a house. "It was this," Ann's niece Edith thought, "that propelled Rosalind Tarver Lipscomb to court. Nobody else in the family objected. She thought this proved that Rose was not in her right mind."

The lawsuit was filed in February 1955, claiming from Edith Weaver and Harry Gamble as co-executors roughly $50,000 from Rose's estate to be paid to Richard Zimmerman Jr. (Rosalind Tarver Lipscomb's son, who was nine years old at the time), the reason being that Rose had mismanaged Clara's estate and that some of the Weaver Parrish trust was in fact owed to the boy for his education. During this unpleasantness, Ann's mother, deeply distressed by the accusations, stayed away from it all and hid in West Palm Beach with Ann. Ann's brother, William, kept them informed, happily announcing to them on April 29 that the court had thrown out the claim. In fact, the Weavers settled. The lawsuit had made Ann's mother so ill that they felt the best thing to do was to terminate the sorry affair as soon as possible. The Tarvers came away with several important items from the estate, including pieces of a mahogany staircase carved by Rose, and Clara's easel, among other objects. The unhappiness remained, not least because of Edith Weaver's crippling legal bills incurred by the lawsuit. (Her son William sold some family diaries, papers, and other objects to help cover these costs.)

The other serious controversy arose over the possessions that Rose had stored in her sister-in-law Edith's house. Apart from the few gifts specified in the will, Rose had left everything to Edith, which meant that some clearing-out was in order. The tricky part, however, was that many of these items had belonged to Clara, and Clara by this time was a significant figure in the southern cultural landscape. While Edith, Ann, and friends began to clear out the attic and garage where Rose had stored stuff, consigning much of it to a bonfire in the back yard, the neighbors began to take notice. Wait a moment! What were those canvases, frames, papers, and other objects being consigned to the flames? Was the family throwing out valuable artworks by the legendary Clara Weaver Parrish? Was this some vengeance for former slights?

Ann's old friend John Lapsley, who had moved back permanently to Selma and lived near the Weavers, saw the fire and what was being tossed into it. According to a young lawyer friend of his, John McCall, Lapsley felt that there were things worth saving, and he rushed over and rescued picture frames, oil paintings, and etchings by the famous Clara. Most of these, it seems, were small, minor works, and unsigned, although at least one was perhaps significant. But the story was spread around that Ann and her mother were destroying Clara's work out of anger at her

miserliness toward them in her lifetime. Ann's nieces dispute this notion. "There was nothing of value in that garage," Edith Haney declared. "There were some unfinished canvases, unsigned work from her New York studio, nothing of importance. Ann was disappointed that her aunt had not left more money to her family, who could have used it. That is true. But it was with no sense of revenge that they cleared out the house." (By this time, of course, Ann's income far outstripped any legacy her aunt might have left her.)

Back in Barcelona Road, Ann distanced herself from the tensions in Selma and began to think about her new life. She was quite clear about her priorities. The first was to make major improvements to her studio. As soon as she took ownership of the house, she hired a local architect, Frederick W. Kessler, to enlarge the studio, almost doubling the space, raising the ceiling, and installing large skylights. In the end it looked remarkably similar to Brancusi's studio in Paris, which she had visited and admired, urging friends going to Paris to see it for themselves.

Ann was now a comfortably off widow. She had come a long way from her days as a starving artist in New York. She had a permanent, regular income for her lifetime, a house she owned and loved, a studio ideal for her to work in, and the freedom to create whatever she wanted. And she was Ann Norton. All of her work, after her marriage to Ralph, was signed "Ann Norton." No more Annie Vaughan, of course. No more Ann Weaver, as she had been in New York. Whatever work she did then, and exhibited then, was by a person with a different name. As she had practiced in her address book, she was beginning her third incarnation, her third reinvention, as "Ann Norton, sculptor."

By 1955, Ann had started work on a "project," as she called it. It was an entirely new form of sculpture. Perhaps there had been clues. She had been producing smaller pieces with elongated bodies and enigmatic heads, faintly cubist, abstract, primitive. Her drawings were equally dramatic—masses of them pouring out of her, with jagged black lines forming abstract, blocky shapes. But this new sculpture was unlike anything she had made before in terms of size and scope.

This new work was to mark the beginning of Ann Norton's late and dramatic entry into the field of monumental sculpture. The tenacious artist now had the opportunity of a lifetime. She could make what she wanted, and she could pay for it. Her imagination knew no bounds. Neither did

her ambition. But was the vision good enough? And could it be fulfilled? For the next few years, these questions were to come up again and again as her first major post-Ralph project slowly evolved into its final, unfamiliar, and very controversial form, a granite monument unlike almost anything anyone had ever seen.

Untitled charcoal drawing showing Ann's continuing obsession with geometric and architectural forms. Undated. Photo courtesy of ANSG.

14

Figures in the
Landscape

IN LATE 1954, Ann and her mother made an extensive trip out west. It
was the first of several trips they were to take together in the coming
years, for after Ralph's death, Ann's mother spent much of every year with
her daughter in Florida. This trip was to be transformative for the artist.
Ann saw for the first time the spectacular rock formations and buttes, the
gorges and canyons, of Arizona, New Mexico, and Utah, those natural
sculptures of the southwestern desert whose colors and images were to
burn into her consciousness for ever after. A photograph of the strange
vertical rock shapes of Bryce Canyon, found in her papers, is a vital clue
to her changed perceptions during that unforgettable, life-changing trip.

Before she left, she had contracted to design and build for the Norton
Gallery a three-figure bronze sculpture as a memorial to Ralph, for which
he had given his blessing. This was Ann's "project." At this point, everyone
was in agreement about the work. Letters had gone out to the trustees of
the Norton Gallery about the design, including to Daniel Catton Rich,
director of the Art Institute of Chicago, one of Ralph's appointees on the
board and charged with approving all projects the Gallery took on. He re-
sponded with great enthusiasm. In a letter to Willis Woods, director of the
Gallery, he wrote, "I like Ann Norton's sculpture project. In fact, it is the
best thing I have ever seen by her. Also I believe that its setting has been
most carefully considered in relation to the Norton Gallery building." He

concluded, "I feel sure Ralph would have been most enthusiastic over the high quality and intense poetry which the scheme conveys."

But what had Daniel Rich seen? No doubt the drawings of the three-foot-high work she had originally envisaged. During this time, all those involved assumed that the sculpture in its completed form would be that size. In December 1955 a contract was drawn up between Ann Norton and the Palm Beach Art League. The League would "procure, erect and maintain" the sculpture. Ann contracted to provide the League with funds during this year and in subsequent years to achieve this goal. Ann also required approval of the design, landscaping, and lighting of the work. In other words, the Palm Beach Art League would own and maintain the work, which would stand in Gallery Park, the original site approved by Ralph before his death.

So far, so good. But when the Continental Illinois National Bank and Trust Company of Chicago (Ralph's bankers and trustees) became aware of this plan, a serious obstacle arose. The vice president of the bank (and Ann's trustee), Cecil Bronston, pounced on the issue of the funds Ann had contracted to pay the League for the project, funds that everyone had assumed would come from her trust income. After consulting with lawyers, he wrote to Willis Woods with rather stern advice: "Our counsel state their opinion to be that legal considerations bar the use of such funds for the project. In addition, some question of propriety arises if funds coming rather directly to Mr. Norton are to be used to provide a memorial to him." (In fact, Ralph had left Ann a separate fund to pay for the memorial.)

But all of these issues became moot after Ann's return from the Southwest. "As I travelled through the rough deserts of Arizona and New Mexico," she told Susan Hubband of the *Palm Beach Post* in 1967, "I saw thousands of figures eroded in the rocks. Only an artist could see those mysterious shapes, those beautiful and impersonal forms." To another reporter she expanded on her description of what she saw in Bryce Canyon. "They are ranged in rows, waiting for something marvellous and majestic to happen. I don't know what."

The exposure to such a dramatic landscape shocked her senses to the core, and when she got home she took a long, hard look at the memorial sculpture she had designed for the Norton. Her visit to the Southwest had changed everything. She felt now that it must become far larger in scale than the original work she had discussed with her late husband. Instead of

creating a small sculpture approximately thirty-six inches in size, as originally envisaged, she wished now to carve a grouping of seven figures, the tallest of which was to be twelve feet high. The complete work would ultimately take up nineteen-and-a-half feet of space, a very different prospect from the first concept. Moreover, after considering bronze as the material, she decided that the work must be carved in pink Norwegian granite, whose coloration perhaps reminded her of the glowing rock formations she had seen in Utah.

Ann knew she was embarking on something very controversial. She was also perhaps a little nervous about how Ralph's family would feel about the changes. She carefully kept them in the loop as events developed, writing reassuringly about the plans to put the project in the park, "an enlarged version so the architects can work with us for exact locations, size etc." The only one who seemed to take an interest was Ralph's daughter, Beatrice, who liked Ann and gave her $5,000 to continue the work.

But it was going to take more than money (and lots of it) to do what Ann wanted to do. The challenge, like the work, was monumental. Even if Ann had been a hulking seven-foot giant of a strongman, let alone what she was, a diminutive, frail woman about to enter her fifties, this enormous work could not have been done without help.

Enter Gene Leofanti, the man who was to work closely with her on all of her projects until the end of her life. Gene Leofanti was born in Lucca, Italy, in 1910, and grew up in New York City. He became an accomplished wood carver but decided to specialize in the enlargement of sculpture, in particular monumental works. Many well-known sculptors visited his studio on Staten Island over the years to work with him, including Georg Lober, William Zorach, José de Creeft (all part of Ann's circle), and Jacques Lipschitz. It was often said that Leofanti was more of an artist/ collaborator than a technician.

Some time in the early 1950s, Ann visited his studio on Staten Island, as so many of her colleagues had done. She watched him work for a while without interrupting. When the shy, reticent southern artist finally showed him her portfolio, Gene was astonished. "I couldn't believe what I was seeing."

It was at first as a technician that Ann hired him. To enlarge sculptural figures is an enormously complicated business of proportions, extensions, weight, and balance. What looks good in a small size often looks top-heavy or off-kilter in an enlargement. Models were made in Plasticene,

then expanded and enlarged to the size the artist required. Leofanti's skill was in finding the right measurements accurately to reflect the artist's original piece in all its proportional perfection.

Granite is one of the most forbidding materials to carve successfully. Moreover, pink Norwegian granite was not exactly the easiest material in the world to obtain. And what about transporting huge blocks of it to West Palm Beach? And once in West Palm Beach, how was Ann herself going to make the basic carvings from this stone? She was not deterred. With Gene Leofanti on board, she hired his friend, René Lavaggi, a distinguished stone-carver, to help hammer the forms that she required.

But all this took time. In 1957, having at first thought that she would make the castings in bronze, she collected several estimates, ultimately choosing the Bruno Bearzi foundry in Florence, Italy, to make the initial castings of the figures. She decided on the granite a year or so later. (She had begun in the meantime to make other pieces in bronze.) The small plaster models that she produced in her studio were transcribed by means of a three-dimensional pantograph machine onto full-size wood and Plasticene models, from which the stone-carvers worked on the stone.

The granite, quarried in Norway, was shipped to Vermont, where it was carved into the rough size of the figures, and then transported by truck to West Palm Beach. The labor and transportation were considerably more expensive than the granite itself. The large team of Norwegians, Italians, and Americans, often bogged down by the bureaucratic paperwork required, all contributed to the effort to get the project up and running. There were endless hitches. Ann had to make several trips to Italy to visit Bruno Bearzi. Shipments from the foundry arrived in West Palm Beach damaged or broken. For a time, granite blocks were stuck in customs in New York, requiring a court order to complete their journey.

The most difficult part remained the technical aspect of the enlargements. To enlarge a model from three feet in height to twelve feet was a challenge that continued to slow down the project. As late as 1961 Gene and Ann were still struggling with these issues. In February of that year Gene wrote to Ann: "This may sound far-fetched, but casting two figures together of this size requires all the planning and knowledge of casting that we can put into them to have them come out perfect."

In May 1961, her old and dear friend Ade Bethune, on her way to Portugal and Spain, visited her in West Palm Beach. With her shrewd artist's eye, Ade at once saw the difficulties Ann and Gene were dealing with

in trying to enlarge the figures successfully. In a hurried letter written from Lisbon airport, she suggested to Ann: "Make us a rough plasticene man. . . . This will give you a sense of scale for the steel tubings." Scale, for Ade, was the issue. "Another thing to help visualize scale is to look at your outer wall and check the width of the door's frame." (Ade made a little sketch here, with the sculpted heads at various heights against the doorframe.) Finally, Ade urged her: "Don't allow your MEGALOMANIA [Ade's capitals] to let the heads become so big that you'd have to glue an extra piece or paper at the bottom. I had forgotten that weakness of yours! Thanks for reminding me. Makes me feel less like an unreasonable monster that tries to make you accept something against your will." One can only imagine how fiercely the two argued over these issues during Ade's visit. It is also clear that Ann was as stubborn then as she had always been.

Ade was not the only one to see the intractability of Ann's vision. The stone-carver René Lavaggi wrote tempestuous letters to Gene and Ann, complaining about the impossibility of doing the work on such a large scale. Even worse, he was running out of money and constantly begging Ann for more funds. His equipment, in particular a compressor, had failed. He needed more help. In the end he admitted to Gene that he was not strong enough to tackle the task. His doctor told him he must stop work on the project or risk muscle damage. Gene tried to talk to him, saying that the project was difficult for everybody, but René quit in despair.

Gene, on the other hand, was a true believer. His career was in making sculptures bigger, but he had never been given such an opportunity as this one. Much later, he said that Jacques Lipschitz, one of his most famous clients, had asked him to work with him in Italy. Without hesitation Gene told Lipschitz that he was going to West Palm Beach to work with Ann Norton.

Gene wrote to Ann in April 1961: "I can't wait to see the whole monument assembled. It should give you the greatest satisfaction any artist has ever experienced in accomplishing a work of art. I am proud to be part of it." In November he wrote again: "I'm thrilled and thankful to be part of this grand project of real sculpture—I believe it will be the greatest sculpture of all ages." How Ann must have basked in Gene's extravagant praise.

In 1965, after ten years, the project was finally finished. It took that long to get the materials, project managers, stone-carvers, and other workers to accomplish her strange and unexpected work of art. Ann herself spent hours on scaffolding and ladders, shaping and sculpting the final form of

the heads and bodies of the seven huge figures. The work, called *Seven Beings*, was at last in place in the garden of Barcelona Road, to the north of the swimming pool.

But wait a moment. Wasn't the work supposed to be installed in the grounds of the Norton Gallery and School of Art as a memorial to Ralph? Had that not been the original plan?

Indeed, it had.

But the tension that had earlier arisen between Ann, the Norton trustees, and the League over the funding became a major confrontation after it was clear that the work was a completely different thing in size and concept from her original proposal. Instead of a small, three-figure work, she had in the end created a seven-figure cluster in Norwegian granite, nineteen-and-a-half feet long by twelve feet high, weighing twenty-five tons. When the sculpture was complete and unveiled to the public, few would have recognized it as bearing any relation to the idea Ann had once drawn up for Ralph's approval.

The obvious issue now was how this gigantic grouping would look rising up from its proposed site in Gallery Park. Or, as Ann proposed, after vandals had desecrated some of the other statuary in the park, in the center of the sculpture patio within the Norton Gallery itself. (She conceded that this would require removing Wheeler Williams' commissioned piece, *Fountain of Youth*, currently in the center of the patio.) Not surprisingly, opinion was unanimous that the work was far too big to be housed in either location.

"The board said NO," said Robert Hunter, who became director of the Norton Gallery for a second time in 1963. Ann was crushed. She even made a scale model of the patio with models of the figures to try to convince them. "I thought it looked awful," Hunter said. "She came to me in tears because they had turned her down. She wanted me to try to fix things for her, but I couldn't. In fact I asked to be recused during the board's decision-making, because I was such a close friend." It didn't make any difference. Hunter knew the board was right. Reluctantly, even Ann had to give in. The sculpture remained in her own garden on Barcelona Road, where it still stands.

In hindsight, it was probably always the best place for the colossal monument. It is shaded by palms, the dappled light accentuating the crevasses and textures of the granite. There is enough space around it for the visitor to step back and see the piece in all its glory, as well as to walk

around it, even touch it, feeling its power. The lush background foliage in the garden and the shimmering water in the distance add to the feeling that the work is somehow organic, rising out of the earth.

There is something mysterious, even mystical, about these figures, with their stylized headdresses, simple robes, and brooding, impassive expressions. They do not touch or look at each other, except for one of the smaller figures whose hand rests on perhaps a parent's arm. They are literally carved in stone, timeless, ageless, and as mysterious as the rock formations that inspired them.

Although Ann was always reluctant to talk about her work except in oblique terms, and often unwilling to title her work for fear it would be too specific, toward the end of her life she opened up a little to a reporter about the grouping. "They're not people really, they're beings," she told Kathryn Robinette in 1980. "They have a quality of waiting and a feeling of mystery. They were inspired by rocks, not by people. They are a part of me." This spiritual note was to become increasingly present in Ann's later work. Gene Leofanti certainly responded to it. "My interest in the project will continue to grow," he wrote to her in 1962. "I could devote the rest of my life to sculpture of this kind which will some day make people realize what truth and beauty means."

In the way that topography and geography inspire artists (Georgia O'Keeffe in Santa Fe and Louise Nevelson in the Mayan ruins in Mexico come to mind), the dramatic visual impact of the Southwest transformed Ann's work. But this was only the beginning. While working on the giant figures at home, Ann set off again, this time traveling much farther afield—to India, where the artist had another life-changing encounter with a new, wildly exotic landscape. India's long cultural history of gods, goddesses, Buddhism, enlightenment, and reincarnation provided the spiritual road map for Ann's mature search for sublimation in her art.

15

East and West,
New Relationships

IN 1964, GENE LEOFANTI AND his wife, Anita, left Staten Island and moved full-time to West Palm Beach. Semi-retired, he was persuaded by Ann to come to her so that he could help her on all of her future projects. As an incentive, Ann gave him land at the northeast corner of the property for him to build a house for his family. The Leofantis' good friends, Helen and Albert Zank, also moved down to Florida with them, and Gene built a two-family house with a pool on Ann's land to accommodate both couples. Helen Zank was a retired New York public school teacher and psychologist, and she was to become a good friend of Ann's. (Later Gene and his wife divorced, and he remained there by himself.)

Now that Ann had Gene, a distinguished sculptor in his own right, as her colleague and collaborator, her output exploded. As well as developing the huge granite grouping, she created a series of bronze torsos that were cast in the Bearzi foundry in Florence. She covered the bronze in multi-faceted surfaces and lacquered them in gold, which caught the light and sparkled like mosaics. She also made some in marble. Again, these were works unlike anything she had ever done. Moving away from the representational sculptures of her mentors, Archipenko, Hovannes, and Zorach, she was finding inspiration in the abstract forms, more associated with Brancusi, that had always fascinated her. The complex beauty of the materials and the effect of her continuing exposure to different cultures found their answer in these fine-tuned, dazzling pieces.

Torso, c. late 1960s, bronze, 48" high. One of a series exhibited at the Bodley Gallery in New York. Photo courtesy of ANSG.

Ann travelled constantly, mostly with her mother or relatives. She did not like to travel alone. It was as though she had been let out of prison: with Ralph's money, she could now satisfy her hunger to see the world. For Ann, travel was more than an escape or a drug. It flung open the door to her soul and liberated the pent-up secrets of her art.

She went to France, Spain, and Italy several times, in particular to Florence where she visited the Bearzi foundry that was producing the bronze for her torsos. In the mid-1950s she visited her old student Ouida George in Paris, and they travelled to Celtic shrines in Brittany. She went to the Château de Polignac, notable for its fortress-like ruins. On the back of a

postcard from the château, she sketched a series of pillars and columns prefiguring her work to come. She went to England and Scotland, searching out Neolithic standing stones, probably visiting the Ridgewood Trail, in the South of England, where circles of monoliths and boulders surrounding burial grounds rise up like prehistoric gods. In 1963, the year her mother died, she went to Salzburg and Kitsbühel in Austria. In Salzburg she visited the artist Oskar Kokoschka. In a postcard to John Lapsley, she described him as "77 years old and still going strong—teaches here every summer."

But perhaps the most significant trip she made was in 1961, when she went with her mother to India for the first time, via Ceylon (as it was then called). Although there is little documentation of this trip, India was the portal to a new world for Ann. As for so many other Westerners, India's delirious fusion of color, movement, smells, temples, and shrines created for Ann a profoundly emotional experience.

She made some significant friends during this brief visit. One was a member of the Nepalese Embassy, Gyani Maharan, who wrote to her in 1964 that he would love to visit her in Florida. "Though we knew each other for only a very few days, yet your kindness and goodness of heart makes me feel that you are quite near to me like a family member." (Gyani was later to become somewhat of a problem. Having lost his job he wrote to Ann describing his lack of funds and clearly angling for help. She must have appeared like a very rich woman.)

She also became a devoted supporter of the Tibetan cause. By the end of her life, she had seventy-five books on Tibet and Tibetan Buddhism in her library, and in her notebooks are scrawled words in Tibetan that she was evidently trying to learn. It's not clear when Ann first heard of Tibetan liberation, but it may have been after she met the woman who was to be her most important and constant companion for the rest of her life.

Countess Monique du Boisrouvray first appeared on the Palm Beach scene in the late 1950s. As with anyone with a title, she was immediately the center of attention. However, gossip soon established that she had been a countess only by marriage, and as she was now divorced, she had thus abandoned her right to the title. Her hanging on to it was a source of annoyance to her critics. Ann's niece Edith described Monique as "all hat and no cattle."

Monique was vague about her background. Born in 1920, she had once enjoyed a certain amount of luxury. Her family had real estate in Paris

An unusual snapshot of Ann enjoying herself with traveling companions in India. Undated, probably 1961. Photo courtesy of ANSG.

and bank accounts in Switzerland. But the money was all lost in family legal disputes that dragged on for years. Monique had been brought up in Europe, and during her marriage, she had spent time in Cannes, Jamaica, and other hotspots. She was energetic and creative and a lover of art and music. She had first come to Palm Beach with her then-husband, who hated it. ("He liked writers, musicians.") She loved it and returned on her own as a divorced "countess" in 1964, the year she met Ann. At the time, apparently penniless, Monique was living on a boat at the Peruvian Avenue docks. Her enemies called her "the countess of the waterfront."

Monique probably first met Ann through the Greg Juarez Gallery in Palm Beach, where Ann was negotiating to show some work. Ann was immediately taken by this extrovert, flamboyant Frenchwoman. Monique was petite, elegant in a French way, with red hair and a strong, bold face. "I was in the world of art and music," Monique later related to a neighbor, Glen Rawls. "Ann was so happy to meet a French person who knew about art." Ann had loved her time in France, and to hear French spoken again, and to speak it—haltingly after so long—gave her enormous pleasure.

Ann showed Monique her studio and the various projects she was

working on. Impressed by Ann's dedication, Monique picked up the message. "Ann was searching for form . . . spiritual meaning . . . She said she was sent to do the work."

Monique responded well to this kind of artistic endeavor. She also responded well when Ann insisted that her new friend abandon the boat and move into the house on Barcelona Road. Ann's mother, her most beloved companion, had died. The house was empty. Ann was lonely. Monique was the right woman at the right time.

Once installed in her comfortable new lodgings, Monique wasted no time in taking charge. She tried to get Ann to eat better. Ann had never been a good eater, and now, frail and thin as she was, she was even more careful with her food, most of which was pureed in a blender. Like most southern white women of her generation, she had never learned to cook. (She could still be tempted by southern food and occasionally managed to make cornbread. Her friend Ouida remembers once visiting Barcelona Road and finding Ann and her mother attempting to cook pork sausages!)

Monique thought Ann should go out more, if only to promote her work. "She didn't speak much at parties, but she was fine," Monique remarked. A natural self-promoter, Monique felt that her friend should open herself more freely to the world and get some recognition for her art (an issue Ann grappled with all of her life). Monique arranged small dinner parties at Barcelona Road where friends and art-lovers would congregate.

Monique also began to take over Ann's household affairs. She wanted to know what Ann's income was and how well it was being spent. In typical French fashion, she once commented admiringly how well Ralph had handled his fortune. "Every penny was spent intelligently." She was not so sure Ann's fortune was being handled so well. After she had been with Ann for a few years, she began to communicate directly with Ann's trustees in Chicago. "I thought the bankers should give her more interest," she said later. One can only imagine how enthusiastically the Chicago trustees welcomed Monique's suggestions.

The bankers were not the only people who found Monique's presence less than ideal. Gene Leofanti, who had been Ann's friend, supporter, and technical adviser since 1961, found himself rudely displaced after Monique moved in. He was still in charge of all of her projects, and as they became more and more complex and more and more difficult to realize, he put his life on the line in attempting to satisfy Ann's vision. He was happy about this; as he had written, her work was his pride and inspiration. But

suddenly here was Monique, elbowing her way into Ann's affections. He felt that the Frenchwoman's influence was dangerous. She took Ann away from the work with the parties and the trips. "He was heartsick at what she was doing to Ann," said his son Leo. Gene continued to run all of Ann's projects to the end of her life, but some of the magic had gone out of their relationship.

Whether Monique's relationship to Ann was sexual will never be known, but all the signs point to it being a platonic friendship only. There is no doubt that Ann was attracted to strong women, Ada Bethune being the most prominent and enduring of her objects of affection. She grew up around powerful women (Aunt Clara, Aunt Rose) and less effective—but charming—men (her father, her brother).

According to Monique, a boy courted Ann when she was a young art student in France in the 1930s. He was very nice, Ann said, and she didn't want to hurt his feelings. So she told him it was too hot to go any further. "Very sweet," Monique commented later.

Like her mother, Ann had a remote quality, a dislike of physicality. She didn't hug people. She avoided conflict, ignoring the constant friction between Monique and Gene Leofanti. These issues were, to her, merely distractions from the work.

Several observers have pointed out that Ann's art is not erotic in nature. It is true that there is little or no trace of femininity in any of her earlier, figurative pieces. But a viewer of the bronze torsos she was producing at this point, and of the monumental brick sculptures she made at the end of her life, might find a sexual element in the voluptuous shapes and subtle apertures of this later, abstract work. There is never anything overt, however. Unlike, say, Louise Nevelson and Georgia O'Keeffe, Ann never gave free expression to her sexual nature either in her art or in her life.

But certainly Monique insinuated herself into Ann's personal world almost totally. They travelled together, worked together, discussed art together. Ann would ask Monique to come into her room at night and pray with her. Monique, with her French accent so reminiscent of Ade's, was a powerful emotional companion for Ann's later years. As for Monique, she found a very satisfactory safe harbor when she met Ann, and she was too shrewd to mess it up.

Perhaps the Frenchwoman's most important and authentic contribution to Ann's later life was her enthusiasm for travel, particularly to the subcontinent. After Ann's mother died in 1963, Ann would have been

alone both at home and as a traveler had not Monique taken up the baton with energy and goodwill. Ann had obviously talked with great passion about her first trip to India, and Monique quickly arranged for more.

In late 1966, the Dalai Lama's older brother, Thubten Jigme Norbu, then a lecturer in Tibetan and Buddhist studies at Indiana University in Bloomington, paid a visit to Barcelona Road and cemented a very important relationship with Ann and Monique. He visited again in 1968 and by 1969 was ready to give the two women important contacts in India—the most important being, of course, his brother the Dalai Lama.

In February 1969 Norbu wrote a letter to Thupten Ningee, of the bureau of the Dalai Lama in New Delhi, introducing "Mrs. Ann Norton of Florida." He goes on: "Besides being a close friend of us she is very concerned and sympathetic about the present situation of the Tibetans and she is particularly very interested in giving aids to our learned monks and lamas." Ningee responded by telling Norbu that they had done everything they could to assist her. "She would be visiting Dharamsala on 9th March 69 and an interview for her with His Holiness has been arranged."

There is no record of Ann's first meeting with the Dalai Lama. There is however a vivid description of a later visit that Ann made with Monique and a companion, Richard Beresford, in 1972. The group first travelled through Nepal, and Beresford gave a wonderful picture of Ann as she encountered this magical terrain: "She would literally dance in the Kathmandu Valley, like a scene from 'Sound of Music,' and point out the enormous peaks and spired temples around us. Monique on the other hand, turned to Ann and I and said, 'Spain! I see Spain in every sight in this place.' We were taken aback and Ann said, 'Monique, you sure you are drinking that bottled water?'"

In northern India, they visited the sacred Gyuto Monastery in Dalhousie, but of course the highlight was the meeting with the Dalai Lama in Dharamsala (the Indian capital-in-exile of the Tibetan community). They eagerly prepared for it. Ann told Monique to write down questions for His Holiness, and Monique would write such things as, "What is the meaning of life?" On the day of the meeting, Ann wore a beige outfit with matching hat and high-heeled shoes. Beresford noted that he rarely saw her in high heels. His description of the ensuing scene is priceless:

Ann came forth with a large prayer scarf for his Holiness. The Dalai Lama held out his hand to Ann, she stepped forward, tripped on the

doorstep, the prayer scarf flew up in the air and hundred dollar bills blew around the room. His Holiness caught her hand and said, "It is always a pleasure to see you again. Is the money for the young monks?" Ann, embarrassed, said yes. Meanwhile, Monique found a corner and assumed the Lotus position in silence.

Conversation flowed between the Dalai Lama, Ann, and Richard Beresford—about photography, art, religion, American youth, and other topics. His Holiness told Ann how much his brother and his family were looking forward to visiting her at her home soon. (Thubten J. Norbu would regularly stay with Ann in the winter months until he died in 2007.)

As the group said goodbye, the Dalai Lama and Richard Beresford found out they were the same age. They laughed a lot. After leaving, Ann questioned Richard about this levity. "How can you laugh when he is so spiritual?" "Well," he said, "He started it!"

As for Monique, Ann asked her what had happened to all of those questions she had prepared. "Why did you not ask him?" Monique, clutching a prayer scarf His Holiness had presented, mumbled, "I was too touched by his spirituality." Beresford told the Dalai Lama this. "He laughed and said he met many people who wanted to know the meaning of this or that and all they had to do was look around them and discover the answer within."

In spite of these light moments, Ann was deeply moved by the encounter and was forever after a true devotee of the Tibetan spiritual leader and the Tibetan struggle with the Chinese for their homeland. She remained in touch with several Westerners who were also involved in helping the Tibetans, including Elizabeth Brunner, a Hungarian-born artist who painted a portrait of the Dalai Lama, and Antoinette K. Gordon, an anthropologist who was an expert on Tibetan art and religion and had translated several important texts. India remained a magical place to Ann. "When you see Asia it will change your life," she told her nieces. "You will see Europe and the world differently."

When Ann returned from India, she brought back objects from her journey—jewelry, pottery, shawls. She had colorful silk suits made for her in the various cities she visited, as many tourists do. According to her nieces, she would cut out the labels on the clothes so as not to pay taxes on them. Like many people whose families were once rich and had lost their fortunes, Ann had a parsimonious streak. Gene Leofanti's daughter remembers being given a wedding present from Ann that consisted of

some silver inscribed with the initials of Ralph's first wife, Elizabeth. Her niece Edith also has some of Elizabeth Norton's silver.

But of course what Ann really brought back was a new impetus for her art, a step farther into the mystical regions that had already been taking shape in the recesses of her imagination. The granite "beings" were the last figurative pieces she ever made. From this time on, she moved full tilt into the world of semi-abstract and abstract sculpture, where in truth she had always belonged.

Now was the time for her to embark on yet another form of sculpture, this time inspired by another new material. In the mid-1950s, she had begun importing heart cedar from the Pacific Northwest. As with the Tibetan shrines, she already had images in mind for this material but did not execute them until the 1960s. As early as 1935 Ann had made a design for a monument in mahogany that bears an uncanny resemblance to the work she began to produce later with the cedar.

According to Palm Beach resident and friend Thomas M. Chastain (heir to a ranching fortune in Wyoming), "She chiseled away strenuously upon these reluctantly yielding hardwoods, exerting the same concentration on detailed surface modeling as she had with the series of pink granite sculptures." She chose the material used not only most often for Tibetan temples but also by the Indians of the Northwest for their totem poles, which were also of great interest to her. She worked the wood by making grooves and lines that created a strongly textural appearance, like her bronze torsos. "I use everything—the cracks in the wood, the knots, the gnarls," she told the *New York Times* in 1978: "I like my work to flow together with nature."

The hundreds of pastel and charcoal sketches she produced during the 1960s bear witness to her fascination with these shapes. These "thoughts on paper," as Bernini called his drawings, became the wooden structures of the 1970s. When she had built a substantial collection of them, she began to call them Gateways. "My first gateway sculptures were of wood and not large," she said. "Gradually I increased the size of these to a height of 10 feet. The increased size gave a greater quality of monumentality." Almost architectural, they appear sometimes cubist, sometimes geometric, sometimes asymmetrical, sometimes Druidic. Observers pointed out that some resembled the Tibetan chortens Ann had so admired on her journeys through the subcontinent, although she was reluctant to concede the influence of these shrines and monuments. "I didn't see those," she

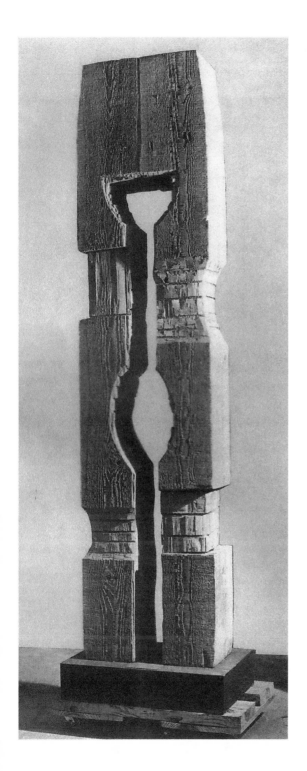

One of Ann's
northern cedar
Gateway series, 1973
(84" high), exhibited
to much acclaim at
the Max Hutchinson
Gallery in New
York in 1980. Photo
courtesy of ANSG.

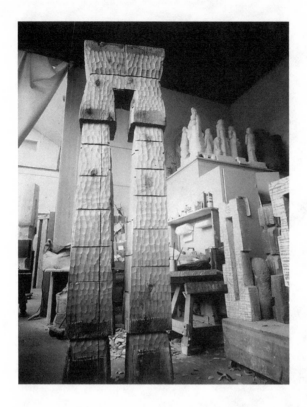

Ann's studio, showing the many cedar columns and forms for the Gateways she produced so prolifically in her later years. Photo courtesy of ANSG.

declared, "until long after I'd begun to make these forms." Her cascades of earlier drawings confirm that she had visualized such abstract shapes well before her trips to Asia.

The materials, like travel, acted like catnip on Ann's imagination. Marble, bronze, granite, and now wood honed her skills and extended her range to an astonishing degree. But the development of these wooden structures, enlarged from maquettes, led her to the material that propelled her to her greatest triumph.

Aware of the beauty (and potential) of the gardens outside her door, she said, "I envisioned yet larger sculptures in the wilderness. . . . What to make them of? Wood was too fragile, stone too expensive, cement ugly. There remained one material: earthy, natural, beautiful, brick."

Ann Norton was now embarking on the last great push of her career, the culmination of a life devoted to attaining the unattainable—transcendence through art.

16

Dreams of Selma

WHILE HER MOTHER WAS ALIVE, Ann made annual trips to Selma. There she would see her young nieces, Edith and Lane, the daughters of her beloved brother, William. The girls admired and enjoyed their aunt "Deat," as she was called within the family. (No one knows the origin of the nickname.) Ann often brought with her a set of sculpting tools and pieces she was working on. She would allow her nieces to try and emulate what she was doing. "We were terrified we would break something," they said.

When she was in Selma during the summers with her nieces, she used to take the little girls on walks at nighttime. This was a pre–Civil Rights Selma, still innocent of the bloodshed that was to come. As Ann and the children strolled through the humid, shadowed streets, she would regale them with stories about the darkened houses and the characters who had lived in them. She would tell them tales about their own family heritage and the bravery their ancestors had shown during the Civil War.

She loved telling them about their famous ancestor, Philip J. Weaver, and how he would oversee his merchandise as it was loaded in New York City onto the ships that transported it to Mobile and his stores. While the other owners would waste time partying and getting drunk, Weaver would stay with the ship to see that his goods were loaded first. This way, if there was a storm (and there were often terrible storms) and the ship was in distress, his merchandise was at the bottom of the hold and would be the last to be jettisoned. "Deat was so proud of this story of her great-grandfather's work ethic," Edith and Lane remembered. Ann knew very well that this was an important part of her inheritance.

"She always preached family to us," Edith said. "She said we must stay close to each other as sisters. She remained a member of the United Daughters of the Confederacy so we could inherit her membership as direct lineage. She also joined the Daughters of the American Revolution and the Colonial Dames for us." She could also be generous financially, paying, for instance, for Edith's college bills at the University of Alabama.

On Sundays the three of them would go to St. Paul's Episcopal Church together. The Weavers had their own pew, the only family to have one, but it was unmarked and few parishioners knew about it. Ann was distinctly displeased when she and her nieces arrived at the pew and found others sitting in it.

The three Weavers would pray under the vibrant colors of Aunt Clara's stained-glass windows. Ann had grown up under the light of these windows, the perfect metaphor for Clara's glowing artistic reputation throughout the South. Now Ann had surely outstripped her aunt: as Clara's reputation waned under the pressure of modernism, Ann's elusive, abstract work seemed the more exciting, important, and likely to last.

Yet even as she escaped the shadow of her famous aunt and her aunt's style of art, Ann saw with increasing clarity the meaning of her family, her southern background, and her history, and how precious it all was to her. Her German shepherd dog was called Jeb Stuart. (He replaced an earlier one called Beauregard.) Monique recalled an occasion when a guest at dinner said how great Abraham Lincoln was, and Ann became very upset. "Lincoln was Public Enemy Number 1!" In her library were over fifty volumes on the Civil War and Confederate history. She even chastised her nieces on occasion for not sounding southern enough.

Yet the ambivalence remained. Her cousin Trot Vaughan tells an amusing story of when he was twenty-eight years old and traveling through India in 1971 as a backpacker. He was in the American Express office in New Delhi when he saw an older woman he thought he knew sitting near a desk. "Annie Vaughan!" he called out across the room in his deep southern accent. She turned and glared at him, horrified. "Who are you?" she demanded. When Trot explained he was her cousin from Selma, she calmed down, telling him she would be happy to see him again but was leaving the next day. So there it was, her old, abandoned southern name and history she thought she had escaped, reaching across the years to her, even as far away as India.

But as the civil rights movement gained in significance during the last decades of Ann's life, she realized she could be permanently tainted by the negative aspects of her hometown. By the end of 1965, when the historic civil rights marches from Selma to Montgomery had burned into the nation's consciousness, Selma as a place-name had become so toxic in the cauldron of American racial politics that Ann was reluctant to admit she came from there. Even the iconic Edmund Pettus bridge caused pain— Edmund Pettus had been a Weaver family lawyer. "I would never say I was from Selma because it's too complicated," she admitted to her nieces. "I would say I'm from a small town in Alabama."

Just as many white southerners had good relations with blacks, so Ann enjoyed and was enjoyed by the black servants and children with whom she grew up. Her children's books are striking examples of this. Lessie, her black cook, and Earl, her black driver, stayed with her to the end. But Ann Weaver Norton was from the South, with all the complexities that implied, and she could never let it go.

As well as the two older girls, Ann's brother had a son, William Weaver IV, who was born in 1951. He was a troubled, unruly child. His sisters thought that a kick to his head by a horse when he was three years old damaged him irreparably. In late 1964 Ann made the decision to have the boy, then a teenager, come to live with her in Florida. He was the last of the Weavers, and by this time both of his parents were dead.

Ann was determined to turn young Bill into a proper representative of the next generation of Philip J. Weaver's legendary line, thus fulfilling the dreams of Aunt Rose. Bill looked a little like his father, a sad reminder that would not have been lost on Ann. She saw in the boy a chance to recover her darling brother. Bill's family was not altogether thrilled by this. Lane in particular resented her brother's departure from Alabama and felt it was a mistake to uproot him so radically. (She later changed her mind.)

In fact, it was a mistake, and it caused one of the most painful episodes in Ann's life.

At that time she also had living with her a very different kind of boy. During her first trip to India in 1961, she met a young Indian artist called Prem Saran, whom she invited to stay with her. He was a colorful figure, always dressed in fabulous Indian silks, like a Maharajah. Ann installed Prem at Barcelona Road and encouraged him to work on his art. The Palm Beach social set was both puzzled by and enamored of this fascinating,

charming, effeminate figure, and he became very popular at parties. Perhaps finding Ann's life a little on the quiet side, the Indian "princeling" soon abandoned West Palm Beach and started making regular appearances in the *Shiny Sheet* (the social section of the *Palm Beach Post*), photographed poolside with a rich widow, or cooking Indian curry at a restaurant, or looking cute at an art opening. By the mid-1970s he was coming back only occasionally to Barcelona Road and ultimately he disappeared from Palm Beach entirely. Much later one of the Palm Beach grandes dames, Mimi Duncan, reported that he had been spotted in Connecticut working as a butler.

To have "adopted" as it were this Indian son may be regarded as one of Ann's more surprising acts. She was mostly very shy and discreet, shunning publicity and avoiding gossip. But with Monique at her side, she began to invite different people, often from Asia or other exotic cultures, to her house. She welcomed people who had been to India and Nepal and who understood the Tibetan struggle with the Chinese. She had Balinese dancers perform in the garden. Florida Seminole Indians would visit and she would buy clothes from them. (Her love of Native American culture was long in the making. When her brother was still alive, they would take trips to the Smoky Mountains, bringing back artifacts made by the local Indians. She had quite a collection of baskets by the end.)

"Many artists came to see her," Monique remembered. "De Kooning came. Menotti came, and she gave him the theme of an opera. She said, 'I thought in the night of it.'" Menotti said that Ann Norton was the only intelligent person he had met in Palm Beach. The American matador John Fulton showed up, penniless as so many of Ann's friends were, but still showy in his bullfighting costume. Ann was attracted to exhibitionists, to colorful personalities, to sexually outrageous individuals, so different from her shy, reclusive self. Did some of these renegades see her as a wealthy and targetable widow, as so many were in Palm Beach? The notion cannot be discounted.

But young Bill Weaver was another matter altogether. The idea was that he would go to the local school, learn to study, and be taught by his aunt the ways of a proper southern gentleman. Perhaps he would even become a companion as her brother had been.

It was not to be.

Bill managed to complete a year at the Palm Beach Day School in

1965–66. (She proudly kept his certificate.) But after that, things deterio-rated. As he got older, he became more and more difficult. He ran away. He would get drunk with Prem. He would come home late and make a terrible noise so Ann could not sleep. From 1966 on Ann struggled to control him. She enlisted Gene Leofanti and Helen Zank to try to han-dle him, but the boy became increasingly unstable. He broke into Prem's apartment and damaged his sound system. On another occasion he "bor-rowed" Ann's truck and crashed it. He wrote his aunt crazy letters ask-ing for money. ("I don't intend to buy liquor or cigaretts [sic] with this money.") He was also gay, which further complicated the situation, dash-ing Ann's desperate dream of continuing the Weaver dynasty and causing complications with her other lodger, Prem.

In 1969, when he was nineteen, he was sent to St. Andrew's School in Tennessee, a boarding school. The doctors there told Ann he was seriously disturbed and needed psychiatric treatment, a fact Ann had tried to deny to herself. The family then sent him to Bryce Hospital in Tuscaloosa for an evaluation, where he wrote pleading letters, saying the others "are mostly alcoholics or nervous."

Bill's guardian, Henry Vaughan, Ann's cousin, wrote to Ann asking her to help pay for these costly programs. Bill continued to write Ann endless letters, promising to be good, thanking her for looking after him, swear-ing to work harder, assuring her of "a new Bill." The tone was increasingly pathetic. He was sent back to his sister Edith, now married and living in Decatur, where he received a message from Ann saying he could never return to Barcelona Road. The family was stunned.

Ann had come to the end of her rope and was adamant: "All your ap-peals have come," she wrote, "and I am really shocked at the last one, that you could talk to me with profanity and complete lack of respect and devotion." She told him how disappointed she was in him. "I hoped you could get your high school diploma behind you, work for a few months and then come home to us here a more mature, gentlemanly boy." Ann's noble experiment had been a disaster. Bill went back to Florida, where he worked at various jobs, living on money from the family. He died in Fort Lauderdale in 2006.

Yet even this unfortunate episode could not keep Ann from her work. And it was exciting work. For by this time she had begun experimenting with brick, the material that was to inspire her greatest art. Her first love

was rare pink Mexican brick, with which she created perhaps her most controversial sculpture, a horizontal piece of gargantuan proportions, forty-seven feet long and undulating like a Himalayan mountain range or perhaps a strange sea creature, installed boldly in the former swimming pool of 235 Barcelona Road. The lovely pink brick was laid in immensely complex contours and curves, creating shadows and planes of mysterious beauty. Ann herself said, "It is whatever you want it to be," perhaps deliberately asking others to interpret its demanding shape.

But the finest of her brick works were the seven vertical sculptures that later came to represent the heart and soul of her palm-filled garden. Everything seems to come together in these twenty-foot-high mysterious monoliths, built in rich red, handmade North Carolina brick, reaching up to the sky, opening doors to the imagination. She once sent a postcard to John Lapsley during a visit to Italy that showed the towers of San Gimignano, with a delighted scrawl from her—"a wonderful place!" Other scraps of memorabilia confirm the obsession: the Château de Polignac with its brick turreted ruins, the photographs of standing stones she requested from the Dublin Museum, the urgent sketches she made everywhere on scraps of paper.

These extraordinary brick monuments represent a new and supremely confident phase in her career. They are carefully positioned in the garden, concealed in glades surrounded by rare palms, objects of wonder that the visitor comes upon by following winding pathways, through shaded *allées*, almost by surprise. They loom above the garden's tropical foliage like memories of Tibetan shrines, Stonehenge, or the primitive rock formations of Arizona and Utah. In their coloration, the deep burning red of the North Carolina brick brings one back to the earth, to the landscape that surrounds them. "Brick blends with this land," she declared. "And nature has always been my inspiration."

But the most telling significance of these brick totems is their link to Ann's southern childhood. It was with such bricks that the Cloister and Parish Hall of St. Paul's Church in Selma were built way back in 1924, when Ann's eyes first rested on them as a teenager. The colors of the brick reflect the rich soil of her home state, Alabama. And perhaps those romantic, sad brick columns of Crocheron that the tourist stumbles upon in the long-abandoned ghost town of Cahawba are part of the story she narrated to herself as her life was coming to a close.

These powerful brick structures were, in essence, her biography. They brought her back to her roots. One could imagine little Annie Vaughan Weaver, followed by her pet dog Potsy, as she ran through the skeleton streets of Cahawba, tracing her fingers along the ridges of the ruins, or pointing out the chimneys that dotted the Alabama landscape as she travelled to the family plantation. Like the theme in a piece of music, these southern images were always sounding in the deep well of Annie Vaughan's creative consciousness. They were her calling card, her memory bank, her claim to immortality.

17

Time Runs Out

IN EARLY 1977, ANN NORTON was diagnosed with leukemia, the disease that was to kill her.

She was just coming into her time of greatest success as an artist. Now, as she celebrated her seventy-second birthday, the commissions were coming in, the critics were recognizing her, and she was seriously making her mark in the art world. Her tenacity and vision were finally paying off.

A series of solo shows of her work in the late 1960s and 1970s indicate the increasing respect galleries were giving to this unconventional artist. One of the problems of course was that most of Ann's work was not portable. For sculptors of monumental works, public commissions are one of the only ways a large number of people can directly experience the sculptures. That is how Henry Moore and Richard Serra, for example, whose huge sculptures are seen in many public parks, have become famous all over the world. Ann had to wait until she was almost on her deathbed for her one and only public commission.

In 1968 and 1970 she had solo exhibitions at the Bodley Gallery in New York. The first—also her first solo show in New York—was called *Theme and Variations* and featured thirty-two bronze and brass cast sculptures, including one marble torso, ranging from figurative pieces (heads and masks) to abstraction (torsos and monumental forms). These sculptures showcased her enthusiasm for textured surfaces, where the light "nibbles nervously at the surface but is met by the dark counterforce of the solid resistant mass," as they were described in the catalogue by Amy Goldin. The critic concluded, "The thematic unity of this show frees the attention

for focussing [*sic*] on the body of each individual piece, so that we may listen for its own particular way of repelling or accepting its environment, its own voice, its own intense poetry."

The second show at the Bodley Gallery, which opened two years later, was entitled *Demons, Magicians and Others*. Here Ann presented maquettes of the seven-figure grouping installed in the Barcelona Road garden, with photographs showing the enlarged realization of the sculpture. The director of the gallery, David Mann, pointed out the unusual nature of this group composition. "Through the ages the emphasis has been on the individual figure or object," he noted. "The quality of mystery noted by the critic in the 1968 review," he added, "continues to project in the works of this showing."

In 1969, Ann's work was finally shown at the Norton Gallery of Art in West Palm Beach, which on the whole had not supported her sculpture. Thanks to her old friend Robert Hunter, in his second term as director, the Gallery put together a replay of the brass and bronze torsos seen at the 1968 Bodley Gallery show. "It is high time," Hunter wrote, "that Ann Norton's work was shown here, and this is the time to do it!" A rather happy note at the bottom of the catalogue listing noted, "There are some pieces of sculpture in this exhibition which replace the works which were sold from Ann Norton's recent New York show."

In 1972–73, and again in 1974, she had solo exhibitions at the Galerie Juarez in Palm Beach. In 1976 one of the most important sculpture museums in the world invited her to participate in a show. The Musée Rodin in Paris was organizing the exhibition *La Forme Humaine*, and Ann contributed a four-foot-high torso to the show. This was a highly important moment of international recognition for her.

No doubt encouraged by Monique, Ann suggested that friends recommend her work to gallery owners, and she herself began offering her works to museums. In 1972 she proposed the gift of a drawing to her acquaintance Charles C. Cunningham, director of the Art Institute of Chicago, sending him eight to choose from. Mr. Cunningham unfortunately resigned that August and in September the curator of prints politely declined her offer. But a friend of Ann's donated one of her bronze sculptures to the High Museum of Art in Atlanta, and the director asked Ann if she would donate a drawing related to the sculpture. (She did.) In early 1978 she was invited to show at the International Cultural Centre in Antwerp, Brussels.

In February 1978 one of her most important exhibitions opened at The Clocktower, a gallery in New York. Here she exhibited six carved wooden structures, each ten feet high, made of the cedar from Western Canada that had so inspired her. Some of these structures, although untitled, had two standing columns and a lintel, like gateways, a description she had already used a year earlier and was to use frequently later. The show at The Clocktower also exhibited forty-one of her abstract drawings.

And it was in this momentous year, 1978, that, increasingly ill and frail, she received her first public commission: to create a sculpture for the plaza in front of the new Harvard Square subway in Cambridge, Massachusetts. Her design was for a twenty-foot-high brick sculpture sited near the entrance to the station on Brattle Square. In a statement, the Cambridge Arts Council and Massachusetts May Transit Authority, which jointly commissioned the work, said, "Mrs. Norton's monument will offer a soothing visual focus for a restless urban nexus, with the work's brick complementing the materials used inmost of the area's surrounding buildings."

This was her first publicly funded piece, and it was to be her last. Increasingly ill with cancer, she set to work to make a plaster model and drawing, giving it, unusually for her, the title *Gateway to Knowledge* (a reference to its proximity to the university). Gene Leofanti, as always her indispensable collaborator, was at her side.

In 1980 the Max Hutchinson Gallery in New York invited Ann to exhibit her work. Here she showed a collection of her cedar Gateways (now officially so named), to great acclaim. Max Hutchinson was a great admirer of her work, and with this very successful exhibition he signed on to become Ann's agent and representative. His main assignments were to see the public art project through to its completion and to promote her work throughout the world.

But time was running out.

Ann was always a terrible sleeper. In Florida, she often worked until 3 A.M., avoiding the issue of sleep entirely. She used to wrap all the doorknobs with cloth to stop the noise of doors closing. When she visited her brother's family in Courtland she would stay in a hotel in nearby Decatur. A railway line ran along the bottom end of the Courtland property, which Ann could not have endured. Her brother would pick her up every morning and bring her to the house. (Ann, like her aunt Rose, never learned to drive.)

Yet even in her final years and months, Ann did not for a moment stop working. She was tough that way. After all, she had been the hardiest of travelers—in the Himalayas, in a jeep, sleeping in monasteries, in the cold mountain air, she endured everything. She ignored her frailty. She urged her team on to help complete her work. Once on a visit, her niece Edith looked out of the window and heard the voices of Ann and the craftsmen who were working on her sculptures. "It was like the UN," Edith recalled, so many different languages floating upward in the muggy air.

She would always tell friends she had much more work to do. "I need ten more years," she said. Her niece Edith's husband once innocently commented, "If there are rejects, we'd love to have them." "There are no rejects!" she retorted. But later she relented. She asked her nieces to come to Barcelona Road to choose some artworks. "I have little money," she said. "And what money I have is going to the Foundation I am starting."

Friends remember her walking around the garden, in her floppy "coolie" hat, wrapped in shawls and jackets, almost like a bag lady. She had always been fearful of the sun, and her skin was vulnerable to infections that in fact ultimately developed into melanomas. She ate carefully. She liked listening to classical music, one of the bonds she had shared with Ralph. But she was everywhere the work required her to be. She discussed with Gene Leofanti the shapes of the concrete castings for the new brick sculptures she had in mind. She talked to rebar experts about the placement of the bricks, and to stone-carvers about sculptural details. She studied photographs of standing stones she had collected over the years. She never stopped drawing, covering the floor of her room with pages of sketches, always searching for a new shape, a more subtle line, a more accurate reflection of what she saw in her head. Friends reported that she would sometimes do this in almost complete darkness, shutting herself away for three or four days at a stretch, pouring out on paper her endless stream of ideas.

She kept in touch with the Dalai Lama's brother and his family in Bloomington, and they continued to visit until she became too ill to receive them. Monique always denied that Ann ever became a Buddhist: "She loved Tibetan people and the rituals of the Tibetans, as an artist it had a big influence on her. But she was not a Buddhist." Monique said Ann saw God everywhere and believed in reincarnation. On the other hand, Robert Hunter's son Nick, who was Ann's godson, remembers her reading

him bible stories when he was a boy. Ann, as always, had bifurcated loy-alties: while deeply involved in Tibetan Buddhism and its teachings, she retained her connection to the old southern religion of her childhood.

But her connection to perhaps the most important religious influence in her life was broken. There is no record of Ade Bethune, neither her name nor her presence, during Ann's last years. By the late 1960s, Ade had become a famous illustrator of holy cards, prayer books, psalters and missals—and children's books!—as well as a spokeswoman for the *Catholic Worker* and other Catholic organizations throughout the country. She founded a Christian housing organization for Newport's low-income families and began receiving awards for her charitable and literary work. In her papers in the archives of the College of St. Catherine, St. Paul, Minnesota, along with (a very few) letters from Ann, Ade has written a short note describing her friend: "We became good pals. She was amused at my accent and so was I with hers, a great, rich Southern sound from Selma, Alabama." After describing Ann's arrival at the Norton School of Art, Ade finishes the note: "When Mrs. Norton died, the widower asked Ann to marry him, & to devote her full time to her sculpture. I visited Ann in WPB in 1961."

That's it. The briskness of this summary, so unlike Ade's usual expres-sive prose, perhaps indicates her feeling about her friend's unexpected marriage. Ade and Ann never saw each other again after that brief 1961 visit. Ade Bethune died in 2002, a legendary figure in the world of Catho-lic charities, religious communities, and liturgical art.

With the sense of mortality haunting her, Ann felt she must create a legacy for future generations that would fulfill her dream of a spiritual haven, dominated by her sculptures, in a carefully planted setting that would offer peace and beauty to all comers.

Ever since Ralph's death she had been working on the roughly two-acre site, taking down trees, adding fruit bushes for the birds, and planting native plants. But now she had more specific ambitions for a foundation, which she laid out in her huge, increasingly scrawly handwriting:

Art and Education: The combination here of the brick sculptures in a natural setting, both really created simultaneously, has produced, I believe, a place with a mood that is quite special and has something of a far-away quality.

It is a wild-life sanctuary for birds: No sprays or insecticides are used, and bushes and trees bearing fruits for the birds are planted on ecological grounds. We are I believe an oasis of green in the midst of cement and condominiums, and thus a benefit for the community.

She elaborated her ideas in a later memo, intent on making absolutely clear what she had in mind: "This garden-museum is especially designed as an ensemble of art and nature—a combination of monumental sculptures with trees, bushes, water, wild-flowers of Florida. This tradition of special museums for the work of individual artists has existed for many years in Europe and is beginning to be established in this country."

Then in a typically simple and no-nonsense summary, she wrote, "I'd like to make this, eventually, a place where people can come and enjoy themselves."

Shortly after her cancer diagnosis, a certificate of incorporation of the Ann Norton Sculpture Gardens, Inc., was filed. The original mission was as follows: "to create an educational museum; to provide for and maintain an outdoor park for wildlife and art; to provide a setting for the display of sculpture and other work of Ann Norton and temporary displays of other art works; and for tours, symposiums and exhibitions."

In February 1980 a press release announced the creation of the Ann Norton Sculpture Gardens. There were a total of three gardens: The first garden contained five monumental brick sculptures, and a not-yet-finished sixth. (The seventh was constructed posthumously.) The second garden contained the cluster of seven granite figures, and the third garden contained the forty-seven-foot-long horizontal sculpture of handmade Mexican brick set in the pool at the back of the house, surrounded by lotus flowers and exotic fish.

The original officers and trustees of the Gardens included Richard Beresford, her companion on the famous Dalai Lama visit in 1979, Gene Leofanti, and Monique.

Everyone was enthusiastic and predicted a huge success for the place. But the whole concept was transformed by the appearance, like a deus ex machina, of Sir Peter Smithers, a distinguished British politician, author, and garden designer who lived in Switzerland. He met Ann in Palm Beach in 1981, when Ann was already seriously ill. She invited him to visit her, and in a series of short walks around the gardens she talked passionately

about her work and the ideas behind the foundation. During her illness, the grounds had been much neglected, and in her weakened state she realized how helpful Sir Peter could be. She begged him to take on a complete redesign of the gardens. Touched by her urgency, he agreed and began to work on an overall plan that would incorporate a selection of rare palms that he said would flourish in the south Florida climate. He recognized at once the power of the monumental sculptures and said his planting plan would work "as though you were walking through the jungle and came unexpectedly on a ruined city."

Smithers read to Ann his ideas as she lay gravely ill in bed at Barcelona Road. "At the end she tried to thank me, and she signified her agreement with the ideas I had put forward. We were both much moved. It was the future of her life's work that we were discussing, and I believe that a burden of anxiety was removed from the last days of her life."

It was multiple myeloma that killed her. She discovered how far the disease had progressed when she tried to open the door of the studio and her wrist snapped like a twig.

When Ann was in the hospital, she set up along one wall of her room a Tibetan-style altar with a prayer shawl, bells, and other objects from the Dalai Lama. (She brought from home the photograph of the Dalai Lama she used to keep in a bookcase, with traditional white *khata* draped over the frame.) Her belief in reincarnation sustained her; she often talked about it to her nieces, hoping to convince them too.

Ann died at the Good Samaritan Hospital in West Palm Beach on February 2, 1982, a few months before her seventy-seventh birthday. Only Monique was there. Gene Leofanti had visited her faithfully and fed her chicken soup when she could no longer eat anything else, but at the last, as usual, Monique outgunned him.

Ann's niece Lane and nephew William came to the funeral at the Church of Bethesda-by-the-Sea in Palm Beach. (Edith and her family were about to leave for Italy, where her husband had been relocated.) It was a simple ceremony, with no eulogies. Ann would have liked that, as she would have liked the postlude, "Before Thy Throne I Now Appear," by Bach.

Lane was put in charge of taking the ashes back to Selma. The urn was placed in a Saks 5th Avenue shopping bag "just like a jewelry box," Lane said. As she got on the plane she told her aunt, "Deat, I'm just going to put you under the seat for the take-off and landing." She held the urn carefully on her lap for the rest of the flight.

So Annie Vaughan Weaver finally returned home to the South. She was buried in one of the Weaver family plots in Selma's beautiful and atmospheric Live Oak Cemetery. Her plain gravestone, true to its subject, reveals as much by what is left out as by what is included. The inscription reads, simply, "Ann Norton sculptor. May 21 1905. Feb. 2 1982. Wife of Ralph Hubbard Norton." She lies there in the family cemetery, a Weaver in everything but name, next to her mother, as she had requested.

18

The Garden as Legacy

ANN'S WILL WAS DATED APRIL 28, 1979. In it, she left $25,000 and Ralph's piano to her sad nephew, William, and $50,000 to Gene Leofanti. Other small bequests were made to Gyani Maharani in Kathmandu ($1,000), her sister Rose ($5,000), her old friend Grace Jones ($2,000), her traveling companion Richard Beresford ($1,000), and her longtime black cook, Lessie ($1,000), among others. (Earl, her driver, had already died.) She bequeathed a sculpture "of her choice" to Ralph's daughter Beatrice Richards, who had supported her work more than the rest of the Norton family had. The largest and most controversial bequest was to Monique du Boisrouvray, "my devoted friend," in the sum of $72,000. In a codicil dated June 18, 1980, Ann also left her "my personal effects, wearing apparel and jewelry."

Following probate, the house and gardens of 235 Barcelona Road were deeded to the Ann Norton Sculpture Gardens Foundation (ANSG). Ann's personal trust from Ralph reverted, as he had stipulated in his will, to the Norton Gallery of Art. (To this day, Ralph Norton's endowments continue to help cover operating costs and acquisitions for the museum.)

Once all of these payments had been made, plus fees and legal expenses, the final bequest to the foundation amounted to something under $40,000—a dismal endowment and a terrible shock to the trustees.

Her lawyer and executor (and later U.S. senator) Harry A. Johnston II had warned her that with the pitiful funds he realized would be available after her death, it would not be possible for the gardens to continue to exist. ("I was doing the math.") He urged her to turn the gardens into a

foundation that could then have a tax-exemption, which, he said, Ann did in six weeks. She was determined for the gardens to survive. According to Johnston, she set up a group of people to take over the ANSG after her death. "But they did not have business acumen or money," he said.

The most pressing problem was Monique. Although not included in the will, Ann had made a private employment agreement with Monique in August 1981, six months before she died, stating that Monique would stay in the Barcelona Road house for her lifetime and that she would be paid a regular monthly salary of $1,500 to maintain the projects and functions of the gardens. (Was Monique "feathering her nest" at a time when her friend was very sick and vulnerable? Her critics of course thought so.)

Few of the trustees of the ANSG thought this arrangement was a good idea. Monique was already making a nuisance of herself by throwing parties at the house and generally disrespecting the place. "She was abusing the privilege," Harry Johnston said. "So I fell back on the IRS." He argued before the board that Ann's attempted gift of the house to Monique for her lifetime could not be considered a charitable gift by the IRS; and if inhabited it would be excluded from the nonprofit status of the foundation and therefore liable for taxes. At this point it was quickly agreed that the

Monique du Boisrouvray (*right*), Ann's controversial companion and supporter, in a picture taken with a friend after Ann's death. Photo courtesy of ANSG.

employment agreement was not binding. In the end, as part of a lawsuit that went to arbitration, Monique was forced out of the house and into the garage apartment. "She didn't go quietly," Harry Johnston recalled.

Fund-raising efforts stalled in angry confrontations between various members of the foundation. Some directors wanted to turn the estate into a private social club. Others wanted it to become a nonprofit, fund-raising foundation that would keep the ANSG maintained and open to the public.

In extremis, the trustees asked the Norton Gallery of Art to take them over, but the Norton board refused. This was the last in a long list of resentments between the two institutions. Ever since Ann's granite memorial had been refused a place on the museum grounds, there had been tension. Many of the Norton Gallery trustees hardly recognized Ann's existence at all, being loyal to Ralph's more satisfactory—and to them, legitimate—first wife. Elizabeth Norton, after all, had herself been a generous donor to the gallery. Although Ann remained on the board of the Norton through the 1970s, it was a token gesture. There was no attempt ever to have her work displayed in the gallery as part of the permanent collection. One might have thought they would be more tolerant, knowing that Ralph Norton's trust to Ann would revert to the museum on her death.

The result of all this bickering over where to find enough money to keep the gardens going was a very nasty lawsuit, but by 1988 things had calmed down. "At last, serenity may return to Norton's Sculpture Gallery," said a headline in the *Miami Herald* in July 1987. In the settlement, Tom Chastain, one of the few directors who actually had some money, and who had promised Ann on her deathbed that he would help the foundation, committed $145,000 to cover the institution's debts and expenses, and new directors were brought in to administer the funds and the maintenance of the ANSG.

Monique, now installed in the garage apartment, continued to work for the ANSG, meeting people, asking for money, and trying to drum up publicity. She also picked up with a group of friends considerably more bohemian than those she had entertained during her years with Ann. "They were sometimes a little bizarre," admitted her neighbor, Gene Rawls. "One day I saw a car covered in leopardskin parked outside the house, and I said to myself, 'This has to be one of Monique's friends!'" Monique died in 2000 at the age of eighty, and her ashes are buried in the garden.

There was another problematic consequence of Ann's death. This concerned the Brattle Square commission, which was unfinished when she died. Max Hutchinson, her agent, had agreed to take on the project and see it through. "It had been known to me from the artist herself that Ann Norton wished me to go on promoting her work and endeavor to both exhibit and sell it to major collections and museums," he said in a March 23, 1982, letter to Richard Beresford, then president of the Ann Norton Sculpture Gardens. "We are prepared to continue this activity in cooperation with Monique du Boisrouvray and the Board of Trustees."

This was a great relief to the ANSG members, who were sitting on a contract to build a sculpture without a clue as to how to get it completed. Now, with Max Hutchinson in charge, and Gene Leofanti entrusted with bringing the sculpture to life, so to speak, the Brattle Street project seemed to be a fitting culmination of Ann's career.

Sadly, as is so often the case in situations when the artist dies or abandons a project, lack of money and misunderstandings about the artwork left everyone unhappy and the finished sculpture a bitter disappointment. Firstly, although a contract with Cambridge Arts on the Line had been drawn up and agreed to, funds to pay for the work were lacking. Gene made a new estimate, saying that the project would cost $35,000, but Max Hutchinson was worried that he would be liable, rather than the ANSG, for any cost overruns. In May 1982 Eric Siegeltuch of the Max Hutchinson Gallery sent a letter to the Cambridge Arts on the Line administrators, pointing out that two years that had elapsed since the original creation of the contract and that it would take two more years until the sculpture was actually realized, which meant that "at best all of us will be, in effect, donating the work to the city of Cambridge, since the normal rate of inflation has long since taken away any hope of profitability from the project." After more negotiations, a new contract was signed and the project went forward.

Two years later, on January 26, 1984, Siegeltuch wrote a letter to John McCarthy, the new president of the Ann Norton Sculpture Gardens, saying that there was "virtually universal unhappiness with the finished sculpture." This was not strictly true. The Cambridge Arts on the Line people expressed great happiness with it.

But the problem voiced by its critics was that the brick used for the piece was exactly the same red brick as was used in most of the other buildings on the square. Ann, whose mastery of the material was said to

be unsurpassed, had envisaged using the much more subtly colored hand-made Mexican or North Carolina brick she used in Florida, which would have stood out against the surrounding uniformity. By using the local red brick, the impact of the sculpture was diminished and it failed to fulfill Ann's intentions.

Who was to blame for this? Fingers were pointed at Gene Leofanti. "I understand that Mr. Leofanti consulted only with the architects working on related projects in the area," Siegeltuch wrote. "It is not surprising that they would recommend using the same brick." The problem was, he argued, that architects are not sculptors, and in the absence of Ann herself, they had to rely on the judgment of the foundation's person on the scene, Mr. Leofanti, which resulted in this disaster.

But in handwritten notes dictated later by Gene Leofanti, it appears that there were other issues affecting the decision about the material. "When Ann was alive she wished to have the brick we used in Florida," he explained in these notes, "but because of weather conditions she conceded that the authorities in the area would make that judgment—and they did! And I went along with her wishes!! After all, she was the artist that won the competition."

Leofanti's explanation clearly did not reach the ears of Max Hutchinson, who, angered that he had not been consulted on the actual construction of the piece, suggested that the sum of $2,000 owed the foundation on the project should be put to use correcting the situation. (How this was to be done was not clear.) The foundation members demurred, preferring to wash their hands of the business and use the money back in Florida.

At this point, Max Hutchinson said that he would no longer represent the Ann Norton Sculpture Gardens and would return all of her work consigned to the gallery as soon as possible. "Given the present circumstances, and the priorities of the Board, it is pointless for us to continue to expend our efforts on behalf of the Foundation." Monique was devastated at his response. Knowing how important he was to the foundation, she wrote a pleading letter to Siegeltuch, regretting that Max had not been present to oversee the erection and construction of the work, and begging him to stay on. Hutchinson refused.

Happily a replica of the Cambridge monument was erected in the Barcelona Road garden after Ann's death, properly overseen by Gene Leofanti. This was her last major work and shows the world what might have been standing in Brattle Square. Made of pale, creamy Boston brick, it

is very elegant and simple, with two twenty-foot-high tapering columns connected by a lintel, overlooking a small reflecting pool that was added later.

In the end, over three hundred species of palms were planted throughout the gardens and around the sculptures, creating a lush display of evergreen canopy foliage and adding a thrilling element of surprise, just as Peter Smithers had foretold. "The palm itself is a sculpture of nature," he wrote later. "Unlike a great oak growing randomly at a thousand points, a palm has staked everything upon a single growth. If that perishes, so does the palm. It is this bold and noble simplicity of design that gives the palms their grace and their majesty. It is the same boldness that gives Ann's complex structures their beauty and their nobility."

The Ann Norton Sculpture Gardens, now in their full glory, began to accumulate widespread praise. Richard Madigan, the new director of the Norton Gallery of Art, said, "Mrs. Norton steadfastly pursued her own artistic course, (building) a monument to her vision and creativity . . . a haven of serene beauty in the middle of an urban area." Thomas M. Messer, director of the Solomon R. Guggenheim Museum in New York, commented: "Secure in their material permanence, powerfully rooted in tradition, Ann Norton's inimitable monuments now carry the force of a spirit that ever since I knew her appeared to lead an independent existence, as if it meant merely to visit her bodily frame while remaining self-sufficient when such a temporary shelter would be no more."

Peter Smithers remained involved throughout the 1980s and 1990s, sometimes as a fierce critic of the garden's development. On hearing that the directors planned to include other sculptures in the garden, he wrote, "The Ann Norton sculptures are in the same class as those of Henry Moore and Epstein. To put minor works into the garden would at once devalue the Ann Norton sculptures and would defeat any attempt to establish them in their rightful place in the world of art." He added that it would also demean the character of the garden. His only praise was for the appointment of a young and enthusiastic garden expert, Veronica Boswell Butler, whom he saw as a worthy successor to himself as guardian of the gardens. (She later became president of the ANSG.) Peter Smithers died in Switzerland in 2006.

From January 15 through February 20, 1983, the Norton Gallery of Art, for so long Ann's nemesis, finally presented a major retrospective of her art. This memorial exhibition of Ann Weaver Norton (as she was

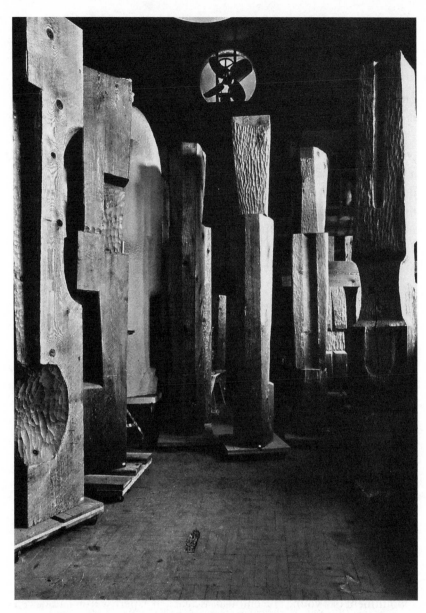

Ann's studio in the garden at 235 Barcelona Road filled with her works including wooden Gateways and maquettes for stone figures. Many still remain there today, almost as she left them. Photo Shunk-Kender © Roy Lichtenstein Foundation.

designated) included the bronzes and marble pieces that Ralph had bought for the Norton, as well as small versions of the cedar Gateways lent by the ANSG. Of course the huge brick Gateways in the garden could not be transported. Director Richard A. Madigan wrote in a foreword: "The Ann Norton Sculpture Garden is a monument to her vision and creativity. . . . Her large brick sculptures in this very personal setting show the culmination of her lifelong dream and reveal her work at total maturity."

In the spring of 1982, shortly before she died, Ann had contributed a work to a show entitled *Women's Art: Miles Apart* at the Aaron Berman Gallery in New York. She sent one sculpture only, but it caught the eye of the critic Diana Morris, who at once understood its power. "Her Gateway Number 3 is perhaps the most forceful work in the entire show," the critic wrote. "Carved from Northern cedar, it stands seven feet by four feet and suggests a primitive religious icon. There is something of Easter Island about it, and Stonehenge, and Native American totems. . . . One does not pass it by easily." This praise came in the context of the work of other artists in the show, including Lee Krasner, Louise Nevelson, and Marisol Escobar. Yes, finally, Ann Norton had come into her own.

After Ann's death, several other major shows of her work were organized. In 1987, her work was featured in a two-person exhibition at the Joy Moos Gallery in Miami. In 1991, *Ann Norton: The Unknown Works* was presented at Old School Square, Delray, Florida. In 2007 her work was included in *A Woman's Eye: Selected Works by 20th Century Women Artists* at the Lighthouse Center for the Arts; and most recently, in March 2012, a selection of her work was presented at the Sarah Moody Gallery of the University of Alabama in Tuscaloosa.

The Ann Norton Sculpture Gardens are open to the public. Shows of other artists (but, following Peter Smithers' advice, never additional sculptures in the garden itself) are sometimes presented there.

Ann's studio is also open to the public, just as she left it. This place, like those of other artists that have been preserved (the studios of Auguste Rodin, Henry Moore, and Jackson Pollock, for instance), feels as though the artist had just stepped away for a moment from the worktable. Reached by a short walk from the house, Ann's studio contains many of her plaster maquettes and wooden Gateways, along with small models of the twelve-foot granite grouping and other pieces. Perhaps most poignantly, visitors can view sets of her chisels, hammers, and other tools, along with those precious few that had belonged to her aunt Rose. The skylit space is

redolent of Ann's small but vital presence and pulses with the paradoxical effect she always provoked of strength and spirituality.

Among the ghosts who haunt these magical monoliths at 235 Barcelona Road, another benign spirit hovers over the rustling palm trees—that of Ralph Hubbard Norton, lovable musician, skillful businessman, passionately art-loving Chicago tycoon, who with one stroke of his generous pen gave his second wife, a mostly unknown, shy southern artist, her ticket to immortality. How pleased and proud he would have been to see the spectacular way she ran with that gift and created for him a reward beyond his imagining.

Although still little known, Ann Norton's mysterious sculptures in their dramatic garden setting often produce a profound and unsettling impact. There are very few sculpture gardens in the United States. Storm King Art Center in New York State is one of the most well known, but it is a vast, sprawling property, offering a very different experience from the intimate intensity of Ann's garden. Her extraordinary vision, determination, and courage give the visitor here an experience that assures the artist a secure place in the history of American art.

Exhibitions of Ann Weaver
and Ann Weaver Norton

1930	Group Exhibition, *46 Painters and Sculptors Under 35 Years of Age*, Museum of Modern Art, New York, N.Y.
1934	*Group Show by Young Americans*, Seligmann Galleries, New York, N.Y.
1935	Group Exhibition, Museum of Modern Art, New York, N.Y.
1936	Group Exhibition, Whitney Museum of American Art, New York, N.Y.
1939	Group Exhibition, Clay Club Galleries, 4 West 8th St., New York, N.Y.
1940	Sculpture Festival of the National Sculpture Society, Whitney Museum of American Art, New York, N.Y.
1943–45	Society of the Four Arts, Palm Beach, Fla.
1943–46	Norton Gallery and School of Art, West Palm Beach, Fla.
1948–45	Norton Gallery and School of Art, West Palm Beach, Fla.
1950	145th Annual Exhibition of Painting and Sculpture, Pennsylvania Academy of the Fine Arts, Philadelphia, Pa.
1950	Two Person Exhibition, Lowe Museum of Art, Coral Gables, Fla.
1950–52	Society of the Four Arts, Palm Beach, Fla.
1952	Group Exhibition, Lowe Gallery, Coral Gables, Fla.
1952	Group Exhibition, National Gallery of Art, Havana, Cuba
1954	Group Exhibition, Carnegie International, Carnegie Museum of Art, Pittsburgh, Pa.
1960	Group Exhibition, National Gallery of Art, Havana, Cuba
1960	Group Exhibition, Schneider Gallery, Rome, Italy
1960	Solo Exhibition, Orlando Museum, Orlando, Fla.
1961	Group Exhibition, Galleria XXII, Venice, Italy

1963	Group Exhibition, Associated Florida Sculptors Sixth Annual Exhibition, Lowe Museum of Art, Coral Gables, Fla.
1968	Solo Exhibition, Bodley Gallery, New York, N.Y.
1969	Solo Exhibition, Norton Gallery and School of Art, West Palm Beach, Fla.
1970	Solo Exhibition, Bodley Gallery, New York, N.Y.
1972	Solo Exhibition, Galerie Juarez, Palm Beach, Fla.
1974	Solo Exhibition, Galerie Juarez, Palm Beach, Fla.
1976	Group Exhibition, *La Forme Humaine*, Musee Rodin, Paris, France
1978	Solo Exhibition, Clocktower Gallery, New York, N.Y.
1978	Group Exhibition, International Cultural Centre, Antwerp, Belgium
1979	Solo Commission, Brattle Square, Cambridge Arts Council, Cambridge, Mass.
1980	Solo Exhibition, *Ann Norton: Gateways*, Max Hutchinson Gallery, New York, N.Y.
1980	Two Person Exhibition, Lowe Museum of Art, Coral Gables, Fla.
1982	Group Exhibition, *Women's Art: Miles Apart*, Aaron Berman Gallery, New York, N.Y.
1982	Group Exhibition, *Women's Art: Miles Apart*, Valencia Community College, Orlando, Fla.
1982	Group Exhibition, Lock Haven Art Center, Orlando, Fla.
1982	Group Exhibition, *50 National Women in Art*, Edison Community College Gallery of Fine Art, Naples, Fla.
1983	*Ann Weaver Norton, Sculptor: A Memorial Exhibition*, Norton Museum of Art, West Palm Beach, Fla.
1987	Two Person Exhibition, Joy Moos Gallery, Miami, Fla.
1991	*Ann Norton: The Unknown Works*, Old School Square, Delray, Fla.
2007	*A Woman's Eye: Selected Works by 20th Century Women Artists*, Lighthouse Art Center, Tequesta, Fla.
2012	*Anthology: Sculpture and Drawing by Ann Norton*, University of Alabama, College of Arts and Sciences, Birmingham, Ala.

Notes

Abbreviations

ABC Ade Bethune Collection, St. Catherine University, St. Paul, Minn.
ANSG Ann Norton Sculpture Gardens, West Palm Beach, Fla.
DLM Doy Leale McCall Collection, University of South Alabama, Mobile, Ala.
NMA Norton Museum of Art, West Palm Beach, Fla.
SPB Selma-Dallas County Public Library, Selma, Ala.

Prologue

Information about old Cahawba comes from "Explore Old Cahawba" and walking-tour brochures published by the Alabama Historical Commission. Details about the heyday of the city of Cahawba in the mid-nineteenth century can be found in a wonderful memoir of the period, *Memories of Old Cahaba* (its old spelling), by Anna M. Gayle Fry (Nashville, Tenn., Dallas, Tex.: Publishing House of the Methodist Episcopal Church South, 1908).

Chapter 1. The Origins of a Great Alabama Family

Much of the information in this chapter comes from family papers, books, and newspapers in the Selma-Dallas County Public Library (SPB); from the private collections of Edith Weaver Haney and Lane Weaver Byrd; and from author's interviews with Rosalind Tarver Lipscomb, Bobby Willis, John Lott, and John P. C. McCall.

From its veranda] Author interview with Jean Martin, curator, Old Depot Museum, Selma, October 27, 2010. A rare photograph of Philip Weaver's Selma house can be seen in the Old Depot Museum.

On April 2, 1865] Rose Pettus Weaver diary, DLM. John P. C. McCall private collection.

Since Philip Weaver had the best house] Mentioned in *Reuben Vaughan Kidd: Soldier of the Confederacy*, by Alice V. D. Pierrepont (Petersberg, Va.: Violet Bank, 1947), 373.

Ann's paternal great-grandfather] The story of his heroic resistance is published in the centennial edition of the *Selma Times-Journal*, November 2, 1927, SPB; also author interview with Edith Weaver Haney, March 16, 2013.

Emerald Place] Now demolished.

William Weaver's major contribution] Longtime Selma residents are full of stories about this fabled house and its ghosts. Abandoned for over twenty-five years, the Castle has recently been bought and is being restored.

With the help of imported German workmen] Author interview with Erin Vaughan Morris, Selma, October 27, 2010.

William installed several unusual features] Rose Pettus Weaver diary, John P. C. McCall private collection.

as a memorial book said of him] *Paul Turner Vaughan Memorial Book* (Nashville, Tenn., Dallas, Tex.: Publishing House of the Methodist Episcopal Church South, 1919), SPB.

Chapter 2. Childhood in Selma

Much of the information in this chapter comes from the catalogue written in 1980 by C. Reynolds Brown for an exhibition of Clara Weaver Parrish's work at the Montgomery Museum of Fine Arts, Montgomery, Alabama. Other references include Christine Crafts Neal, "Daughters of the South," *Alabama Heritage* 21 (Summer 1991): 6–19; and William U. Eiland, *Ann Weaver Norton: Sculptor* (ANSG: 2000). Sturdivant Hall in Selma contains an archive of Clara Weaver Parrish's papers, as well as artwork by the artist and furniture that belonged to her.

A lovely portrait] Now in Sturdivant Hall.

According to several Vaughan cousins] Author conversation with Edith Weaver Haney. Ms. Haney also found out that her great-grandfather, Henry Vaughan, inherited a trust fund worth $20 million from his father Dr. Samuel W. Vaughan, a major beneficiary of which is the Vaughan Regional Health Center in Selma.

Ann later told Jerry Tallmer] Jerry Tallmer, "A Tiny Woman Who Shapes Big Visions," *New York Post*, March 4, 1978, 6.

A clue as to Clara's influence] Unpublished memoir by Henry A. Vaughan.

According to Rosalind Tarver Lipscomb] Author interview with Rosalind Tarver Lipscomb, October 26, 2010.

In 1922, while in Paris] Letter from Clara Weaver Parrish to her nephew William. Edith Weaver Haney, private collection.

The Weavers were of course all deeply interested] A copy of Clara Weaver Parrish's will is in the archive at Sturdivant Hall in Selma.

Chapter 3. Early Success

She did well there] Information about Ann Weaver Norton's career at Smith comes from author correspondence with Deborah A. Richards, Smith College Archives, Northampton, Mass.

Frawg, Boochy's Wings, and *Pappy King*] Originals of Annie Vaughan Weaver's three children's books are housed with Edith Weaver Haney's private collection.

That is the writing of someone who had been there] Mary Ann Patterson, the granddaughter of a close friend and neighbor of the Weaver family, remembered hearing the story of how Annie Vaughan and her brother would go with their mother to listen to the black church services: "They went in a wagon so they could pull up to the window to see and hear inside."

When she saw copies of them] Author interviews with Edith Weaver Haney and Lane Weaver Byrd, April 24, 25, and 26, 2011.

There is no trickier subject] In her novel, *The Help,* Kathryn Stockett quotes from Howell Raines's article "Grady's Gift," *New York Times Magazine,* December 1, 1991.

Chapter 4. A Tumultuous Education

General information about the National Academy of Design, the Cooper Union Art School, and the Art Students League comes from their respective archives in New York City.

On September 17, 1928] Ann Weaver's attendance was registered on index cards, 1928–1930.

Annie Vaughan attended classes] The names of her teachers were written on the index cards mentioned above.

When [Curran] went there to paint portraits] Unidentified, undated press clipping.

Annie Vaughan gained admission to Cooper Union Art School in 1932] Letter from Ann Weaver to Helen W. Burgess, director of the summer school, Norton School of Art, West Palm Beach, Florida, July 31, 1942, NMA.

Georg Lober] Lober's assistant and sculpture-enlarger for these and other famous pieces was a young Italian called Gene Leofanti, later to play a huge role in Ann Weaver Norton's artistic career.

The subject was entitled *Negro Head*] By the late 1920s, the interest of artists (including Matisse, Brancusi, Picasso, and Picabia) in African art was peaking. This was the heyday of the Harlem Renaissance, and black subject matter dominated many of the big shows in New York, such as the 1925 exhibition *The New Negro* at the Brooklyn Museum and *The Negro in Art Week,* which showed at New York's Neumann Gallery in 1927 and later at the Art Institute of Chicago.

Even more impressive] Letter from Ann Weaver to Helen W. Burgess, director

of the summer school, Norton School of Art, West Palm Beach, Florida, July 31, 1942, NMA.

She received another traveling fellowship in 1935] Letter from Ann Weaver to Helen W. Burgess, July 31, 1942, NMA.

For one summer] Letter from Ann Weaver to Helen W. Burgess, July 31, 1942, NMA.

Chapter 5. The Emergence of an Artist

Many books and articles have been published on the subject of the New York art world in the 1930s. Of particular relevance is the exhibition catalogue, *Vanguard American Sculpture, 1913–1939*, organized and with essays by Joan M. Marter, Roberta K. Tarbell, and Jeffrey Wechsler (Brunswick, N.J.: Rutgers University Art Gallery, 1979).

During Ann's years in New York] Much of the information about Rockefeller Center comes from Daniel Okrent, *Great Fortune: The Epic of Rockefeller Center* (New York: Penguin: 2004).

Zorach spoke and wrote eloquently] William Zorach, *Art is My Life: The Autobiography of William Zorach* (Cleveland, Ohio: World Publishing Co., 1967), 85.

William Zorach describes] William Zorach, *Art Is My Life*, 119–20.

Chapter 6. A Rare Friendship

Most of Ade Bethune's papers are in the Ade Bethune Collection, St. Catherine University Library, St. Paul, Minn. (ABC). A selection of Ade Bethune's letters to Ann Weaver is housed in the archive of the Ann Norton Sculpture Gardens, West Palm Beach, Fla. (ANSG).

In 1938] July 31, 1942, letter from Ann Weaver to Helen W. Burgess, director of the summer school, Norton School of Art, West Palm Beach, Florida, NMA.

She took drawing lessons in Brussels] Judith Stoughton, *Proud Donkey of Schaerbeek: Ade Bethune, Catholic Worker Artist* (St. Cloud, Minn.: North Star Press, 1985), 6.

We became good pals] Explanatory handwritten note by Ade Bethune inserted into her papers when they were acquired by St. Catherine University, ABC.

As Ade tells it] Judith Stoughton, *Proud Donkey of Schaerbeek*, 37.

She brought us a number] Dorothy Day, "On Pilgrimage—May 1978," *Catholic Worker*, May 1978, 2. Online at http://www.catholicworker.org/dorothyday/reprint2.cfm?TextID=588.

She loved to laugh] Author interview with John Benson, April 27, 2011.

Carey was an intriguing character] Author interview with John Benson, April 27, 2011.

Carey and Ade began a correspondence] Housed in the Ade Bethune Collection (ABC), St. Catherine University, St. Paul, Minn.

It fills a great need] Letter from John Howard Benson to Ade Bethune, February 10, 1935, ABC.

John Howard Benson's fame] Author interview with John Benson, April 27, 2011.

One of the chief proponents] Rama P. Coomaraswamy, *The Door in the Sky: Coomaraswamy on Myth and Meaning* (Princeton, N.J.: Princeton University Press, 1997), passim.

The Lord be with you, Chile] Letter from Ade Bethune to Ann Weaver, "The tenth Sunday after Pentecost," 1935, ANSG archive.

Today feast of St. Anne] Letter from Ade Bethune to Ann Weaver, July 26, 1937, ANSG archive.

Been thinking lots] Undated letter, ANSG archive.

Learning that Ann was to include England] Letter from Ade Bethune to Graham Carey, June 26, 1935, ABC.

May I recommend ANN WEAVER] Letter from Ade Bethune to Graham Carey, July 25, 1937, ABC.

Ade was already running the place] Author interview with John Benson, April 27, 2011.

The younger woman's letters] Recent controversy over the letters between Eleanor Roosevelt and the newspaperwoman, Lorena Hickock, are evidence of a different kind. Their letters, written at the same time Ade was writing to Ann, are too specifically erotic to ignore and far more physical in description than Ade's ever were.

Chapter 7. Career Challenges

Much of the information for this chapter comes from William U. Eiland, *Ann Weaver Norton: Sculptor* (ANSG: 2000), who interviewed Crawford Gillis and John Lapsley extensively before their deaths.

In 1935, William] Letter from William Weaver to Edith Weaver, Edith Weaver Haney private collection.

It was important] Author interview with Edith Weaver Haney, April 26, 2011.

The New South School] Miriam Rogers Fowler, "New South School and Gallery," essay in *New South, New Deal, and Beyond: An Exhibition of New Deal Era Art 1933–1943* (Montgomery: Alabama Artists Gallery, 1989).

The Art Students League] Patricia Phagan, introduction to exhibition catalogue, *The American Scene and the South: Paintings and Works on Paper, 1930–1946* (Athens: Georgia Museum of Art, University of Georgia, 1996).

According to Crawford Gillis] William U. Eiland, *Ann Weaver Norton: Sculptor* (ANSG: 2000), 28.

John Lapsley remembers] William U. Eiland, *Ann Weaver Norton: Sculptor* (ANSG: 2000), 92n43.

Ann suggested he write to Ade] Letter from John Lapsley to Ade Bethune, February 6, 1939, ABC.

He and Crawford Gillis] Letter from Ade Bethune to Graham Carey, November 2, 1939, ABC.

In May 1939, she argued] Letter from Ann Weaver to Crawford Gillis, May 31, 1939, ANSG archive.

The most momentous event] Letter from Ann Weaver to Helen W. Burgess, director of the summer school, Norton Museum of Art, West Palm Beach, Florida, July 31, 1942, NMA.

It is a real jenu-ine commission] Letter from Ann Weaver to Crawford Gillis, May 31, 1939, ANSG archive.

Dr. McSweeney was delighted] Letter from Katharine E. McSweeney to Ann Weaver, July 18, 1940, Edith Weaver Haney private collection.

In March 1941, Ade wrote to her] Letter from Ade Bethune to Ann Weaver, March 16, 1941, ANSG archive.

Through her internships] Letter from Ann Weaver to Helen W. Burgess, July 31, 1942.

Ann left this studio] Letter from Ann Weaver to Helen W. Burgess, July 31, 1942.

A surprising appearance] Author interviews with Edith Weaver Haney and Lane Weaver Byrd, April 24, 25, and 26, 2011.

Only one other name] Letter from Ann Weaver to Helen W. Burgess, July 31, 1942.

They wouldn't care a scrap] Letter from Ade Bethune to Ann Weaver, December 20, 1941, ANSG archive.

She listed where her work] Letter from Edward R. Murrow to Ann Weaver, January 18, 1932; letter from George Lober to Ann Weaver, undated; letter from L. P. Skidmore to Ann Weaver, March 18, 1942, all in NMA.

She did not hesitate to engage] Letters from Ann Weaver to Helen W. Burgess, September 9, 1942, and July 31, 1942.

The director of the Norton School of Art] Letter from Mrs. Mary E. Aleshire to Ann Weaver, October 13, 1942, NMA.

Chapter 8. A Turning Point

Comprehensive information about Ann's career as a sculptor is available at the ANSG archive.

According to John Lapsley] William U. Eiland, *Ann Weaver Norton: Sculptor* (ANSG: 2000), 29.

She exhibited a limestone doorstop] Letter from Ann Weaver to Helen W.

Burgess, director of the summer school, Norton School of Art, West Palm Beach, Florida, July 31, 1942, NMA.

Several of these pieces] As well as being the archivist of photographs at MOMA, Soichi Sunami was a distinguished photographer of twentieth-century artists and dancers, including Martha Graham, Anna Pavlova, Ruth St. Denis, Edward Hopper, and Leopold Stokowski.

I could have exhibited] Letter from Ann Weaver to Helen W. Burgess, July 31, 1942, NMA.

Robert Hunter, director] E. Robert Hunter, *Ann Weaver Norton, Sculptor: A Memorial Exhibition*, catalogue, Norton Gallery of Art, January 1983.

Lapsley and Gillis] Author interview with John P. C. McCall, April 5, 2011.

In the judgment of William U. Eiland] William U. Eiland, *Ann Weaver Norton: Sculptor* (ANSG: 2000), 38.

As the contemporary artist] Author interview with Claudia Aronow, May 11, 2011.

The politics of the conflict] *The Art Critics—! How Do They Serve the Public? What Do They Say? How Much Do They Know? Let's Look At the Record!* Brochure published by the American Abstract Artists and distributed at the American Abstract Artists Fourth Annual Exhibition in New York, June 1940.

The more interesting comparison] Biographical information about Louise Nevelson comes from Laurie Lisle, *Louise Nevelson: A Passionate Life* (New York: Summit Books, 1990), passim.

Composing in space] Letter from Ann Weaver to Crawford Gillis, December 16, 1943; William U. Eiland, *Ann Weaver Norton: Sculptor* (ANSG: 2000), 38n93.

Louise Nevelson was also] Laurie Lisle, *Louise Nevelson,* passim.

These are the most important pieces] Letter from Ann Weaver to Anton Basky, August 7, 1946, ANSG archive.

She arranged to pay] Letter from Ann Weaver to Anton Basky, March 18, 1946, ANSG archive.

Lead is dull] Letter from Anton Basky to Ann Weaver, March 15, 1946, ANSG archive.

I would appreciate it] Letter from Ann Weaver to Anton Basky, April 29, 1946, ANSG archive.

She alerted Basky] Letter from Ann Weaver to Anton Basky, March 18, 1946, ANSG archive.

Basky in fact was having his own troubles] Letter from Anton Basky to Ann Weaver, July 28, 1947, ANSG archive.

Chapter 9. The Savior from Chicago

The life of Ralph Norton and his creation of the Norton Gallery of Art have been well chronicled by William McGuire in *Ralph Norton and the Norton Gallery*

of Art, published by the Norton Gallery of Art, West Palm Beach, Florida, 1994. Much of this chapter has been drawn from this work. The letters included in this chapter from Ann Weaver to Crawford Gillis and John Lapsley are in the ANSG archive.

Gift of $500,000] *Palm Beach Post*, April 6, 1940.

West Palm Beach at that time] Caroline Seebohm, *Boca Rococo: How Addison Mizner created Florida's Gold Coast* (New York: Clarkson Potter, 2001), 181.

In a statement] E. Robert Hunter, "Norton Gallery of Art, Young and Vital, Attains National Position," *Art Digest*, November 15, 1948, 15.

On December 15, 1942, Mrs. Aleshire] NMA.

Moreover, the atmosphere at the school] Author interview with E. Robert Hunter, October 3, 2009.

Hunter called the scene] William U. Eiland, *Ann Weaver Norton: Sculptor* (ANSG: 2000), 26n57.

Robert Hunter always said] Author interview with E. Robert Hunter, October 3, 2009.

Ann used to come to our house] Author interview with E. Robert Hunter, October 3, 2009.

She was intellectually] Author interview with E. Robert Hunter, October 3, 2009.

Ouida described Ann] Author interview with Ouida George, October 4, 2009.

Chapter 10. A Reticent Romance

Two author interviews with E. Robert Hunter form the basis of much of the information here about Ralph Norton's collecting. E. Robert Hunter was present at many of the first meetings between Ralph Norton and Ann Weaver, and his recollections are reflected in this chapter.

All the letters quoted between Ann Weaver and Ralph Norton are in the ANSG archive.

Mr. Norton had a good grasp] William McGuire, *Ralph Norton and the Norton Gallery of Art* (West Palm Beach, Fla.: Norton Gallery of Art, 1994), 21.

Fortunately for us, a young man] George Hatzenbuhler, *My War Years 1941–1947*, self-published, 70.

Profit: $447] Ann Weaver's expenses notebook, ANSG archive.

Chapter 11. Marriage and a New Life

All the letters quoted here between Ann Weaver and Ralph Norton in April and May 1948 are in the ANSG archive.

She was white as a sheet] Author interview with E. Robert Hunter, October 3, 2009.

They were finally hustled onto the train] William U. Eiland, *Ann Weaver Norton: Sculptor* (ANSG: 2000), 94n76.

Much later, after Ralph's death] "The Gold Rush: A Guide to the Gold Coast's Widows and Divorcees," *Country*, March 1981, 100.

Chapter 12. A Growing Confidence

There probably will be great social doings] Letter from Ralph Norton to Ann Weaver, June 4, 1948, ANSG archive. (Ann married Ralph on June 12, 1948, and changed her name to Ann Norton thereafter.)

Rose responded] Rose Pettus Weaver diary, John P. C. McCall private collection.

Once she spotted] Rose Pettus Weaver diary, John P. C. McCall private collection.

Rose was looked after] Author interviews with Edith Weaver Haney and Lane Weaver Byrd, April 24, 25, and 26, 2011.

Her young nieces] Author interviews with Edith Weaver Haney and Lane Weaver Byrd, April 24, 25, and 26, 2011.

Ralph evidently liked southerners] Letter from Ralph Norton to Ann Weaver, February 6, 1948.

Touching evidence] Letter from Ralph Norton to Edith Vaughan Weaver, July 13, no year, Edith Weaver Haney private collection.

William's own career] Author interviews with Edith Weaver Haney and Lane Weaver Byrd, April 24, 25, and 26, 2011.

When William's wife, Jeanne] Author interview with Edith Weaver Haney, March 16, 2013.

After his sister's marriage] Author interviews with Edith Weaver Haney and Lane Weaver Byrd, April 24, 25, and 26, 2011.

Anything you decide is all right with me] Letter from Ralph Norton to Ann Weaver, May 14, 1948, ANSG archive.

She later described] Jerry Tallmer, "A Tiny Woman Who Shapes Big Visions," *New York Post*, April 3, 1978, 16.

becoming honorary president for life] *Chautauqua Daily*, July 26, 1954, 7.

During these separations] Postcard from Ralph Norton to Ann Norton, April 16, 1951, ANSG archive.

In 1947, Ralph had bought] The list of acquisitions during these years comes from NMA.

and the spectacular Brancusi sculpture] One wonders whether Ralph was inspired to buy the Brancusi after seeing it (or another version of it) in the Society of the Four Arts sculpture exhibition in Palm Beach in March 1949. The sculpture show, the first of its kind, also exhibited sculptors such as José de Creeft, William Zorach, and John Flannigan to shock the traditionally minded art-lovers of Palm Beach. The prime organizers of this exhibit, which reflected quite strikingly what

was going on across the bridge, were none other than Mr. and Mrs. William Mc-Kim. *Palm Beach Daily News,* March 27, 1949.

In 1950 an extraordinary number] William McGuire, *Ralph Norton and the Norton Gallery of Art* (West Palm Beach, Fla.: Norton Gallery of Art, 1994), 26.

It was a one-hundred-thousand dollar purchase] William McGuire, *Ralph Norton and the Norton Gallery of Art,* 26.

In a talk to the Norton museum staff] William McGuire, *Ralph Norton and the Norton Gallery of Art,* 27.

In a talk he gave two years later] Ralph Norton, "Art and the Norton Gallery," address to the Membership of the Palm Beach Art League, December 1, 1952, ANSG archive.

It is clear that Ann] Author interview with E. Robert Hunter, October 3, 2009.

Gallery director Bill Woods] William McGuire, *Ralph Norton and the Norton Gallery of Art,* 28.

Tributes poured in] Telegram from Pierre Matisse to Ann Norton, January 13, 1954, ANSG archive.

A fond memory came] Letter from Theodore Roszak to Ann Norton, April 5, 1954, ANSG archive.

Alfred Barr, the director] Letter from Alfred Barr to Ann Norton, February 2, 1954, ANSG archive.

Ann had kept a clipping] ANSG archive.

Chapter 13. New Freedom, New Work

Hunter said] William McGuire, *Ralph Norton and the Norton Gallery of Art,* 30.

Among Ann's papers] ANSG archive.

Ralph's will was duly probated] On file at ANSG archive, as well as in Edith Weaver Haney's private collection.

The reason was explained to her] Letter from Cecil B. Bronston, Continental Illinois National Bank and Trust Company of Chicago, to Ann Norton, June 22, 1954, ANSG archive.

But while he continued to urge her] Letter from Cecil B. Bronston to Ann Norton, November 22, 1954, ANSG archive.

After Rose's will was read] Author interviews with Edith Weaver Haney and Lane Weaver Byrd, April 24, 25, and 26, 2011.

She left only $500] Author interview with Rosalind Tarver Lipscomb, October 26, 2010.

The lawsuit was filed] Edith Weaver Haney private collection.

According to a young lawyer friend of his] Author interview with John P. C. McCall, April 5, 2011.

But the story was spread around] William U. Eiland, *Ann Weaver Norton: Sculptor* (ANSG: 2000) 16.

Ann's nieces dispute this notion] Author interviews with Edith Weaver Haney and Lane Weaver Byrd, April 24, 25, and 26, 2011.

As soon as she took ownership] Floor plans of the new studio, ANSG archive.

In the end it looked remarkably similar] Author interview with James Y. Arnold, December 8, 2009.

Chapter 14. Figures in the Landscape

Correspondence between Ann Norton, Gene Leofanti, and René Lavaggi used in this chapter are in the collection of ANSG archive.

A photograph] ANSG archive.

for which he had given his blessing] Letter from Cecil B. Bronston to Willis F. Woods, November 28, 1955, ANSG archive.

In a letter to Willis Woods] Letter from Daniel Catton Rich to Willis F. Woods, November 21, 1955, ANSG archive.

In December 1955 a contract] ANSG archive.

After consulting with lawyers] Letter from Cecil B. Bronston to Willis F. Woods, November 28, 1955, ANSG archive.

As I travelled] Susan Hubband, "Massive Statuary Group Slated for Norton Gallery," *Palm Beach Post-Times*, April 16, 1967, 11.

To another reporter] Melinda Robinson, "Small Sculptress Creates Giant Works of Art," *Palm Beach Daily News*, March 7, 1971, 11.

She carefully kept them in the loop] Letter from Ann Norton to Mr. and Mrs. Christopher Norton, undated, ANSG archive.

It was often said] Author interview with Leo Leofanti, October 6, 2009.

In a hurried letter] Letter from Ade Bethune to Ann Norton, May 11, 1961, ANSG archive.

The board said NO] Author interview with E. Robert Hunter, October 3, 2009.

They're not people really] Kathryn Robinette, "Artist sculpts bridges between the earth and sky," *Evening Times*, December 10, 1980, B1.

Chapter 15. East and West, New Relationships

Much of the information about Monique du Boisrouvray comes from author interviews with Thomas M. Chastain and extensive tape-recorded interviews with Monique du Boisrouvray conducted by Glen Rawls in 1994, courtesy of Mr. Rawls.

In the mid-1950s] Author interview with Ouida George, October 4, 2009.

One was a member] Letter from Gyani Maharan to Ann Norton, September 14, 1976, ANSG archive.

Monique probably first met Ann] Glen Rawls interview of Monique du Boisrouvray, tape recording, November 1994.

Ann had never been a good eater] Author interviews with Edith Weaver Haney and Lane Weaver Byrd, April 24, 25, and 26, 2011.

He was heartsick] Author interview with Leo Leofanti, October 6, 2009.

In February 1969] Letter from Thubten Norbu to Thupten Ningee, February 3, 1969, ANSG archive.

There is however a vivid description] E-mail from Richard Beresford to Cynthia Palmieri, September 18, 2008, ANSG archive.

When you see Asia] Author interviews with Edith Weaver Haney and Lane Weaver Byrd, April 24, 25, and 26, 2011.

I use everything] Grace Glueck, "Ann Norton, Sculptor, Says She's like the Tip of an Iceberg," *New York Times*, March 26, 1978.

My first gateway sculptures] Ann Norton unpublished, undated essay, ANSG archive.

I didn't see those] Grace Glueck, "Ann Norton, Sculptor, Says She's like the Tip of an Iceberg."

I envisioned] Ann Norton, unpublished, undated essay, ANSG archive.

Chapter 16. Dreams of Selma

Family stories about Ann Norton and her nephew, William Weaver IV, in this chapter come mostly from author interviews with Edith Weaver Haney and Lane Weaver Byrd. Quoted letters from William Weaver to Ann Norton are in the collection of ANSG archive.

Her cousin Trot Vaughan] Author interview with Trot Vaughan, March 17, 2013.

Much later one of the Palm Beach] Author interview with Mimi Duncan, December 9, 2009.

She had Balinese dancers] Author interview with Lynn Leofanti Cole, February 26, 2010.

Many artists came to see her] Glen Rawls interview of Monique du Boisrouvray, tape recording, November 1994.

All your appeals have come] Letter from Ann Norton to William Weaver, undated, ANSG archive.

A wonderful place!] Postcard from Ann Norton to John Lapsley, date obscured, ANSG archive.

Brick blends with this land] "Ann Norton, Sculpture and Drawings," press release, *The Clocktower*, February 8, 1978.

Chapter 17. Time Runs Out

Information about Ann Norton's shows in the 1960s and 1970s can be found in the collection of ANSG archive.

These sculptures showcased] Amy Goldin, introduction to *Ann Norton Sculpture*, the catalogue from her 1968 Bodley Gallery show in New York. ANSG Archive.

The director of the gallery] David Mann, "Ann Norton Sculpture and Drawings," Bodley Gallery, New York, November 5–28, 1970. Reprinted from *Arts Magazine*, December/January 1969.

It is high time] E. Robert Hunter, catalogue introduction to *Ann Norton Sculpture*, published by the Norton Gallery of Art, West Palm Beach, Florida, for her show at the Norton Gallery of Art, West Palm Beach, January 8–26, 1969.

Mr. Cunningham unfortunately resigned] Letter from the Art Institute of Chicago to Ann Norton, September 13, 1972, ANSG archive.

Max Hutchinson was a great admirer] Letter from Max Hutchinson to Richard E. Beresford, president, Ann Norton Sculpture Gardens, March 23, 1982, ANSG archive.

She used to wrap all the doorknobs] Author interviews with Edith Weaver Haney and Lane Weaver Byrd, April, 24, 25, and 26, 2011.

I need ten more years] Author interviews with Edith Weaver Haney and Lane Weaver Byrd, April 24, 25, and 26, 2011.

Friends remember her] Author interviews with Leo Leofanti, October 6, 2009; Thomas M. Chastain, October 5, 2009; and Edith Weaver Haney and Lane Weaver Byrd, April 24, 25, and 26, 2011.

Monique always denied] Tape-recorded interview of Monique du Boisrouvray with Glen Rawls, November 1994.

But now she had more specific ambitions] Ann Norton, handwritten notes, undated, ANSG archive.

Shortly after her cancer diagnosis] Certificate of incorporation, September 1977, ANSG archive.

Smithers read to Ann] William U. Eiland, *Ann Weaver Norton: Sculptor* (ANSG: 2000) 102.

Chapter 18. The Garden as Legacy

Ann's will was dated] ANSG archive.

Once all of these payments] Letter from Karren L. Maxwell, legal assistant, Johnston, Sasser, Randolph, and Weaver, to Dr. Duncan R. McCuaig, treasurer, Ann Norton Sculpture Gardens, November 11, 1983, ANSG archive.

Her lawyer and executor] Author interview with Harry A. Johnston II, Esq., December 7, 2009.

Although not included in the will] Employment contract between Ann Norton Sculpture Gardens and Monique du Boisrouvray, August 1, 1981, ANSG archive.

She was abusing the privilege] Author interview with Harry A. Johnston, December 7, 2009.

In extremis] Author interview with Harry A. Johnston, December 7, 2009.

At last, serenity may return] Mike Wilson, "At last, serenity may return to Norton's sculpture gallery," *Miami Herald*, July 10, 1987.

In the settlement] Author interview with Thomas M. Chastain, October 5, 2009.

They were sometimes a little bizarre] Author interview with Glen Rawls, October 6, 2009.

Gene made a new estimate] Letter from Eric Siegeltuch (Max Hutchinson's assistant) to Monique du Boisrouvray, May 1, 1982, ANSG archive.

In May 1982 Eric Siegeltuch] Letter from Eric Siegeltuch to John Chandler, Arts on the Line program, May 11, 1982, ANSG archive.

Two years later] Letter from Eric Siegeltuch to John McCarthy, president, Ann Norton Sculpture Gardens, January 26, 1984, ANSG archive.

But in handwritten notes] Draft manuscript courtesy of Lynn Leofanti Cole. Gene Leofanti dictated the draft to Helen Zank, his neighbor and sometime secretary, obviously as a defense to the accusations against him. Its addressee was John McCarthy, president, ANSG, but whether the letter was ever sent is not clear.

At this point, Max Hutchinson] Letter from Max Hutchinson to John McCarthy, February 15, 1984, ANSG archive.

Happily a replica] Letter from Gene Leofanti to John McCarthy, January 14, 1984, ANSG archive. Leofanti estimated the cost of the replica at $14,000.

In the end, over three hundred species of palms] Letter from Veronica Boswell Butler to the Tourist Development Council, September 20, 1993, ANSG archive.

Richard Madigan, the new director] Richard Madigan, catalogue foreword, *Ann Weaver Norton, Sculptor: A Memorial Exhibition* (West Palm Beach, Fla.: Norton Gallery of Art, 1983).

Thomas M. Messer] Thomas M. Messer, catalogue introduction, *Ann Weaver Norton, Sculptor: A Memorial Exhibition.*

Peter Smithers remained involved] Letters from Sir Peter Smithers to Thomas M. Chastain, Richard Moyroud, and John McCarthy, 1988–1990, ANSG archive; also see Anne Kilmer, "Smithers: Multifaceted Gardener," *Palm Beach Post*, March 6, 1988, 8L.

Her Gateway Number 3] Diana Morris, "Women's Art: Women Miles Apart," *Women Artists News* 7 (March/April 1982): 15–16.

Acknowledgments

First and foremost I wish to thank Ann Norton's two nieces, Edith Weaver Haney and Lane Weaver Byrd, who shared their memories and archives with me with unstinting generosity and patience. Edith, the family archivist and historian, pored over Weaver family papers for years, teasing out the necessary facts about Ann's background, following up leads, and making contact with people who might be able to help. No researcher could have done more. She was also wonderfully hospitable during my trips to Alabama, as was her husband, Lynn, who uncomplainingly (and expertly) drove us around during these complex visits. My visit to Lane in Chatham, Massachusetts, was equally productive.

Another key person in helping me write the book was Cynthia Palmieri, director of the Ann Norton Sculpture Gardens and guardian of the flame. She knows every file, every artwork, and every photograph that exists in the house where Ann Norton lived and died (and much material elsewhere), but far more than that, she almost channels Ann Norton herself, giving me constant guidance and revelations about the life and art of this exceptional woman. Cynthia also assumed the enormous responsibility of sorting and scanning most of the images required for the book—a herculean task.

Aiding Cynthia were her indispensable colleagues, Donna Pfeiffer and Isolde Koester, who welcomed and helped me the many times I visited Barcelona Road. Sherri Sabo at Zabo Graphics worked tirelessly and under great pressure to improve the many problematic images. I cannot thank them enough.

I was given permission to access the archives without restrictions by Rodman Steele, former president of the Gardens, and David Miller, former president and current vice-president of the Gardens, both of whom received my proposal to write the book with enthusiasm. They have my

gratitude. Veronica Boswell Butler, former president and vice president, supported me from the beginning.

Ann's story begins in Selma, Alabama, her birthplace. During my visits there, several relatives and family friends, including Bobby Willis, Erin Vaughan, Christine Vaughan, and Trot Vaughan, took the time to speak to me about her family. I talked to Selma native John Lott in Palm Beach, where he now lives. The late Jean Martin, guardian of the Old Depot Museum in Selma, was very helpful, as were Manera Searcy, director of Sturdivant Hall in Selma, and Becky Nichols, Anne Wright, and Mary Morrow at the Selma-Dallas County Public Library.

I was inspired by the artist Rosalind Tarver Lipscomb, Ann's cousin, whom I met at an exhibition of Weaver art at the Birmingham Museum of Art in Alabama in 2010 and afterward talked to at her home in Huntsville. Graham Boettscher, curator of American Art at the Birmingham Museum of Art, gave me fascinating insights into the art and politics of the South and introduced me to useful contacts, including Joe and Christine Wilson, who generously showed me their collection of Clara Weaver Parrish's art in their Birmingham home. John P. C. McCall in Mobile was an essential source; his collection of Weaver papers and knowledge of Selma history were invaluable. Joel Rosenkranz, of the Conner Rosenkranz Gallery in New York, was particularly informative about the New York art world in the 1930s.

I also wish to thank Karol Lurie, former curatorial administrator, and Maggie Edwards, both at the Norton Museum of Art; librarians Stephanie Cassidy, at the Art Students League, in New York, and Deborah Kloibe, at St. Catherine University, St. Paul, Minnesota; and archivists Deborah A. Richards, at Smith College, Carol Salaman, at Cooper Union, Debbie Vaughan, at the Chicago Historical Museum, and Laura Zelasnic, at the National Academy of Design.

Scott Moses at the Preservation Foundation of Palm Beach, and Debi Murray, director of the Historical Society of Palm Beach County, were both generous with their archives.

John Benson, whose father ran the John Stevens School in Newport when Ann studied there, was enormously helpful in describing life at the studio, which was such an important part of Ann's early life.

Others who provided me with important information, contacts or hospitality were Hope Alswang, Claudia Aronow, James Y. Arnold, Cartledge Blackwell, the late Thomas M. Chastain, James M. Clark, Lynn Leofanti

Cole, Dr. Joseph Doane, Mimi Duncan, Ouida George, Helen Goldberg, the late E. Robert Hunter, Nicholas Hunter, Leo and Peggy Leofanti, Cara Montgomery, Glen Rawls, Joan Rosenbaum, Edwina Sandys, John Strange.

Sian M. Hunter, my acquisitions editor at the University Press of Florida, understood the story, sharpened my prose, and fielded my endless ignorant technical inquiries with patience and remarkably good humor. Project editor Nevil Parker and copy editor Penelope Cray edited the text with meticulous care. I also thank Shannon McCarthy, who prepared the book to launch, Louise OFarrell for outstanding book and cover design, and all the individuals at the press who shepherded my book into print.

Finally, I'd like to thank Walter Lippincott, who supported this project from the beginning and helped bring it to fruition.

Index

Betts, Louis, 33
Birmingham Museum of Art in Alabama, 29
Birth, 7
Bodley Gallery, 158, 159
Boettcher, Graham, 29
Boochy's Wings (Weaver, A.): illustrations in, 27; language footnotes, 26; Southern history in, 26–27
Boss, Homer, 35
Brancusi, Constantin, 98, 120; on direct carving, 41; introduction to, 39
Braque, Georges, 39
Brick, 150; monuments, 155–57
Bronston, Cecil, 128, 134
Bronx Post Office in New York, 36
Brunner, Elizabeth, 147
Bruno Bearzi foundry, 136, 141
Bryce Canyon, 134, *p12*
Buddhism, 161–62
Burchfield, Charles, 61
Burgess, Helen, 66
Butler, Veronica Boswell, 171

Cahawba, Alabama, 1–2, 156; towers, *p16*
Cahill, Holger, 70
Calder, Alexander, 121
Calhoun, Elizabeth: background of, 84; death of, 102; illness of, 97
Calhoun, John C., 84
Cambridge Arts Council, 160
Campbell, Joseph, 52
Carey, Arthur Graham: background of, 50; Bethune correspondence with, 50–51, 58; traditionalism beliefs of, 52
Carnegie Corporation, 37
The Castle, 10, *11*, 11–12
Casualties I (Mother and Child), 75; Norton purchasing, 102
Casualties II, 75
Casualties III (Three Widows), 75
Casualties IV, 75; Norton purchasing, 102
Catholic Art Association, 64

The Catholic Worker, 48; illustrations in, 50–51
Catholic Worker movement, 48
Cézanne, Paul, 120; explaining, 111
Chalice sketches, *44*
Chapin, Francis, 98
Charcoal, *p4*, *p8*
Charles J. Connick studios, 50
Chase, William Merritt, 14
Chastain, Thomas M., 148, 168
Château de Polignac, 141–42
Chautauqua Institution, 84; Norton resigning from, 119
Chicago Chamber Music Society, 84
Childhood home, *15*
Children Pumping Water, 75–76, *78*
Children's books: controversy over, 28–29; dialect in, 24; illustrations, 27–28; subject matter in, 28–29; throwing away, 28–29. *See also specific children's books*
Chinese bronzes, 120
Chinese jade, 96, 120
Civil rights movement, 153
Civil War, 2, 8, 9, 152
Claudel, Camille, 73
The Clocktower, 160
Cohen, George M., 35
Cole, Thomas, 33
Communism, 61–62
The Confessions of Nat Turner (Styron), 28–29
Continental Illinois National Bank and Trust Company of Chicago, 134
Coomaraswamy, Ananda K., 66; followers of, 52
Cooper Union Art School, 34, 47; admission to, 35; graduation from, 38–39
Cotter, Holland, 43
Courbet, Gustave, 96, 98
Crocheron, Richard, 2–3
Cubism, 72; Cotter on, 43; Hoffmann on, 43; as push and pull of space and light, 43

Harlem Renaissance, 179
Hassam, Childe, 96
Heart cedar, 148
The Help (Stockett), 24–25
Hickock, Lorena, 181
High Museum of Art in Atlanta, 159
High school, 15–16
Hinton, Charles, 34, 35
Hoffman, Malvina, 73
Hoffmann, Hans, 43
Homer, Winslow, 121, 123
Honeymoon, 113
Hovannes, John, 46, 52, 97–98, 121; influence of, 39; realism over romance preference of, 43
Hubband, Susan, 134
Hunter, Nick, 161–62
Hunter, Robert, 71, 79, 100, 138; background of, 90–91; influence of, 96–97; on Norton School of Art, 89; Norton's eulogy by, 127
Huntington, Ann Hyatt, 73
Hutchinson, Max, 160, 169

India, 139, 142; Beresford in, 146–47; objects brought back from, 147–48; traveling companions in, *143*
Institute for International Education, 37, 38
International Cultural Centre in Antwerp, 159
International Style, 40

J. B. Lippincott, 25
Jitterbug Dancer, 119
John Stevens Shop, 51–52, 54–56, 64
Johnston, Harry A., II, 166–67
Jones, Grace, 106, 113, 117
Joy Moos Gallery, 173

Kane, Margaret Brassler, 64–65; recognition for, 65
Katz, Leo, 63
Keck, Charles, 34, 35
Kessler, Frederick W., 131

Keyes, Emilie, 121
Klee, Paul, 111
Kneeling Figure, 76
Kokoschka, Oskar, 142
Krasner, Lee, 173
Kroll, Leon, 34, 35

Lady with a Bird, 70, 71, 72
Lange, Dorothea, 61
Lapsley, John, 21, 60, 61; Bethune on, 62; drafting of, 91; on leaving New York, 70; letters to, 91–92, 95; sexuality of, 63
Lavaggi, Rene, 136; quitting *Seven Beings* project, 137
Leale, Charles A., 65
Leale, Lilian: charity of, 65; reference letter from, 68
Léger, Fernand, 39, 123
Leofanti, Gene, 137, 160, 163, 164, 169–70, *p14*; du Boisrouvray displacing, 144–45; hired as technician, 135–36; moving to West Palm Beach, 140; on *Seven Beings*, 139
Less is more, 40
Leukemia, 158
Lincoln, Abraham, 152
Lindbergh, Charles, 65
Lipschitz, Jacques, 121, 135, 137
Lipscomb, Rosalind Tarver, 17–18, 129–30
Lober, Georg John, 34, 35, 135
Lofting, Hugh, 28, 36
Loo, C. T., 120
Lundgren, Eric, 91
Lundgren, Frances, 91

Machine I, 76; Norton purchasing, 102
Machine II, 76; Norton purchasing, 102
Machine III, 76
Machine IV, 76, 119
Mademoiselle Pogany II, 98, 120
Madigan, Richard, 171; on Ann Norton Sculpture Garden, 173
Maharan, Gyani, 142
Mammy's Reminiscences (Gielow), 24
Man and Machine, 101

English-born Caroline Seebohm has published books on art, architecture, and gardens including *Boca Rococo: How Addison Mizner Invented Florida's Gold Coast* and *Under Live Oaks: The Last Great Houses of the Old South*. She has also published two novels and four previous biographies.